D0529476

ANATOMY FOR THE ARTIST

DRAWINGS AND TEXT
BY
JENŐ BARCSAY
PROFESSOR OF APPLIED ANATOMY
AT THE BUDAPEST ACADEMY OF FINE ARTS

BARNES
&NOBLE
BOOKS
NEW YORK

© heirs of Jenő Barcsay
First Hungarian edition © by Jenő Barcsay, 1953

Medical revision and contribution to the
drawings illustrating the muscular system by
Dr Barnabás Somogyi

Translated by Pál Antal

This edition published by Barnes & Noble Inc., by
arrangement with Little, Brown and Company (UK) Ltd

1995 Barnes & Noble Books

All rights reserved
No part of this publication may be reproduced,
stored in a retrieval system, or transmitted, in any
form of by any means without the prior
permission in writing of the publisher, nor be
otherwise circulated in any form of binding or
cover other than that in which it is published and
without a similar condition including this
condition being imposed on the subsequent
purchaser.

Printed in the Czech Republic
50982/6

ISBN 1-56619-245-5

11 10 9 8 7 6 5

CONTENTS

INTRODUCTION

Anatomy, so far as it is concerned with a knowledge of the bones and muscles of the human body, is an indispensable foundation for any artistic portrayal of human beings. Without such knowledge, it is impossible to observe with understanding the various attitudes, positions and movements of which the human body is capable, up to and including those which reflect emotion. This knowledge not only aids study of the body at rest, but also helps in capturing rapid movements and fleeting changes of expression. Even with the assistance of a trained model one cannot paint these facial and bodily appearances if one lacks any knowledge of anatomy.

So far as the artist is concerned, the impact of the human body is exclusively a visual one. His eye studies only the visible details of it. The artist should therefore approach anatomy from an artist's point of view, not a doctor's. He should make himself acquainted primarily with the bones and muscles whose forms and actions are visible at or just below the surface. The study of heart, liver and lungs will improve his general knowledge but not his ability to draw. Therefore ANATOMY FOR THE ARTIST does not deal with the internal organs. Some of the blood vessels appear on the surface, but it would be unprofitable to analyse their characteristics at any length.

The bones and muscles of the human body compose a very complex three-dimensional system. A very small change of position may affect the whole system and change its equilibrium and form. With this in mind, I have endeavoured, while following the inescapable stage-by-stage description, not to neglect the relationships between the parts of the organism. I have used drawings in preference to photographs, since the latter offer only the impersonal viewpoint of a mechanical device and not a selective one which emphasises the essential details, and tones down the unimportant ones.

This work deals with the healthy adult human body. Its structure corresponds to that of my lectures at the Budapest Academy of Fine Arts. Wanting to make as much use as possible of historical sources, I found that

the well-known work of Mollier, Plastische Anatomie *(1924), was especially valuable where the analysis of movements was concerned. As regards the systematic description of the skeleton and the musculature, I paid great attention to the* Anatomie Artistique *of Richer (1890), all the more so since this text has become the main sourcebook for every work on anatomy for artists published in this century. For certain details I consulted the following handbooks:* Anatomischer Atlas *by Toldt-Hochstetter (1948),* Atlas der descriptiven Anatomie des Menschen *by Sobotta (1903—1907), Kollmann's* Plastische Anatomie *(1928),* Textbook of Human Anatomy and Histology *by Mihálkovics (1898, in Hungarian),* Descriptive Human Anatomy *by Krause (1881, in Hungarian), as well as the experiences of Kálmán Tellyesniczky, and the celebrated Hungarian painter Bertalan Székely. The layout of the theoretical sections was greatly helped by the study of* Systematic Anatomy *(1951, in Hungarian) by Ferenc Kiss, professor of anatomy. My sincere thanks are also due to several painters and sculptors for their friendly advice and information.*

JENŐ BARCSAY

ANATOMICAL TERMS

In describing forms, directions, positions, parts of the body, and anatomical structures, my endeavour has been to employ characteristic and objective terms.

The starting point of any description is the simple standing posture.

The term *medial* designates those parts nearer to the median plane (page 13) of the body. The parts farther from this plane are termed *lateral*. The term *anterior* is applied to the surface of the face and front of the trunk and limbs, the hands being held palms forward; *posterior* is applied to the opposite surface. In the limbs, *proximal* means nearer the trunk and *distal* further from the trunk.

Superior and *inferior* mean directions toward the calvaria (upper part of the skull) and the sole of the foot, respectively. *Superficial* and *deep* are terms by which the lesser or greater distance of a part from the body surface is expressed.

Besides the adjectives lateral and medial, referring to the limbs, the terms *radial* (of the thumb side), *ulnar* (of the little finger side), *tibial* (of the hallux or great toe side), *fibular* or *peroneal* (of the little toe side), will occasionally be used.

The more accurate definition of a direction will often require terms differing from the usual ones, for example, with the limbs: *palmar* (on the side of the palm), *plantar* (on the side of the sole), or *volar* (on the side of the palm or sole), and *dorsal* (on the side opposite the palm or sole).

Tendons are generally located at the ends of muscles as their prolongations. They may be thick or thin, long or short, rarely round, in most cases slightly flattened. By them, muscles are attached to bones. *Tendinous intersections* are fibrous parts crossing certain muscles in varying directions.

Aponeuroses are broad, flat, membrane-like tendons, generally continuations of broad and flat muscles. They may be attached to a bone or continue into fasciae.

Fasciae are fibrous laminae of variable thickness and strength, found in all parts of the body, investing the whole muscular system. They maintain the muscles in their position.

Tendinous arches are fibrous bands connected with the fasciae of muscles.

Ligaments are fibrous or fibro-elastic bands. They present a white, shining, silvery and flexible aspect. They have a double role. The majority are found at joints where they connect the articulating bones, or they are stretched between two immobile bones. (For instance: the ligament between the sacral bone and the pelvic bone, or the deep transverse ligament of the palm and the cruciate ligament of the knee.)

Capsular ligaments of the joints are fibrous membranes enclosing the cavity of the joints.

*

The anatomical terms employed in the book are mainly those of the Birmingham revision of the Basel Terminology.

AXES
Vertical (perpendicular) axis (a)
Transversal axis (b)
Sagittal axis (c)

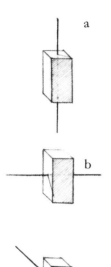

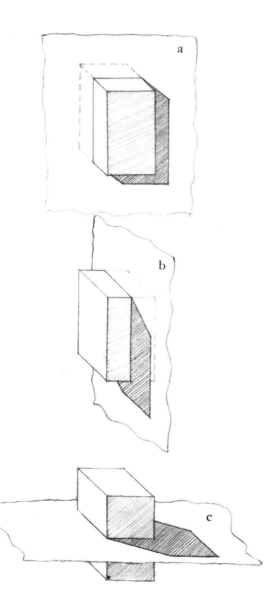

MAİN PLANES
Coronal plane (a)
Sagittal plane (b)
 (the midline sagittal plane is the median plane)
Horizontal (transversal) plane (c)

THE SKELETON

I—II

The skeleton is the firm framework of the human body. It constitutes partly a support, partly a protective cover for the inner organs. The individual bones are linked together in different ways. The majority of the bones are moved by the muscles. As a rule, they move like levers.

The majority of the bones composing the skeleton are symmetrical bones. The single bones, such as the vertebrae, are composed of two similar subdivisions (Plate II, fig. 8). As for their form, the bones may be long, flat, broad, small or irregular, as seen in figs. 1—6 and 9 of Plate II.

The bones of the limbs are long and cylindrical. The bones forming the elastic wall of the trunk resemble hoops. The ends of the long bones are thicker than their middle parts. They are slightly curved like an S. Such a bone is the bone of the upper arm (humerus) illustrated in Plate II, fig. 2. The broad and flat bones surround and protect the inner organs of the body.

The most mobile parts of the body, the hand and foot, consist of small bones (Plate II, figs. 6 and 9). There are irregular bones differing from all other bones, such as certain bones of the skull. The articular extremities of the long cylindrical bones consist of cancellous tissue invested by a compact layer. The arrangement of the cancelli corresponds to the greatest tension and pressure to which the bone is exposed (see Plate II, figs. 7 and 9). This architecture may be seen on sagittal or transverse section of the bone. The architecture of the heel bone corresponds to the influences to which it is subjected (Plate II, fig. 9 a).

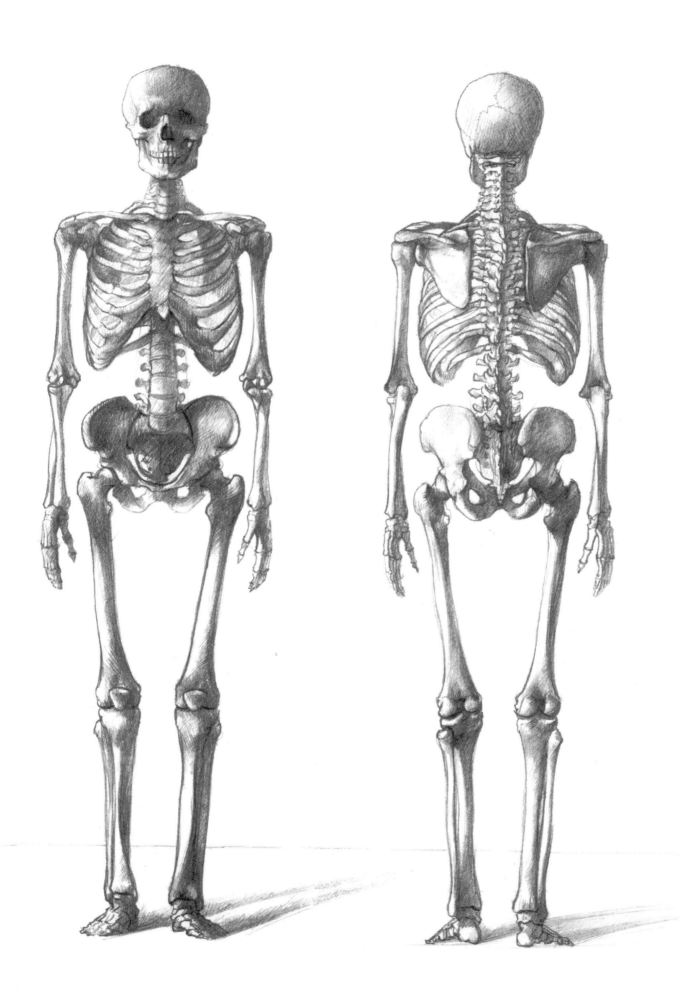

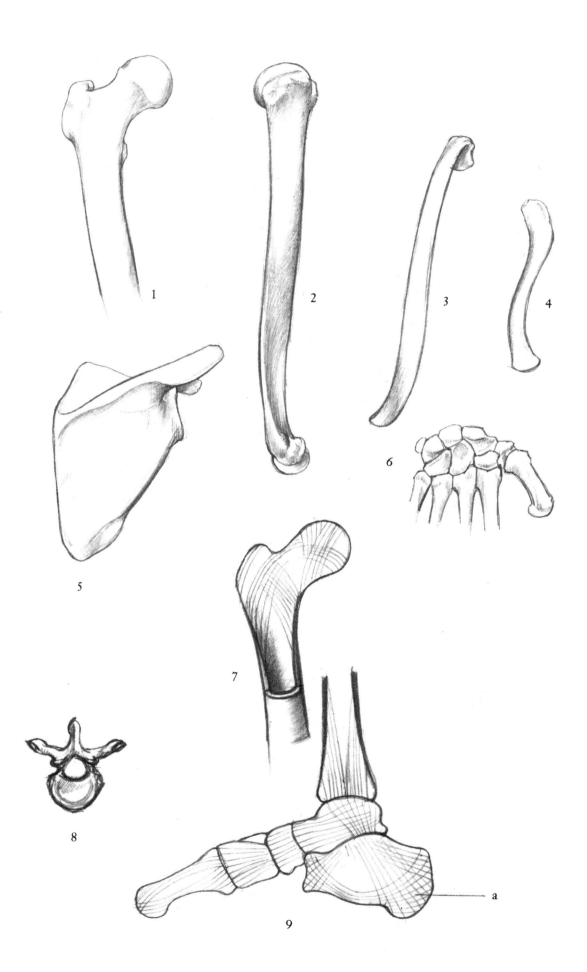

JOINTS

III

Our bones form a firm system, as they are connected by joints. These joints may be fibrous, cartilaginous or synovial.

There is no appreciable movement at *fibrous joints*. They include *sutures* (e.g., between the bones of the skull, or between the teeth and the jaws) and *syndesmoses* (e.g., the inferior tibio-fibular joint).

There is limited movement at *cartilaginous joints* or *synchondroses* (e.g., the symphysis pubis).

The bones are not fixed at *synovial joints* (i.e., not ankylosed).

The forms of the articulating surfaces determine the function. The joint may be flat, spherical, cylindrical, conical, saddle- or screwlike. The modes of articulation may be represented by geometrical diagrams, as seen in Plate III, figs. 1—6.

In movable joints the bones move around an imaginary axis. When the muscles moving a given joint are in the state of minimal possible contraction, the position of the joint is one between the extremes of flexion, extension, adduction and abduction.

This position is called state of rest. It is the starting point to every analysis of the movements.

Here are the main forms of joints:

1. Plane joints (fig. 1), with flat or slightly curved surfaces. In such joints little movement is allowed. Example: the joints of the wrist and the instep.

2. Hinge joint (fig. 5). One of the articular ends is a cylinder, the other is a cylindrical excavation. Movements are possible in one plane only. Example: knee, elbow, finger joints.

3. Pivot joint (fig. 6). The bone can move round another or, along with the latter, round its own axis. The head of the joints in cylindrical. Such movement is carried out by the head of the preaxial bone of the forearm (radius) round its own axis and the postaxial bone (ulna).

4. Ball and socket joint (figs. 2 and 3). The spherical end of one bone moves in a spherical excavation. Example: the hip joint.

5. Saddle (biaxial) joint (fig. 4). One of the surfaces is convex, the other is concave; the transverse curvatures are oppositely formed, whereby in both directions saddle-like joints are formed. Flexion, extension, adduction, abduction are the chief movements. Example: the joint between thumb and wrist.

The chief movements at joints are *flexion* (bending to more acute angle); *extension* (straightening); *abduction* (moving away from the midline); *adduction* (moving towards the midline); and *medial* and *lateral rotation*. If the arm is held horizontally, and the hand is turned palm upwards, the movement is called *supination*; if it is turned palm downwards, the movement is termed *pronation*.

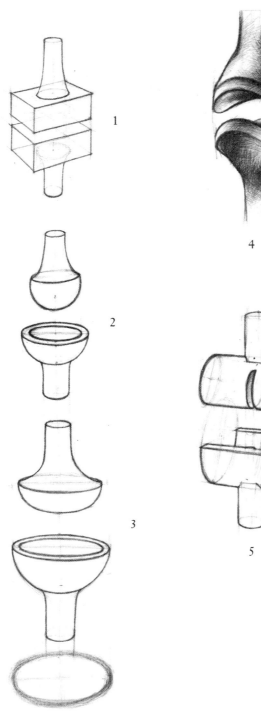

1

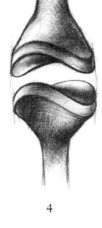

4

2

3

5

6

FORM AND FUNCTION OF MUSCLES

IV

Bones are moved by muscles. These are flesh-coloured fibrous structures encapsulated by fasciae. There are variously shaped muscles (Plate IV, figs. 1—5). Their ends are attached to bones by tendons (or broad fasciae). Long muscles are as a rule located on the limbs. Broad muscles generally move the trunk. The thick muscles are short and represent great power. Ring-shaped muscles surround the openings of the body (for instance, the circular muscle of the mouth).

Certain muscles are grown together. They have two, three or four heads and ends (fig. 4). These are combined muscles originating at different places. Other muscles are interrupted by an intervening tendon (fig. 7), for instance, the digastric muscle. There are muscles divided transversely into several areas (fig. 6), for instance, the straight muscle of the belly (rectus abdominis). Muscles are, as far as possible, named according to their form, site and function. Example: pyramidal muscle, two-headed (biceps) muscle of the arm, oblique abdominal muscles, etc. Muscles perform action, they contract, i.e., become shorter and thicker, whereby their ends are approximated. Owing to their contraction, parts of the body come nearer to, or farther from, each other, rotate medially or laterally.

This function of muscles may be learned from figs. C, D, E in Plate IV. The two bones to which the muscle is attached are represented by two laths. At C and D the muscle is contracted, thickened; at E, it is stretched. In the two former cases the bones are brought nearer, in the latter they are removed from each other.

The action of a muscle may be assisted (synergism) or counteracted (antagonism) by that of another muscle. As a rule, these opposite actions are alternately performed, as on the limbs moved by flexor (bending) and extensor (stretching) muscles. They may, howerer, act simultaneously, as in the case of the clenched hand.

The more fixed end of a muscle is termed origin or head. The other end, being usually at a greater distance from the centre of the body or the spinal column, is called insertion.

Muscles act like levers. The muscle represents the power, the bone to be moved constitutes, along with its soft parts, the weight, the joint is the point of support. This is illustrated by figs. A and B in Plate IV (p: power, w: weight, s: point of support).

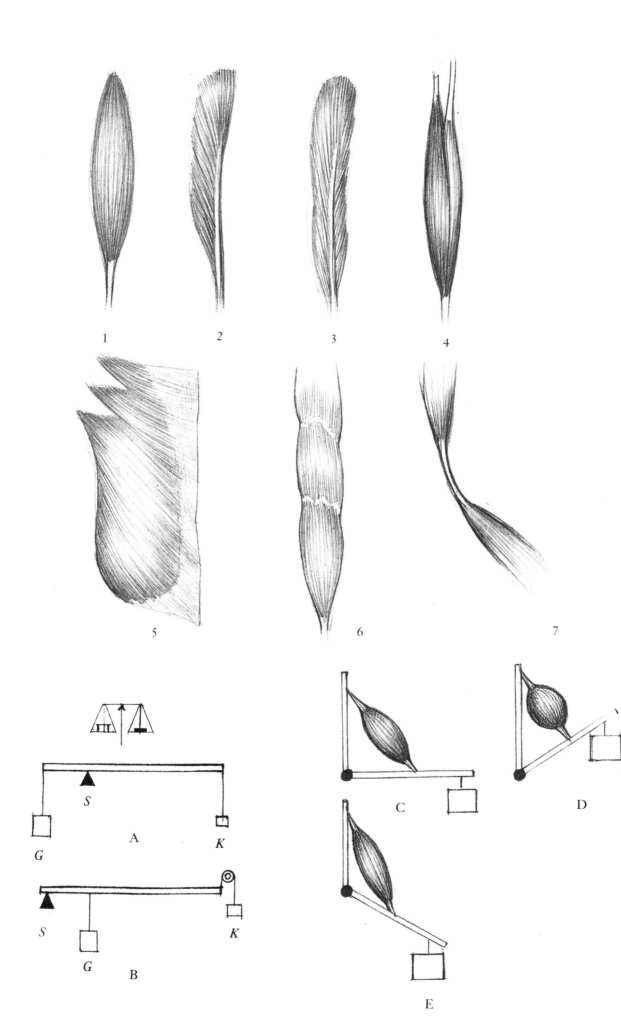

1 2 3 4

5 6 7

A

S

G K

B

S

G K

C D

E

BONES OF THE UPPER LIMB

V

BONES OF THE SHOULDER GIRDLE

The shoulder girdle consists of two bones: the scapula (Plate V, A) and the clavicle (Plate V, B).

SCAPULA (SHOULDER-BLADE)

This is located on the posterior side of the chest between the second and seventh ribs. Its axis is vertical, as shown in fig. A. Its form is like a triangle, the shortest side of which is uppermost. The bone consists of a body and two processes. The body (A 3 and 7) has three edges forming three corners. The lateral edge becomes broader (A 5) and forms an oval articular surface joining the corresponding articular surface of the humerus. The anterior surface of the scapula (A 7) is concave, the posterior one convex (A 3). The latter is bisected by the scapular spine (A 1). The supraspinous fossa (A 2) is smaller, the infraspinous fossa is larger (A 3). Arising as a triangle at the inner border, the scapular spine widens out to form the apex of the shoulder (acromion). The other process of the bone, turning forwards and sideways (A 4), is called the coracoid process.

CLAVICLE (COLLAR-BONE)

A longish, slightly S-curved bone. Its long middle part is the shaft (B 3). B 1 and B 2 are its ends. Its medial two-third parts are, in the normal position, forwardly convex, the lateral third is forwardly concave. Its outer, oval and flattened end attached to the shoulder-blade is covered with cartilage (B 1). The inner end (B 2) is convex, likewise covered with cartilage.

V

A

Lateral aspect

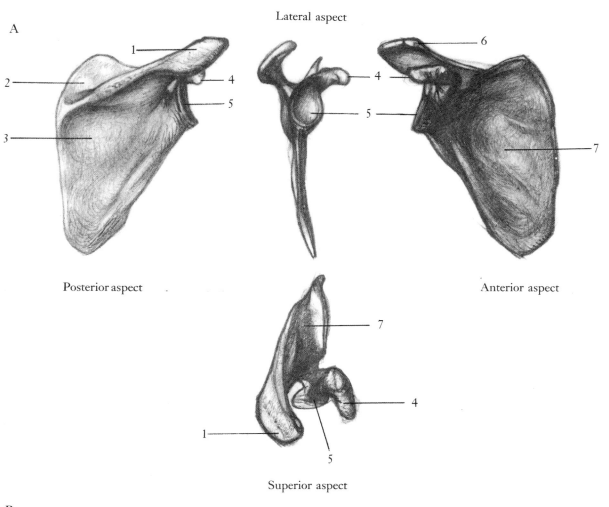

1
2
4
5
3

Posterior aspect

6
4
5
7

Anterior aspect

7
4
1
5

Superior aspect

B

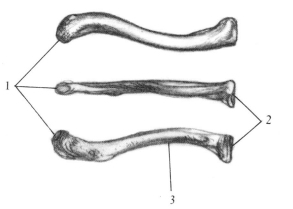

Superior aspect

Anterior aspect

1

2

Inferior aspect

3

VI

BONES OF THE FREE UPPER LIMB

HUMERUS (BONE OF THE UPPER ARM)

The humerus is a cylindrical bone with characteristic curvature. Both its ends are broadened. The middle part is the shaft of the humerus (Plate VI, 6). The top end (1) is the articular surface. Below this, the neck is seen (5). Further down there are, on the frontal aspect, two tuberosities (2, 3), a larger one above and a smaller one in front, with a groove (bicipital groove) between them (4). The lower end of the bone is wider than the upper one; it is considerably flattened. At this end, there are two epicondyles; the medial one is sharper and lower seated (12) for the flexor muscles, the lateral one (9) is less sharp, serving the insertion of the extensor muscles. Between the two condyles the trochlea is seen (11) with which the ulna articulates. On the posterior side, there is a deep semilunar excavation for the olecranon process (13). At the lateral side of the spiral surface the capitulum (10) (a knoblike protuberance) articulates with the end of the radius. Above the spiral surface the fossa (7) for the coronoid process of the ulna is seen, above the capitulum the groove for the radius (8). The cross section of the shaft is triangular.

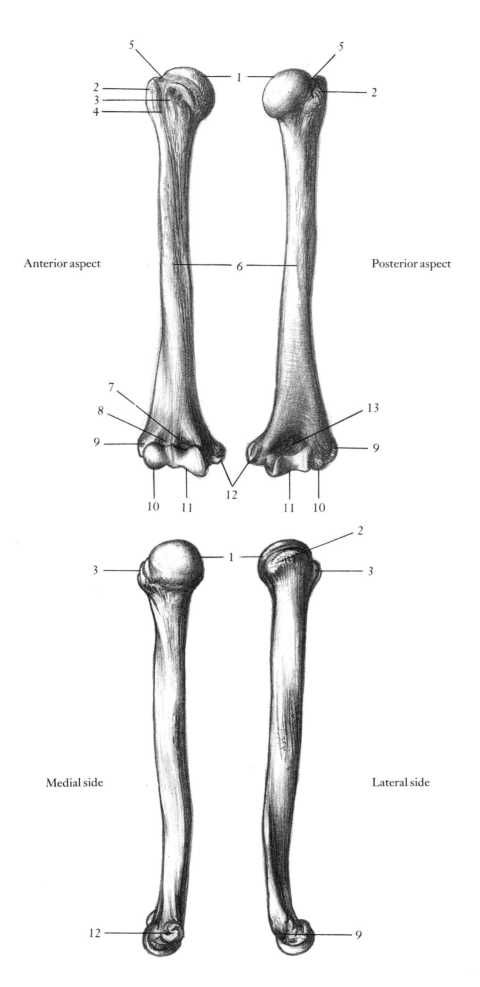

5
2
3
4

1

5

2

Anterior aspect

6

Posterior aspect

7
8
9

13

9

10 11

12

11 10

3

1

2

3

Medial side

Lateral side

12

9

BONES OF THE FOREARM

The forearm contains two bones: the radius (Plate VII a) (on the thumb or lateral side), and the ulna (b) (on the side of the little finger). The two bones differ in shape, the ulna being longer and thicker at its upper end, while the radius is thicker below. Each bone has a sharp edge facing the other. The space between the two bones, overbridged by an interosseous membrane of connective tissue, is narrower at both ends than in the middle part.

Ulna

Above, the ulna (b) has a rough projection named the olecranon (5). The anterior surface of the latter is concave in the longitudinal direction (6). Along its middle line there is an elevated ridge by which the cartilaginous surface is bisected. In front, the upper end of the bone has another process (coronoid process) (7), on the radial side of which there is an excavation covered with joint cartilage (lateral aspect 13). It is on this groove that the circumference of the head of the radius rotates. The cross section of the ulna is triangular. The lower end is narrow, with a small head on the radial side (12), and a somewhat curved process on the medial side (styloid process) (8).

Radius

The radius (a) has, when seen from the front, a long S-shape. It is parallel with the ulna. Its upper end is thinner. The top end is a small cylindrical head (1), the upper articular surface of which is slightly excavated (medial aspect 14). Below the head the neck (2) joining the shaft is seen. On the ulnar side (anterior aspect 3) a small rough tuberosity is found. The lower end of the radius is larger. There is a crescent-shaped excavation on the ulnar side (medial aspect 15). On the lateral side of the lower end a small process (styloid process) (4) is seated. On the base of the lower end (9) two articular surfaces separated by a ridge (10 and 11) are located.

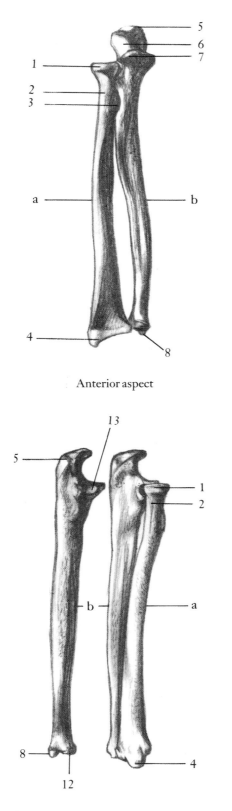

5

6

7

1

2

3

a b

4

8

Anterior aspect

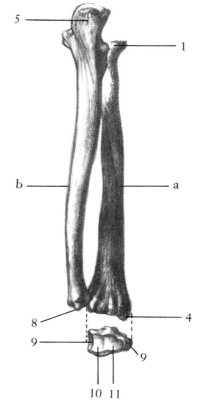

5

1

b a

8 4

9 9

10 11

Posterior aspect

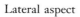

13

5

1

2

b a

8

12

Lateral aspect

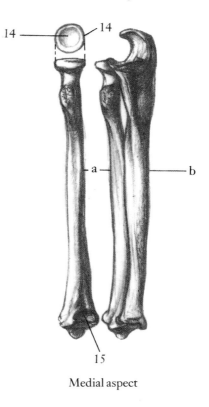

14 14

a b

15

Medial aspect

BONES OF THE HAND

The bony structure of the hand is composed of three parts: the wrist (carpus), the palm (metacarpus), and the fingers (phalanges).

Carpal bones

These are arranged below the forearm in two rows. Their number is eight. The following bones, starting from the thumb side, are found in the upper row:

1. scaphoid,
2. lunate,
3. triquetral,
4. pisiform,

those of the lower row are:

5. trapezium,
6. trapezoid,
7. capitate,
8. hamate.

The largest bone of the wrist is the capitate. Above, it has a small head covered with cartilage. The hamate bone has a hook-like process projecting on its palmar aspect.

The bones of the upper row form, by their peculiar articulations, a concavity resembling an excavated joint surface by which the capitate is surrounded.

Metacarpal bones

There are five metacarpal bones (a—e). From the little finger towards the thumb they become gradually larger, and form, along with the bones of the wrist, a united mass. The metacarpal bone of the thumb differs from the others in regard to form and position: four lying in the same plane as each other, whilst the metacarpus of the thumb is more anteriorly located, and is shorter and thicker than the others. Both ends of the metacarpal bones are thicker. The proximal ends are the bases, the distal ones are the heads. The base has the form of an irregular quadrangle. The head of the thumb metacarpal is larger in the transverse direction and less convex than the others.

Phalanges

Each finger consists of three phalanges, while the thumb consists of only two (lower figure in Plate VIII, anterior aspect). Here, too, shaft ends are distinguished. They are unequal in length, the distal phalanx (3) is two-thirds as long as the middle one (2), and the latter is equal to two-thirds of the first one (1). The phalanges are slightly concave anteriorly. At the proximal end of the proximal phalanx there is an excavated joint surface, at the distal end a characteristic helix (1). The base of the middle phalanx is provided with a double articular surface fitting the helix of the proximal phalanx (2). The distal phalanx is similar to the former (3).

Sesamoid bones

Two small bones opposite the head of the metacarpus of the thumb, upon the rough palmar eminences of the articular surface. There are sometimes similar bones opposite the heads of the other metacarpal bones, particularly the second and the fifth.

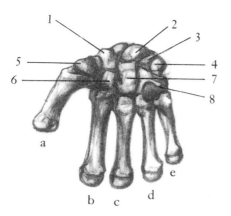

Anterior aspect

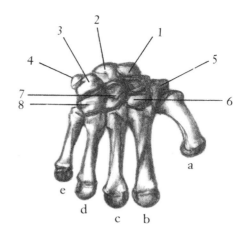

Posterior aspect

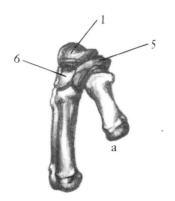

Medial side

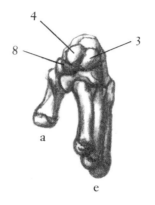

Lateral side

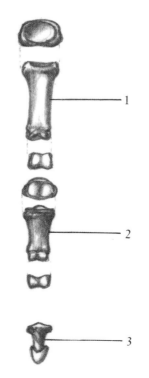

Anterior aspect

JOINTS AND MOVEMENTS OF THE BONES OF THE UPPER LIMB

IX—XII

THE BONY STRUCTURE OF THE UPPER LIMB

The figures in Plates IX—XII show the articulations of the bones of the upper limb as seen from the anterior, posterior, lateral and medial sides. The drawings of details mainly demonstrate the joints during movement.

JOINTS BETWEEN THE HUMERUS AND THE SHOULDER GIRDLE

The humerus is connected with the trunk by two bones, the clavicle (Plate IX, A 1) and the scapula (Plate IX, A 2). In fig. B the elements of the joints are exhibited. It may be seen from this figure that the oval surface of the lateral end of the clavicle articulates with the similar surface of the scapular spine (Plate IX, B 1, 2). The spherical head of the humerus (Plate IX, B 3) articulates with the articular excavation of the scapula (Plate IX, B 4). The latter is slightly concave, widening inferiorly.

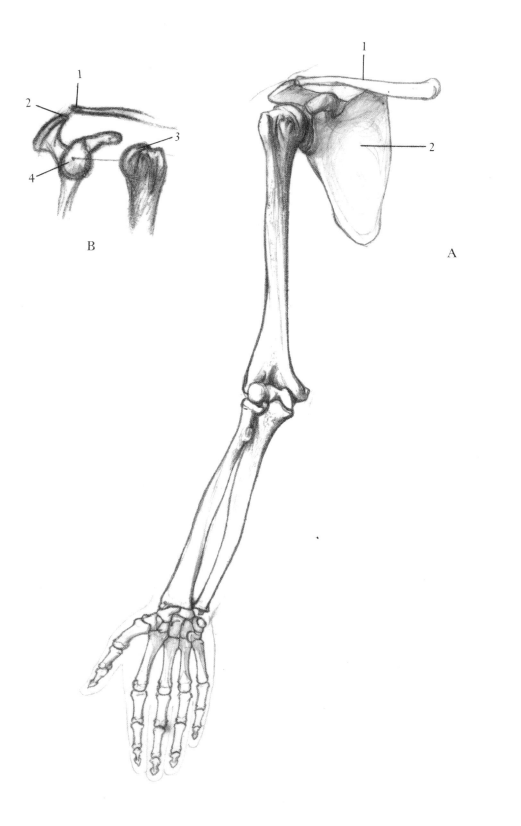

1

2

3

4

B

1

2

A

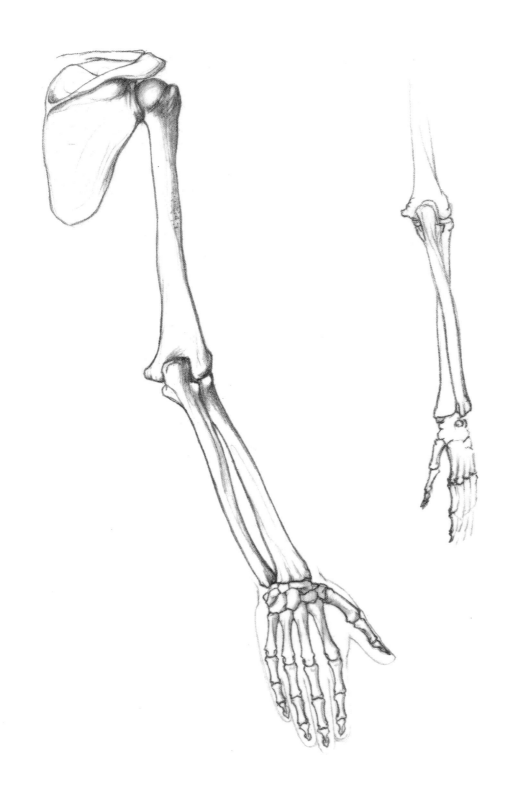

Posterior aspect

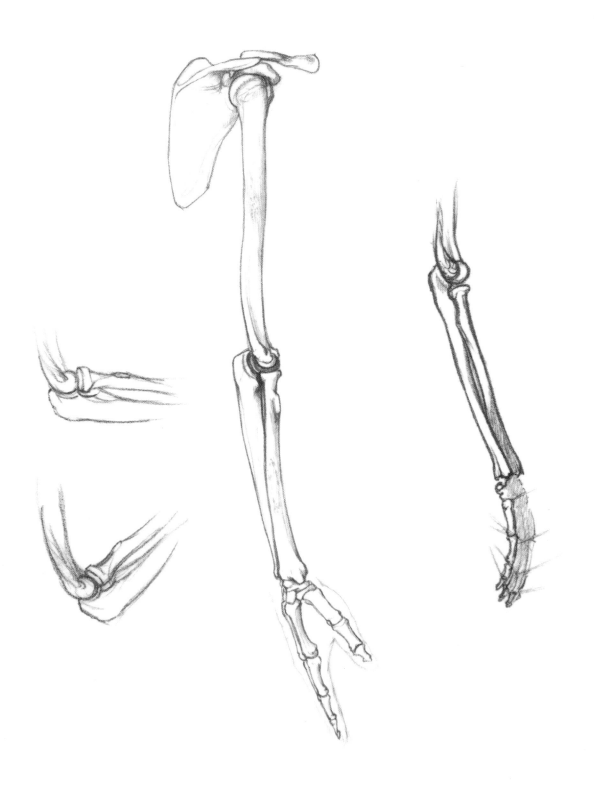

Lateral side

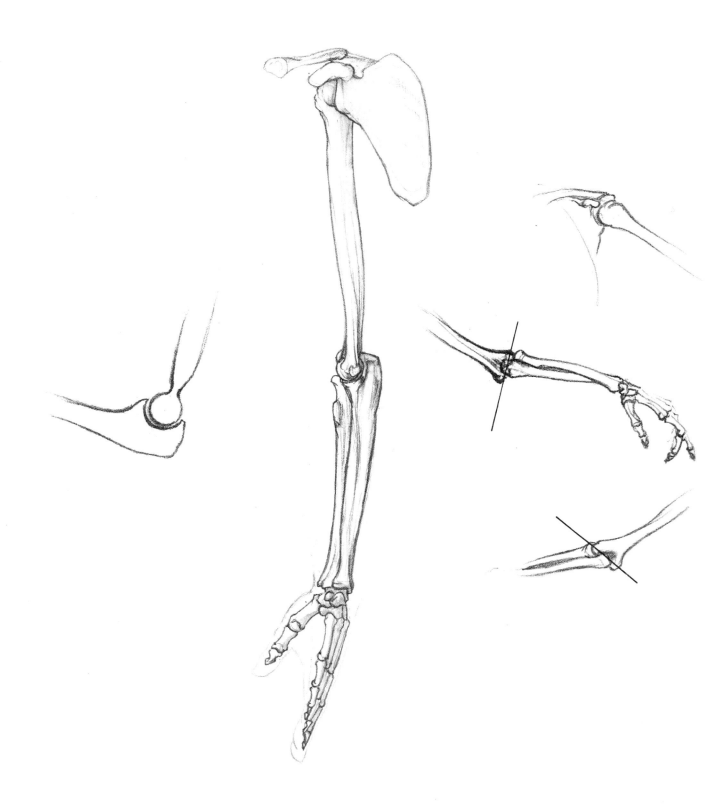

Medial side

THE JOINTS OF THE ARM AND THE SHOULDER
IN MOVEMENT

As there is a close correlation between humerus and shoulder bones, any movement of the former is followed by those of the latter. The clavicle may rise or descend, move forward or backward. While its medial end articulates with the sternum, its lateral end may move in a circle (Plate XIII, fig. 7). In the sketches the direction of movement is shown by arrows (Plate XIII, figs. 1—11 and 13). Parallel to the moving clavicle, the scapula attached to it glides on the chest wall superiorly, inferiorly, laterally and medially (Plate XIII, figs. 1—6, 9, 10, 11; Plate XIV, fig. 2). In this movement, a conic surface is described by the clavicle (Plate XIII, fig. 7), and an ellipse by the shoulder joint (Plate XIII, fig. 8). These movements produce characteristic changes on the body, as seen in fig. 12 of Plate XIII and fig. 1 of Plate XIV. The mechanism of the changes produced by the movement may be understood by studying fig. 2 in Plate XIV.

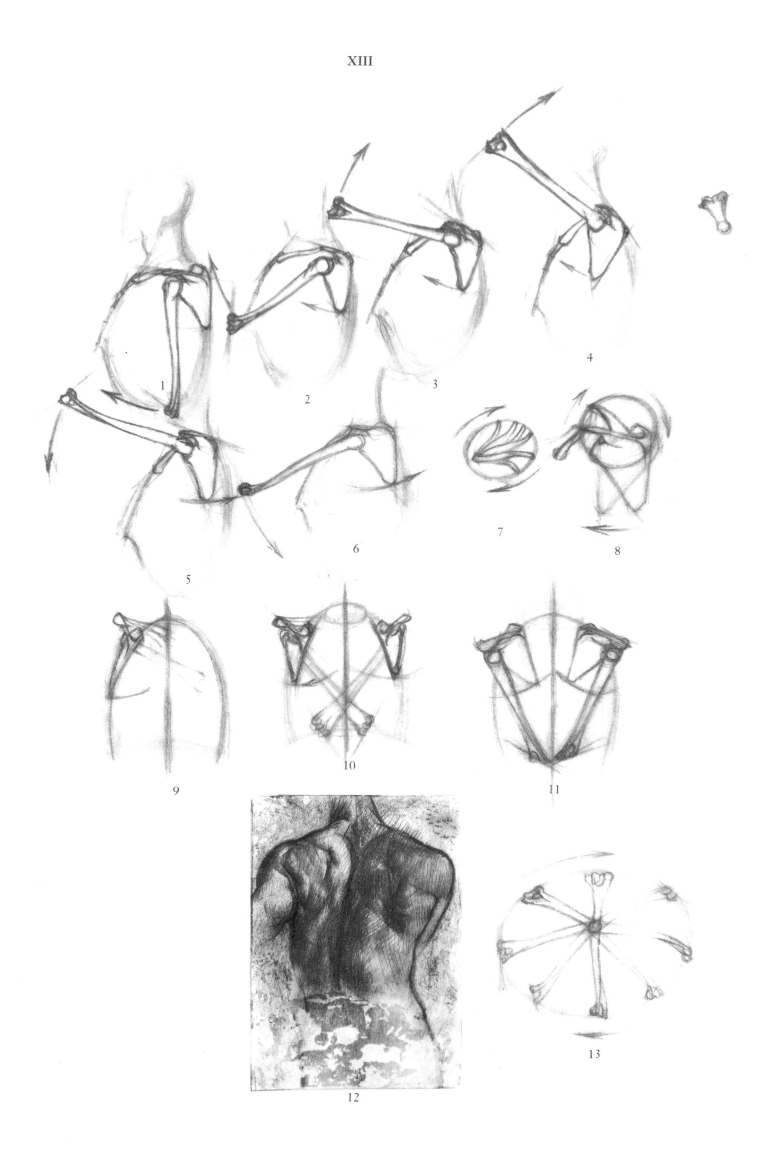

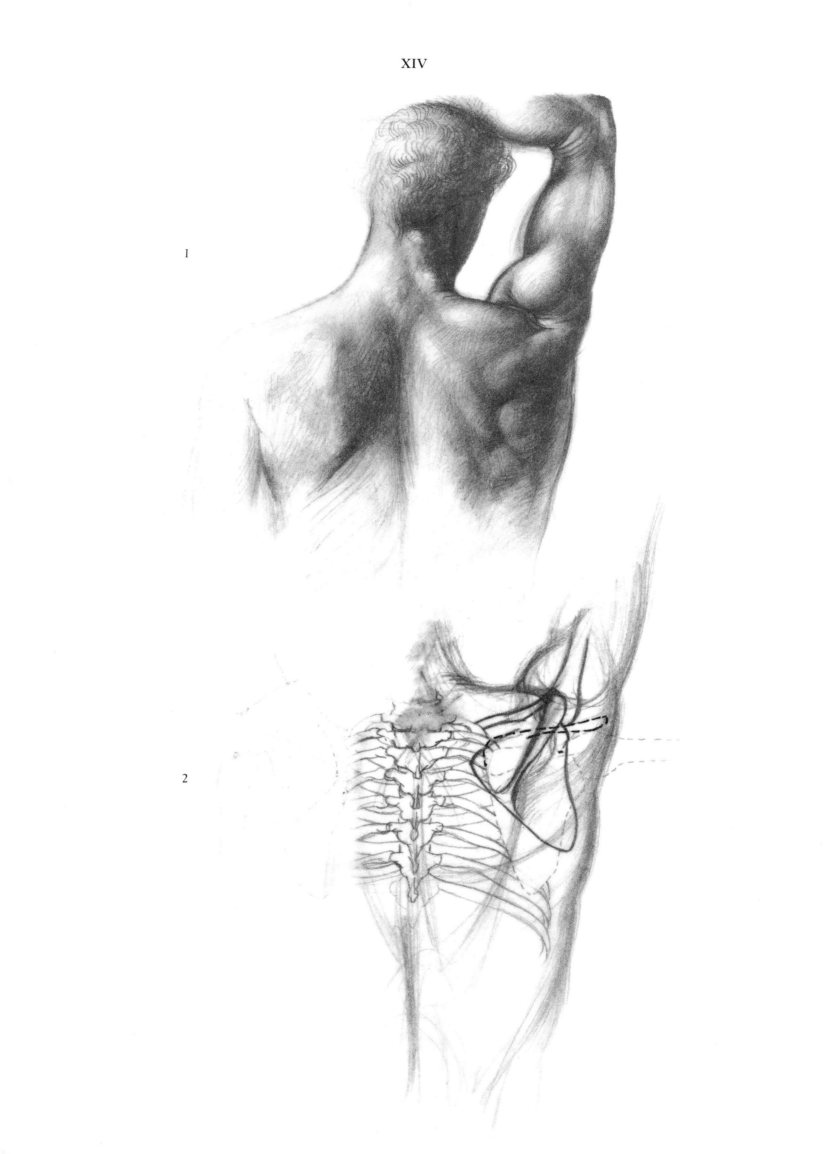

1

2

XV

MOVEMENTS OF THE ARM

Owing to the spherical form of its articular surface, the arm is able to carry out various free movements. It moves freely in all directions, and rotates round its own axis. Its mobility makes it possible to touch any place of the trunk, and, if the lower limbs are in flexion, any point of the body, except the posterior surface of the same limb. It is suspended at a certain distance from the trunk, thus its movements are not hampered by the latter. In order to analyse the movements of the arm, one should start from its resting position: the arm is suspended freely near the trunk, turned slightly inward, while the elbow is located between the sagittal and horizontal planes, twisted round its axis, owing to the predominance of the inward rotating muscles. The movements of the arm take place within a conic space. Within this space, the arm can move forwards and backwards like a pendulum, it can approach the trunk or depart from it, rotate round its own axis, or describe a conic surface. Forward and backward movements take place round the horizontal axis, adduction and abduction round the sagittal, rotation round the longitudinal axis of the shoulder joint.

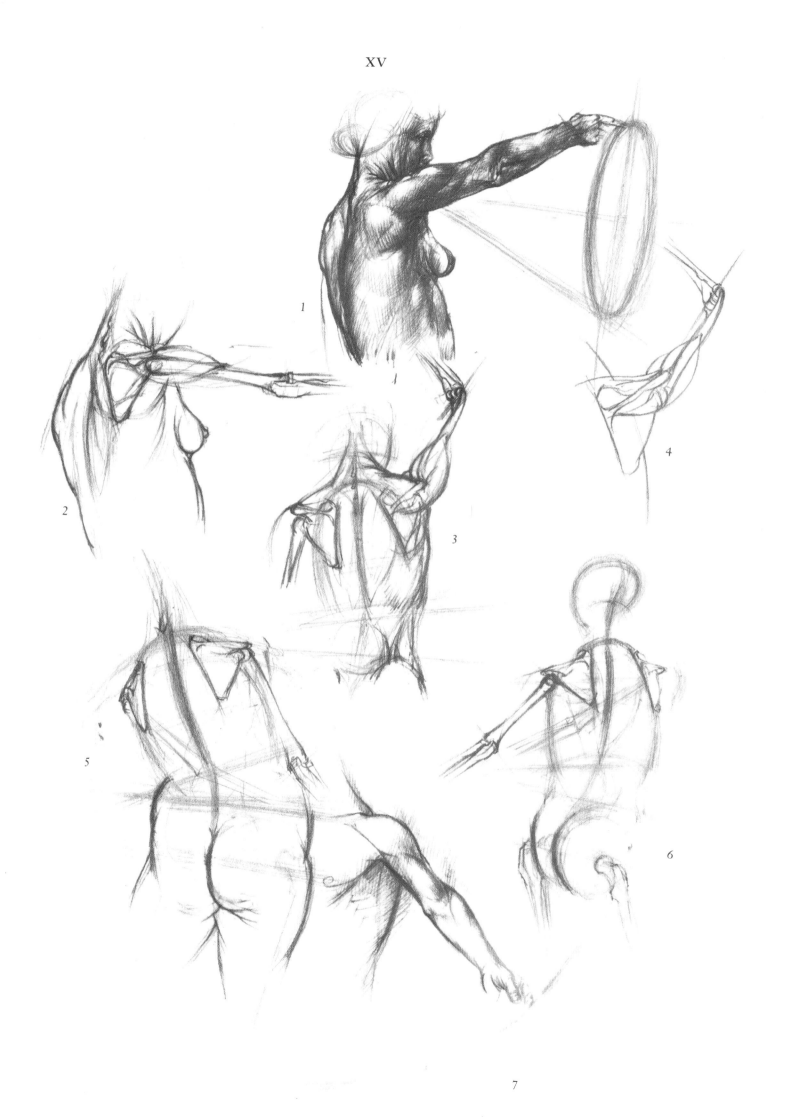

JOINT AND MOVEMENTS OF THE ELBOW

The elbow joint is composed of three articulations: the humero-ulnar (Plate XVI, fig. 8 a), humero-radial (fig. 8 b) and superior radio-ulnar (fig. 8 c) articulations. The elements of the joint are shown in fig. 8. In the humero-ulnar articulation the trochlea of the humerus is surrounded by the trochlear notch of the ulna (figs. 1 and 8 a). In the humero-radial articulation the capitulum of the humerus is in contact with the excavated articular surface of the radius (figs. 1, 2, 8 b). In the superior radio-ulnar articulation the head of the radius is, by its circumference, lodged by the small semilunar groove of the ulna (figs. 1 and 8 c). On the maximal extension of the forearm, the olecranon process enters the fossa of the humerus (fig. 1).

On pronation and supination the lower end of the radius runs, along an arch-like line, round the lower end of the ulna (fig. 7). The axis of rotation crosses the excavated articular surface of the radius in its centre, and, below, the styloid process of the ulna (fig. 5 a). Arm and forearm constitute an obtuse angle. On pronation the angle disappears, the forearm becomes the straight prolongation of the arm (fig. 9).

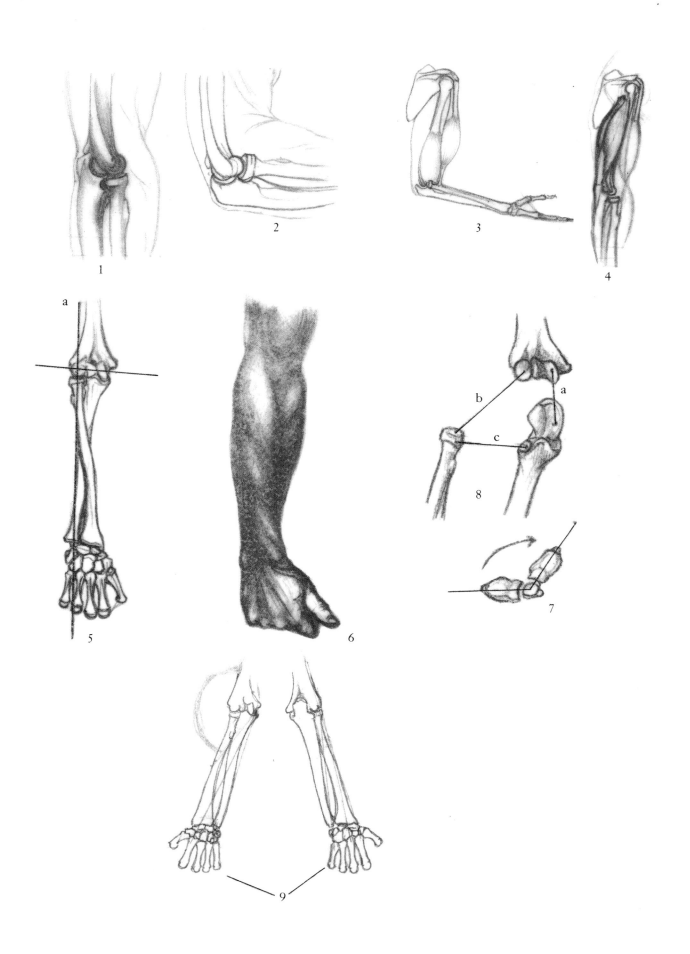

1

2

3

4

a

b

a

c

8

7

5

6

9

XVII

JOINTS AND MOVEMENTS OF THE HAND

The movements of the hand are various. It can be flexed (Plate XVII, fig. 1), hyperextended (Plate XVII, fig. 2), abducted (Plate XVII, fig. 3), adducted (Plate XVII, fig. 4) and rotated. The drawings on the left side of Plate XVII show these movements of the bones; on the right side the same movements of the hand of a living person are represented.

The function of the carpo-metacarpal joints (Plate XVII, figs. 3 and 4 a) is not uniform, as the mobility of the thumb is different from that of the other fingers. The joints of the other fingers are rigid, while the thumb has a saddle-like articular surface (Plate XVII, fig. 2 b), whereby it can be flexed, extended, abducted, adducted and also rotated (Plate XVIII, fig. 2).

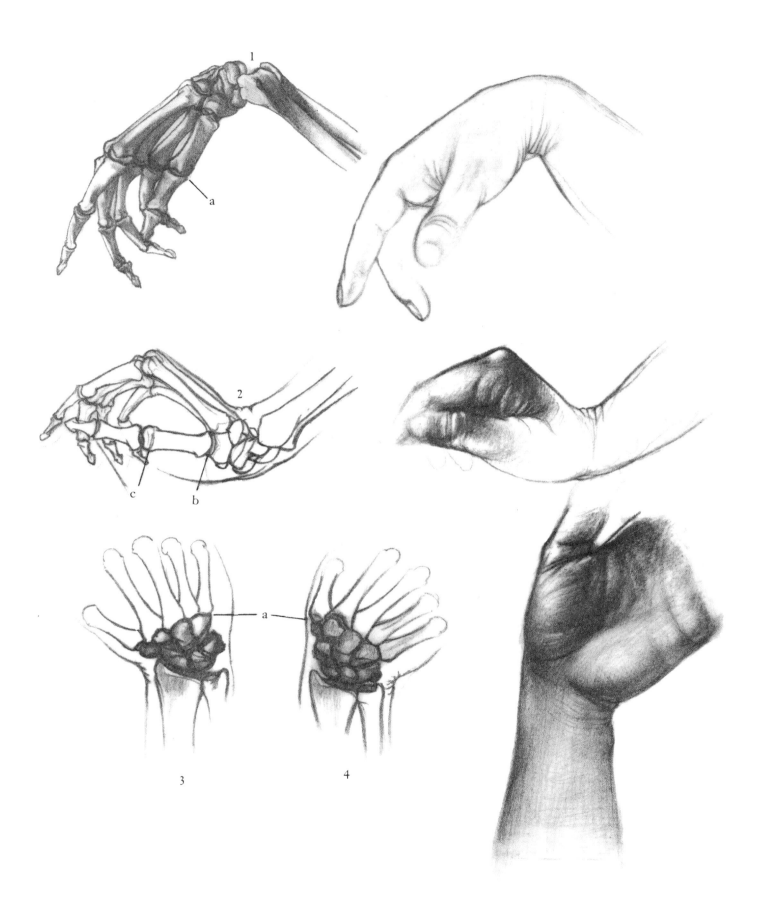

JOINTS AND MOVEMENTS OF THE FINGERS

The articular surfaces of the metacarpo-phalangeal joints are, in the three-phalangeal fingers, spherical and slightly cylindrical, whereby in these joints flexion, extension, adduction and abduction and even circular movement are possible (Plate XVIII, figs. 1, 3, 4). The articular surfaces of the two interphalangeal joints are cylindrical; thus they represent typical hinge-joints (Plate XVIII, fig. 1). Between the two phalanges (Plate XVII, fig. 2 c) of the thumb there is a hinge-joint allowing movements in one plane only. The possible movements of the thumb and the other fingers are demonstrated by the figures drawn in Plates XVIII and XIX.

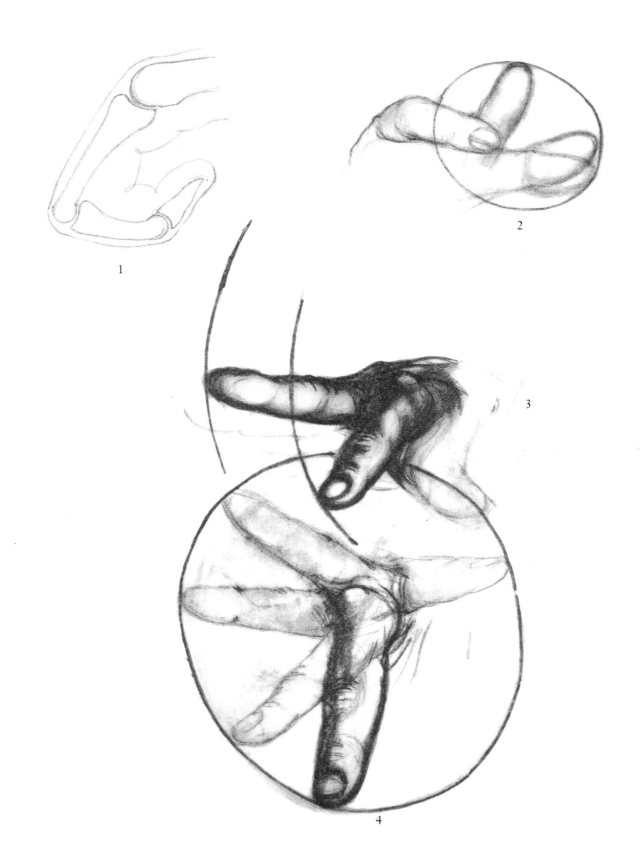

1

2

3

4

THE FORM OF THE ARM IN GENERAL

XX—XXI

The cross-sectional shape of the arm varies from one level to another. In the upper arm the sagittal diameter is the greatest; the mass and number of the flexor and extensor muscles is, however, so great at the level of the elbow that the major diameter is, at this place, near the coronal (Plate XX and Plate XXI, b, c).

The forearm becomes, at its lower end, flattened, whereby it has two sides. The radial one is slightly convex, whereas the ulnar side is flat. These conditions may be seen from the cross section of the forearm drawn in Plate XXI, a. The upper figure in the same plate shows the foreshortened forms as seen from a distance.

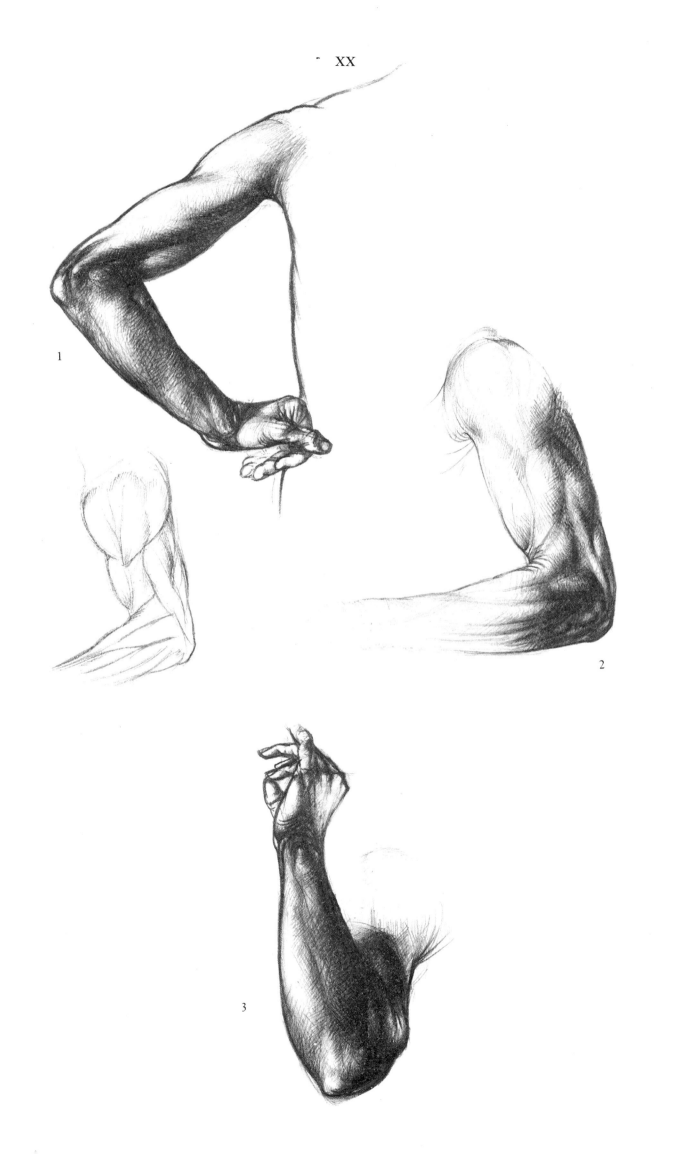

1

2

3

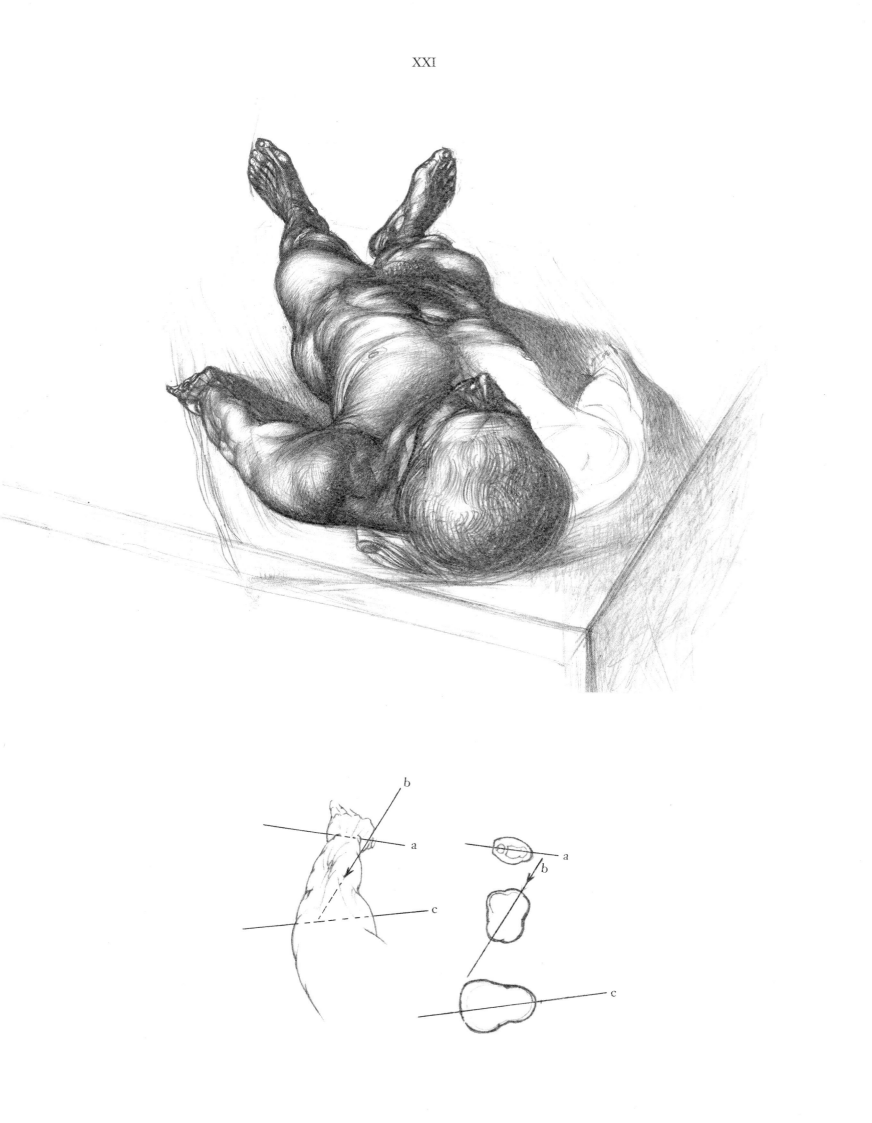

MUSCLES OF THE UPPER LIMB

XXII

Having become acquainted with the bones of the upper limb, we shall now study the muscles moving these bones and enabling them to perform work. The function of these muscles varies according to their many tasks.

The drawings in Plate XXII present the muscles of the shoulder. Below, their origin, insertion, and function will be briefly summarised in the order given by the numbers against each muscle. As in the case of the bones, the presentation will start with the muscles of the shoulder.

MUSCLES OF THE SHOULDER

The muscles of the shoulder are seen in three figures: *a* designates the clavicle, *b* the scapula, *c* the humerus.

The muscles of the shoulder are as follows:

1. Supraspinatus

 Origin: in the supraspinous fossa and the covering fascia.
 Insertion: upper muscular impression of the greater tuberosity of the humerus.
 Function: raising and outward rotation of the arm.

2. Infraspinatus

 Origin: the major part of the infraspinous fossa and the covering fascia.
 Insertion: middle muscular impression of the greater tuberosity of the humerus.
 Function: outward and backward rotation of the arm.

3. Teres minor

 Origin: lateral margin of the infraspinous fossa and the fascia covering it.
 Insertion: lower muscular impression of the greater tuberosity of the humerus.
 Function: outward rotation of the arm.

4. Teres major

Origin: posterior aspect of the lower corner of the scapula and lower section of its lateral margin. It runs slightly outwards and upwards, turning round the humerus on the frontal side.

Insertion: along with the latissimus dorsi below the lesser tuberosity of the humerus.

Function: together with the latissimus dorsi, approximation of the arm raised forwards or sideways to the trunk, followed by medial rotation of the arm.

5. Subscapularis

Origin: the inner surface of the scapula.

Insertion: the lesser tuberosity of the humerus.

Function: medial rotation of the arm, adduction of the raised arm.

6. Deltoid

Triangle-shaped muscle composed of seven bundles.

Origin: bones of the shoulder girdle, lateral third of the clavicle, acromion (sharp eminence of the shoulder), inferior border of the scapular spine.

It covers the shoulder joint, its bundles uniting at the point of attachment.

Insertion: rough area on the lateral aspect of the humerus shaft, about its middle section.

Function: contraction of the entire muscle will raise the arm to the horizontal plane. Partial contraction of the anterior or posterior part will result in a forward or backward traction of the arm. These conditions are outlined in Plate LXXXV, a, b, c, and Plate LXXXVI, a, c, d.

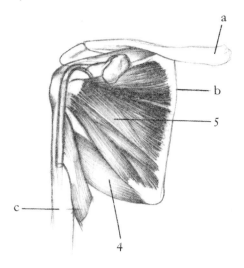

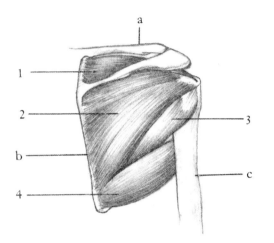

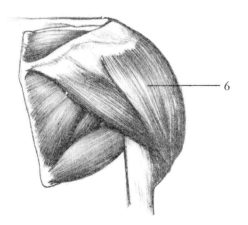

XXIII

MUSCLES OF THE ARM

A) FLEXOR (BENDING) MUSCLES

On the flexor side of the arm a marked eminence is due to the belly of the biceps (two-headed) muscle (9). On both the medial and lateral sides, there is a groove coursing downwards. At the insertion end of the deltoid muscle, the lateral groove becomes smooth, and ends in a small excavation. The medial groove is marked; it separates the biceps from the mass of the triceps muscle (10). (See also Plates XXX and XXXI.)

The posterior surface of the humerus is covered by the triceps (three-headed) muscle (10). At about the middle part of the arm, a long groove extending to the middle portion of the muscle belly is seen. Contraction of the muscle is accompanied by the swelling of the muscle bundles on both sides of this groove (Plates XCI and XCV).

7. Coracobrachialis

Origin: coracoid process of the scapula.
Insertion: middle portion of the medial surface of the humerus, opposite the deltoid insertion.
Function: raising of the arm, pressing to the trunk of the abducted arm.

8. Brachialis

Thick quadrangular muscle; its greater part is covered by the biceps (9).
Origin: anterior surface of the humerus below the deltoid insertion.
Insertion: by a short tendon into the anterior surface of the coronoid process of the ulna.
Function: flexion of the forearm.

9. Biceps brachii

A cylindriform muscle lying on the anterior surface of the humerus above the brachialis muscle (8).
Origin: the long head (A, a) originates on the scapula, above the articular surface. Its long tendon running round the head of the humerus lies in the bicipital groove (A, d). The short head (A, b) originates, likewise with a tendon, at the coracoid process of the scapula, along with the coracobrachialis muscle.

Insertion: with one tendon on the tuberosity of the radius (A, e). A fibrous sheet of two fingers' width (A, h) starting from the inner side of the tendon radiates in the fascia of the forearm.

Function: mainly the flexion of the arm (Plate XX), and also supination of the pronated arm.

B) EXTENSOR (STRETCHING) MUSCLES

10. Triceps

It originates with three heads: the medial (B, a) and lateral (B, b) originate from the posterior surface of the humerus. The long head (B, c) starts from below the articular surface of the scapula, and, after a course between the two teres muscles, unites at the middle third of the humerus with the two other heads. The thick muscle continues in a flat, broad tendon, the deep fibres covering the posterior side of the elbow joint.

Both the tendinous and the muscular portion insert at the olecranon process.

Function: extension of the forearm, adduction of the arm. The muscle is a strong extensor of the forearm.

11. Anconeus muscle

A small, flat, triangular muscle, continuation of the outer head of the triceps.

Origin: lateral epicondyle of the humerus.

Insertion: posterior aspect of the olecranon and upper fourth of the ulna.

Function: extension of the forearm.

A

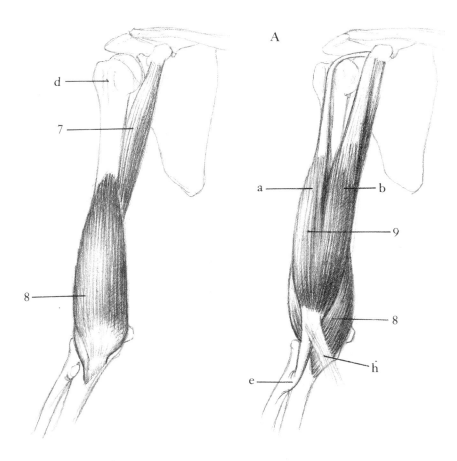

B

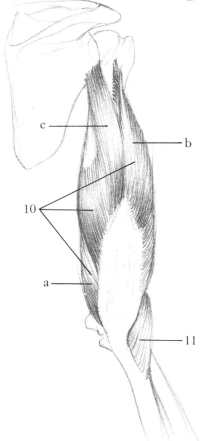

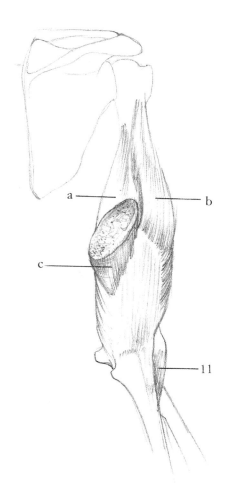

XXIV

MUSCLES OF THE FOREARM

A) FLEXOR SURFACE

Towards the wrist, the forearm becomes gradually thinner, and the bones project more and more between the muscles and tendons, until the region of the styloid processes is covered only by skin.

The muscular mass originating on the medial epicondyle of the humerus turns to the flexor side and remains there. The tendons can be well recognised above the wrist through the skin, especially the flexor carpi radialis and ulnaris, and palmaris longus muscles (Plate XXVIII). The group of muscles originating from the lateral epicondyle of the humerus courses towards the dorsal aspect of the forearm. Both groups are divided into a superficial and a deep layer (Plate XXIX).

Deep Layer

12. Pronator quadratus

A deep-seated muscle uniting the two bones of the forearm above the wrist.
Origin: anterior surface of the ulna.
Insertion: anterior surface and outer edge of the radius.
Function: pronation of the radius.

13. Flexor pollicis longus

Origin: upper two-thirds of the anterior surface of the radius, radial side of the deep flexor muscle of fingers.
Insertion: palmar aspect of the distal phalanx of the thumb.
Function: flexion of this distal phalanx.

14. Flexor digitorum profundus

Origin: volar surface of the upper two-thirds of the ulna, partly extending over the interosseous membrane as low down as to the upper margin of the pronator quadratus muscle. At about the middle forearm, the common head of the muscle

divides into four bellies the tendons of which run deep to those of the flexor digitorum sublimis and to the flexor retinaculum (a fibrous band anterior to the small bones of the wrist), down to the palm. At the level of the proximal phalanges, the deep tendons perforate the superficial ones.

Insertion: flexor surface of the distal phalanges of the fingers with the exception of the thumb.

Function: flexion of the same (4) fingers and phalanges.

Superficial Layer

15. Flexor digitorum sublimis

This is the strongest muscle of the superficial group.

Origin: medial epicondyle of the humerus, medial side of the ulna and the ligament joining them, as well as the anterior surface of the radius. While coursing downwards, it divides into four bellies continuing, in the distal third of the forearm, in four thin tendons. The latter proceed, along with the tendons of the deep flexor, below the flexor retinaculum to the palm. At the level of the proximal phalanges, they are perforated by the tendons of the deep flexor.

Insertion of the divided tendons: base of the middle phalanges except that of the thumb.

Function: flexion of the middle and distal phalanges of the fingers (except the thumb) and, along with them, the wrist.

16. Flexor carpi ulnaris

Origin: medial epicondyle of humerus, olecranon and posterior aspect of ulna. Its tendon appears in the distal third of the forearm.

Insertion: pisiform bone.

Function: flexion of the wrist and its pulling towards the ulnar side.

17. Palmaris longus

Origin: medial epicondyle of humerus. It is the weakest muscle of this group. Its short belly continues in a long tendon at the height of the proximal third of the forearm, then runs straight downwards, and, having passed superficial to the flexor retinaculum, enters the palm where it ends in the central part of the palmar fascia, between the tendons and the palm (f).

Function: flexion of the hand.

18. Flexor carpi radialis

Origin: medial epicondyle of humerus. Its thin belly runs towards the radial side and continues, at the middle of the forearm, in a strong flat tendon.

Insertion: the base of the second metacarpal bone.

Function: flexion and inward rotation of the hand.

19. Pronator teres

The shortest muscle of its group. It is separated from the group and runs obliquely.
Origin: medial epicondyle of the humerus, and olecranon.
Insertion: middle of the lateral surface of the radius.
The belly of this muscle constitutes the inner boundary of the antecubital space.
Function: pronation of the forearm, help in the flexion of the forearm.

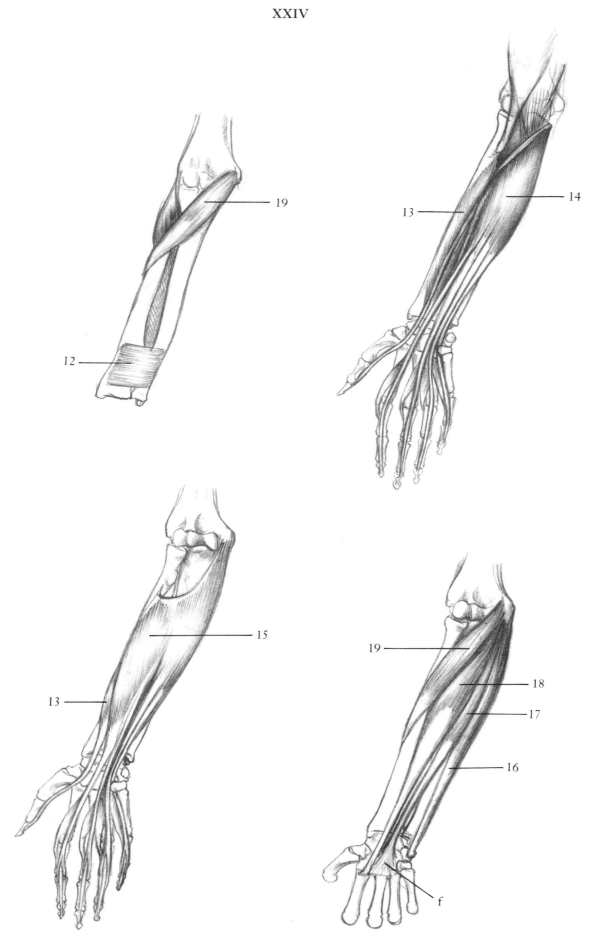

XXV

B) EXTENSOR SURFACE

Deep Layer

20. Extensor indicis

Origin: middle portion of ulna and interosseous membrane. It passes, together with the tendon of the extensor digitorum communis, below the extensor retinaculum (Plate XXIX, x).
Insertion: along with the index-tendon of the extensor digitorum communis.
Function: extension of the forefinger.

21. Abductor pollicis longus

This long flat muscle lies obliquely on the radius.
Origin: posterior surface of the ulna, medial third of posterior aspect of the radius, and interosseous membrane.
Insertion: base of the first metacarpal bone.
Function: extension and abduction of the thumb.

22. Extensor pollicis brevis

Origin: distal to the former muscle from the interosseous membrane and radius. It runs along the metacarpal bone of the thumb.
Insertion: base of the proximal phalanx of the thumb.
Function: extension of the distal phalanx of the thumb.

23. Extensor pollicis longus

Origin: shaft of the ulna and interosseous membrane below the middle portion. It runs obliquely below the extensor retinaculum (Plate XXIX, x) to the thumb.
Insertion: distal phalanx of the thumb.
Function: extension of this phalanx.

24. Supinator muscle

This is the shortest extensor.
Origin: lateral epicondyle of the humerus, upper lateral surface of the ulna and adjacent ligaments. It turns round the upper end of the radius.
Insertion: lateral surface of the proximal third of the radius.
Function: outward rotation of the radius round its own axis.

Superficial Layer

25. Extensor carpi radialis longus

It runs downwards along the radius, together with the brachioradialis muscle (Plate XXX).
Origin: lateral edge of the humerus, above the lateral epicondyle.
Insertion: base of the second metacarpal bone.
Function: extension and abduction of the hand.

26. Extensor carpi radialis brevis

Origin: lateral epicondyle of the humerus.
Insertion: base of middle metacarpal bone, dorsal side.
Function: extension of the hand.

27. Extensor digitorum (communis)

Origin: lateral epicondyle of the humerus. At the lower third of the forearm, it divides into four flat tendons running below the extensor retinaculum to the fingers (except the thumb). Each of these tendons divides, after a gradual flattening, into three thin bundles at the middle of the proximal phalanges. The middle bundle inserts at the base of the middle phalanx, the lateral ones at the base of the distal phalanx. At the level of the proximal phalanges, each tendon is strengthened by a triangular aponeurosis, into which small muscles insert.
Function: extension of the fingers other than the thumb.

28. Extensor digiti minimi

Essentially, it is but a part of the former muscle from which it is detached at the boundary of the middle and distal thirds of the forearm.
Insertion: along with the tendon of the extensor digitorum.
Function: extension of the little finger.

29. Extensor carpi ulnaris

It lies next to the former muscle, but is stronger.
Origin: lateral epicondyle of humerus and posterior aspect of ulna.
Insertion: ulnar side of base of medial metacarpal.
Function: extension of the wrist, adduction of the hand.

30. Brachioradialis

This is the longest extensor (Plate XXX).
Origin: lower third of the humerus, above the lateral epicondyle. It runs, twisting, downwards along the radius.
Insertion: lateral side of lower end of the radius.
Function: flexion of the elbow joint.

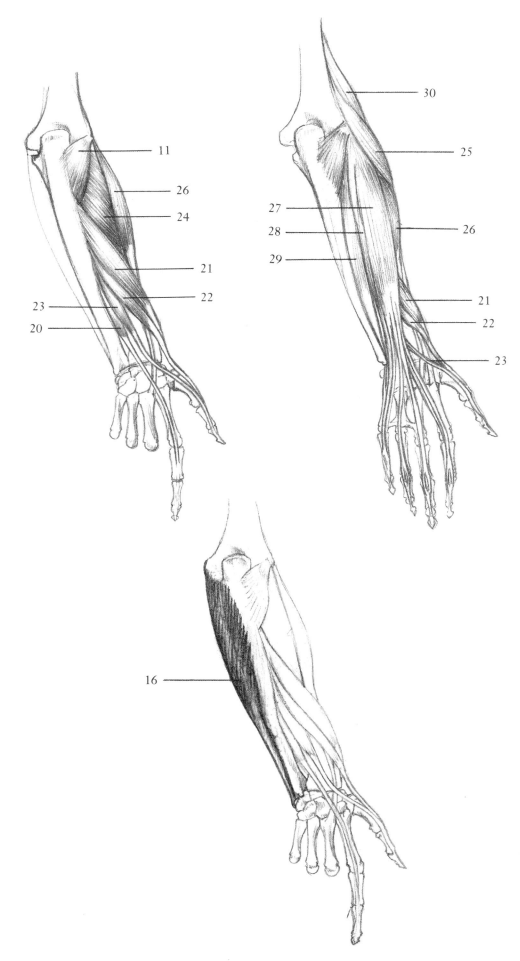

MUSCLES OF THE HAND

The wrist is a connection between forearm and hand. The metacarpus (mid-hand) is a broader part to which the cylindrical fingers are attached. Superficial to the wrist, on the volar surface, appear the flexor tendons, on the dorsal surface the extensors. The muscles of the palm may be divided in three groups: the prominent muscles of the *thenar eminence* (on the thumb-side), the *hypothenar eminence* (on the little finger side), and the muscles lying in the *palmar excavation*.

1. Dorsal interossei

Their number is four (Plate XXVI, 1 a—d) and they are to be found on the palmar side in the deepest layer. The first muscle, originating on the metacarpal of the thumb, is the largest and strongest of them. The others start from the respective metacarpal bones.

Each is inserted into the base of the proximal phalanx of the corresponding finger and into the triangular aponeurosis of the extensor digitorum.

Function: they abduct the fingers from the middle line.

2. Palmar interossei

Their number is four. Three are shown in Plate XXVI, 2 a—c; the other is covered by 4.

They originate on the shaft of the first (thumb), second, fourth and fifth metacarpal bones; each inserts into the base of the corresponding proximal phalanx and the triangular aponeurosis of the same finger.

Function: approximation of the fingers to the middle line (longitudinal axis) of the hand.

3. Lumbrical muscles

Four thin muscles.

They originate from the tendons of the flexor digitorum profundus, and insert into the free edge of the triangular aponeurosis.

Function: flexion of the proximal and extension of the middle and distal phalanges.

4. Adductor pollicis

This has an oblique and a transverse head. The oblique head originates in the depth of the wrist, on the palmar surface, from the capitate and the trapezoid. The transverse head starts from the volar aspect of the metacarpal bone of the middle finger.
Insertion: the base of the proximal phalanx of the thumb.
Function: approximation of the thumb to the palm of the hand.

5. Flexor pollicis brevis

Origin: lower border of the flexor retinaculum and the crest of the trapezium.
Insertion: on the base of the first phalanx of the thumb.
Function: flexion of the proximal phalanx of the thumb.

6. Opponens pollicis

Origin: same as flexor pollicis brevis.
Insertion: along the lateral edge of the metacarpal of the thumb.
Function: opposition (bringing to a position opposite to the other fingers) of the thumb (Plate XIX, 3).

7. Abductor pollicis brevis

Origin: flexor retinaculum of wrist, and scaphoid bone.
Insertion: radial side of the base of the proximal phalanx of the thumb.
Function: drawing the thumb forwards in a plane at right angles to the palm of the hand.

8. Opponens digiti minimi

Origin: hook of the hamate and the flexor retinaculum of the wrist.
Insertion: entire length of the fifth metacarpal bone.
Function: drawing the fifth metacarpal bone forward and medially, to deepen the hollow of the palm.

9. Flexor digiti minimi

Origin: hook of the hamate and the flexor retinaculum of the wrist.
Insertion: base of the proximal phalanx of the little finger.
Function: flexion of this phalanx.

10. Abductor digiti minimi

Origin: pisiform bone and pisohamate ligament.
Insertion: base of the proximal phalanx of the little finger.
Function: abduction of this phalanx (Plate XXVII).

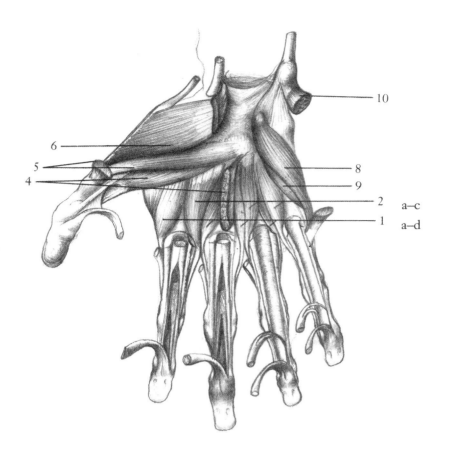

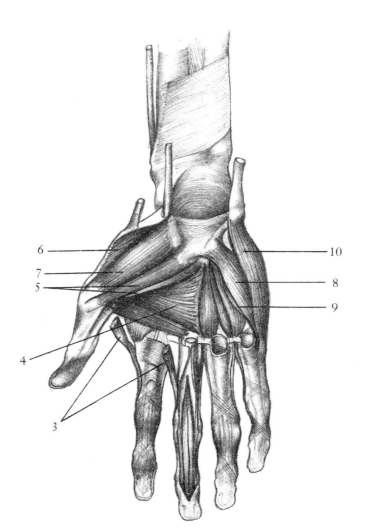

6 ——————

7 ——————

5 ——————

4 ——————

3 ——————

10

8

9

MUSCULAR SYSTEM OF THE UPPER LIMB
AND ITS FUNCTION

XXVIII—XXXIII

In previous chapters, the muscles of the upper limb have been described in detail. The figures in Plates XXVIII—XXXI demonstrate the correlations of these details. The muscular system of a limb forms an organic unit. The figures show the muscular system from four sides. The muscles are numbered as in previous plates.

ARM AND HAND IN MOVEMENT

Plate XXXII refers to the whole limb. Figure 1 shows the biceps muscle (a) in action. In fig. 2, the brachioradialis muscle is particularly prominent, while in fig. 3 the upper limb is seen as foreshortened by perspective sight.

On the hand, the most important movements are those of the thumb.

On the radial side of the wrist, the tendons of the abductor and extensor muscles of the thumb are especially striking (Plate XXXIII, 3 a, b, c). This side of the wrist is rather flexible, which is due to the free movements of the metacarpal bone of the thumb at its base.

In fig. 6, the stretched tendons of the superficial flexor muscles (e, f, g) appear with the clenched hand.

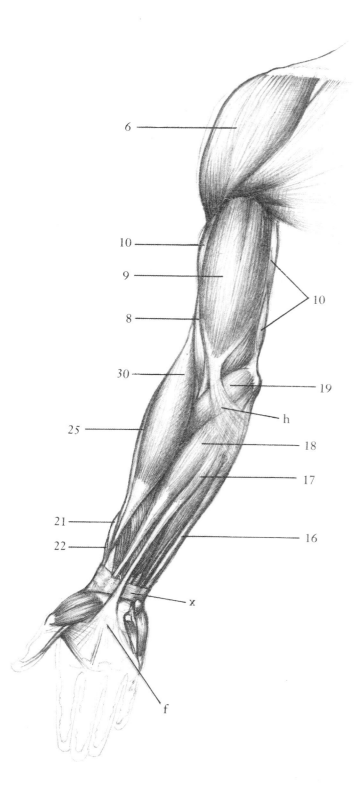

6

10

9

10

8

30

19

h

25

18

17

21

22

16

x

f

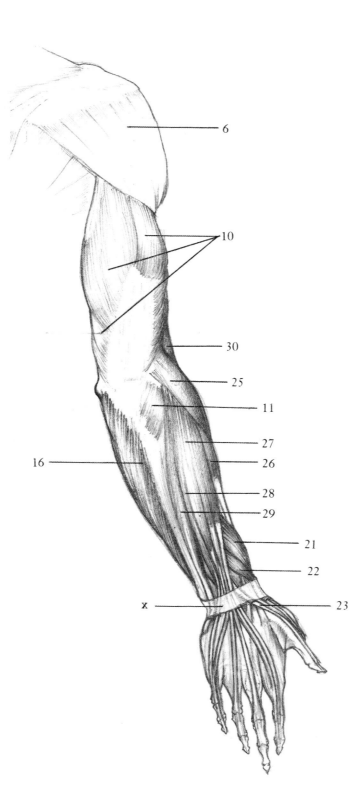

6

10

30

25

11

27

16

26

28

29

21

22

x

23

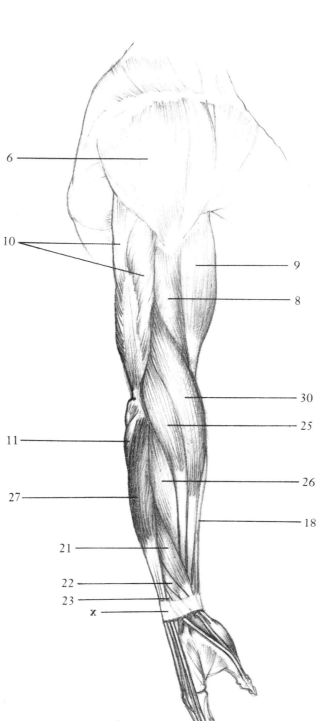

6

10

9

8

30

25

11

26

27

18

21

22

23

x

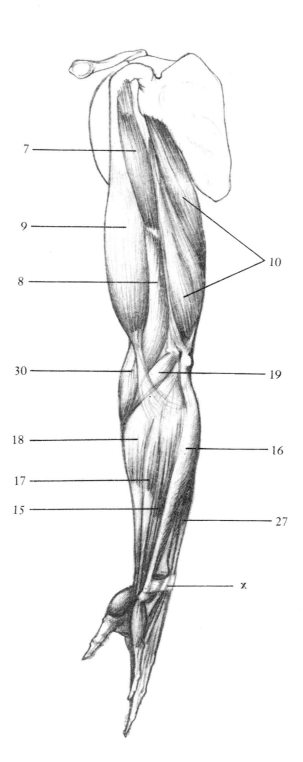

7

9

8

10

30

19

18

16

17

15

27

x

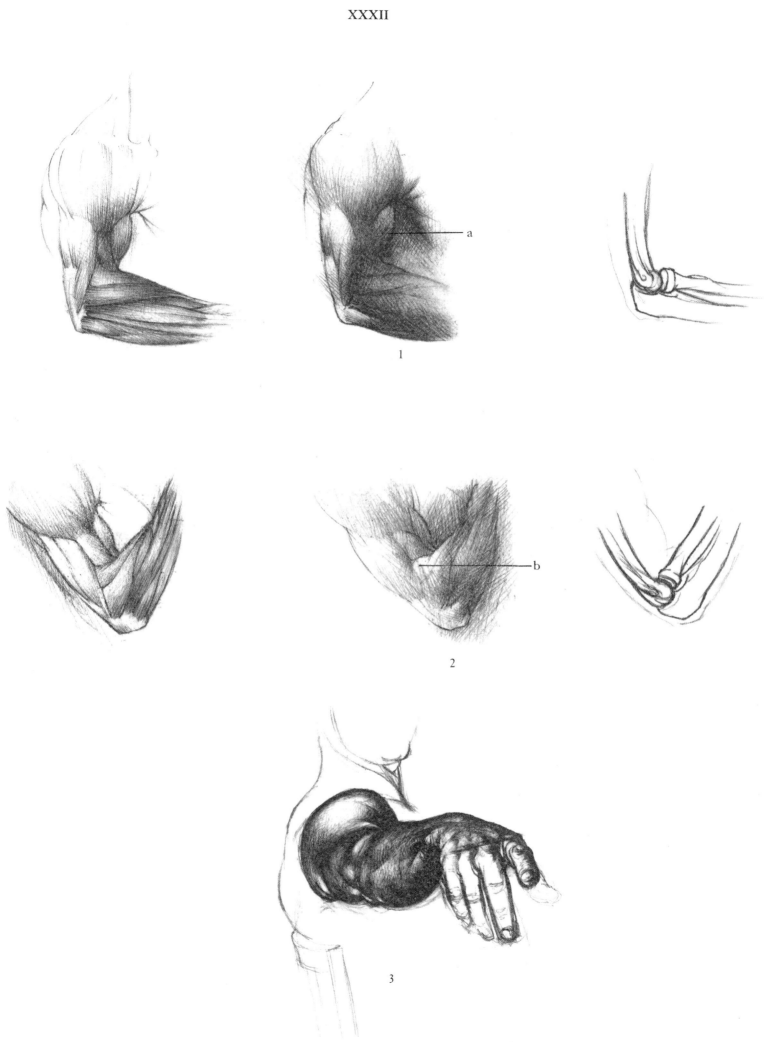

1

a

2

b

3

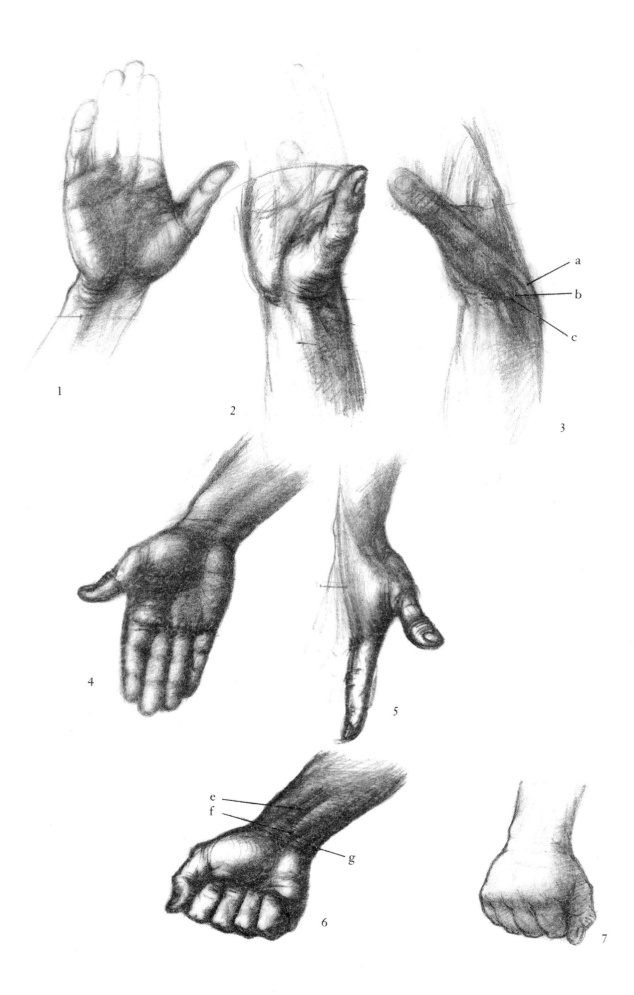

BONES OF THE LOWER LIMB

XXXIV

GIRDLE BONES OF THE LOWER LIMB

HIP BONE (INNOMINATE BONE)

It is composed of three bones: ilium (B, a), ischium (B, c), and pubis (B, b), which are in close connection. At their point of union there is a hemispherical excavation, the articular cavity for the head of the thigh bone *(femur)* (A, lateral aspect, 4). Below this is a gap in the bone, termed the obturator foramen; its margins are formed by the ischium and pubis.

Ilium

The broadest part of the pelvic bone (B, a). Its upper edge, the iliac crest, is S-curved. Along the crest three lines can be distinguished; they are termed inner, intermediate and outer (outer and inner: A 1). The prominent anterior end of the crest is the anterior superior iliac spine (A 2). Below this, the anterior inferior iliac spine (A 3) is seen. Backwards, it ends in the posterior superior and inferior iliac spines (A, posterior aspect, 8, 9). Below this, there is a deep arch-like notch (greater sciatic notch, A 6). The lateral surface of the iliac bone is convex. On this surface more rough lines, the posterior, middle and inferior gluteal lines, are seen (A, lateral and posterior aspects, 11, 12).

Ischium

A body and a ramus can be distinguished (B, c). The body is thick and triangular. From the middle of the body (A 5) a process (the ischial spine, A 10) projects backwards from the body at the inferior end of the greater sciatic notch, separating it from the lesser sciatic notch. The inferior extremity of the body is roughened (ischial tuberosity, A 13). The ramus springs from the inferior part of the body and joins the inferior pubic ramus.

Pubis

This has a body and two rami (B, b), a superior and an inferior one. The superior ramus becomes, while running towards the midline, thin and triangular. The crest of the upper branch is called the pectineal line (A 7). The body articulates with that of the opposite side (pubic symphysis, A 14). Together with the sacrum the two pelvic bones form a bony ring.

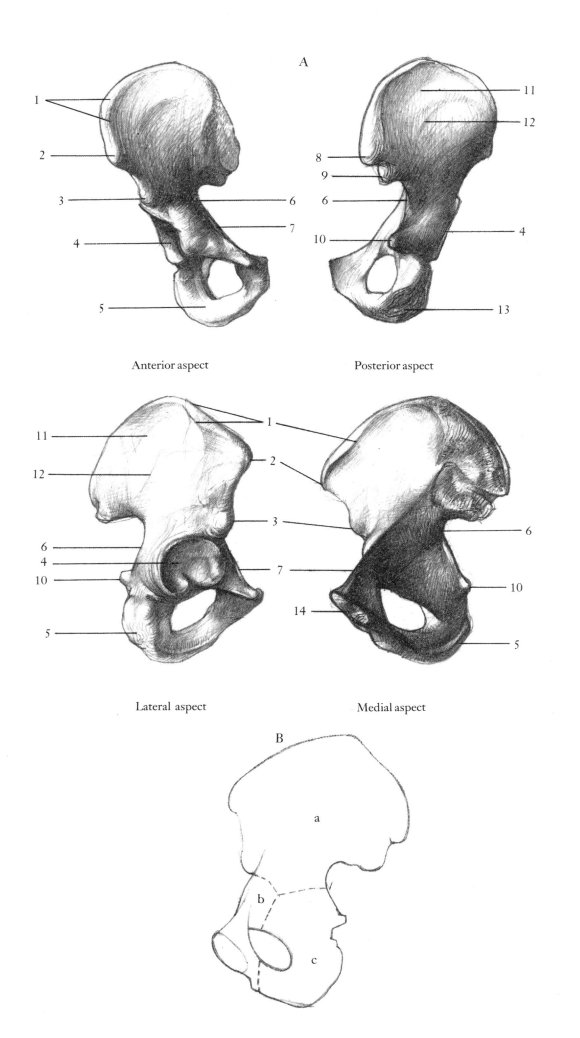

A

Anterior aspect

Posterior aspect

Lateral aspect

Medial aspect

B

BONES OF THE FREE LOWER LIMB

FEMUR (THIGH BONE)

It is the longest bone of the skeleton (Plates XXXV and XXXVI). In a standing person it runs obliquely, inferiorly and medially. Its top end is the hemispherical head covered with cartilage (1). Below the head the neck follows, its axis forming an angle of about 45° with that of the trunk (Plate XXXV, 2). Posterior and lateral to the neck is the greater trochanter (3), posterior and medial to it the lesser trochanter (4), and between them (posteriorly) the trochanteric crest. If visualised from the front, the shaft is straight. From the side, it curves backwards. Its thicker inferior end consists of two, a medial (Plate XXXV, 8) and a lateral (Plate XXXV, 10), condyles which come in contact anteriorly; there, a shallow excavation is formed (Plate XXXV, 7). The lateral condyle is broader and more forward-projecting than the medial one. On the posterior side, there is a deep notch between the condyles (Plate XXXV, 9). The superficial surface of both condyles is rough; there is a small tuberosity on each, termed epicondyles (Plate XXXV, 5, 6). The condyles are covered by a cartilaginous coat; they present a common articular surface resembling a horse-shoe from below. In the middle third of the posterior aspect of the shaft is a rough line, the linea aspera (Plate XXXV, 11).

On the anterior side a triangular bone, the patella (kneecap), lies between the thigh and the leg (Plate XXXVII, A). It is embedded in the common tendon of the quadriceps femoris muscle. The anterior surface of the patella is rough (Plate XXXVII, 1), the posterior one is coated by cartilage (Plate XXXVII, 2) and bisected by a longitudinal ridge (Plate XXXVII, 2 a).

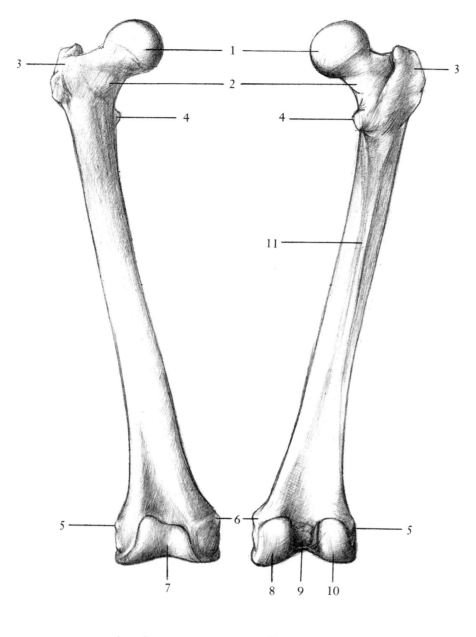

3

1

2

4

3

4

11

5

6

5

7

8 9 10

Anterior aspect Posterior aspect

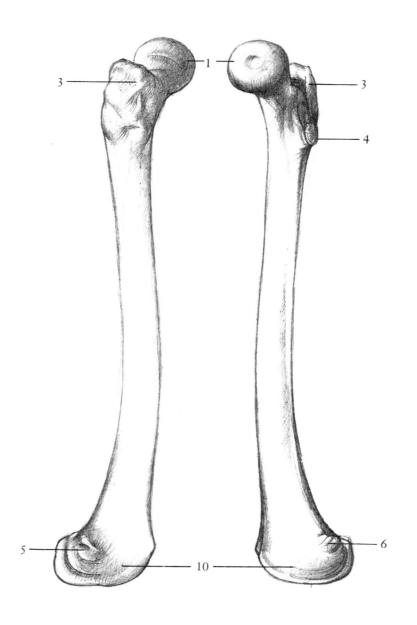

Lateral side Medial side

BONES OF THE LEG

The leg is the part of the lower limb distal to the knee joint; it contains two long bones situated next to each other. The medial one is the tibia (b), the lateral one the thinner fibula (a) (Plate XXXVII, B, and XXXVIII). On comparing the leg with the forearm, the tibia corresponds to the ulna, the fibula to the radius.

Tibia (Shin Bone)

On its thicker top end there is a lateral and a medial condyle (Plate XXXVII, 5, 6, and XXXVIII, 5, 6). On the lateral one, there is a small articular surface for the fibula (Plate XXXVIII, 13). Above the condyles, two concave articular surfaces are located (Plate XXXVII, 3) and separated from each other by sharp eminences (Plate XXXVII, 4). Below the joint, in front, a prominent tuberosity is seen (Plate XXXVII, 8, and XXXVIII, 8) the continuation of which is an S-shaped long edge. From this edge, toward the middle, the bone surface is not covered by any muscle. The lower end (Plate XXXVII, 11) is quadrangular; on its medial side the medial malleolus projects (Plate XXXVII, 10). On the lateral side a groove lodges the fibula (Plate XXXVIII, 14).

Fibula

The upper end of the fibula (Plate XXXVII, 7, and XXXVIII, 7) is attached to the tibia below the lateral condyle of the latter (Plate XXXVII, 5).

The fibula is rather a slender bone with a pointed head (Plate XXXVII, 7). On the medial side of the head there is an articular surface (Plate XXXVIII, 15), which forms a joint with the similar area on the outer side of the tibia (Plate XXXVIII, 13). Its inferior end, the lateral malleolus, is located deeper and more posteriorly than the medial one (Plate XXXVII, 9, and XXXVIII, 9). On the medial surface of the lower end of the fibula there is a plain articular surface (Plate XXXVIII, 12).

A

Lateral side

1

2

Posterior aspect

a

Anterior aspect

B

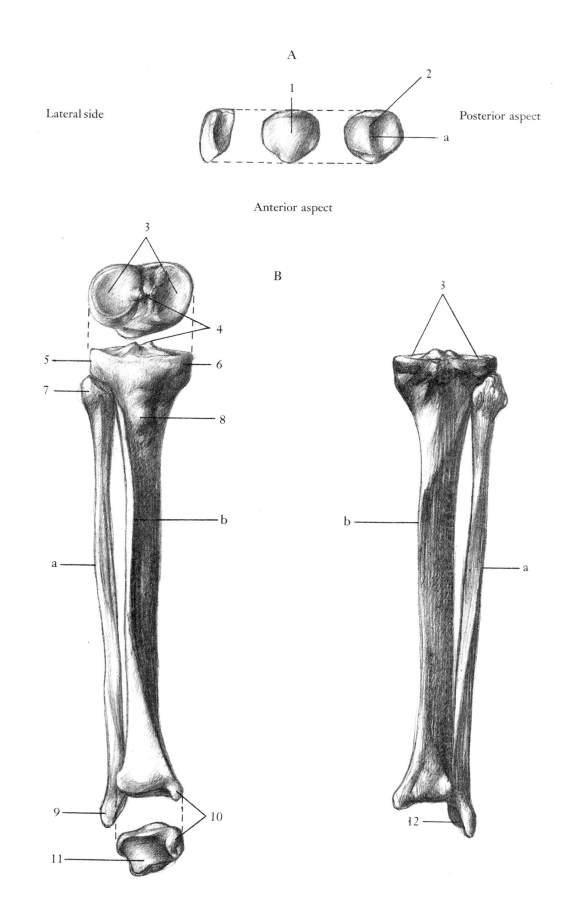

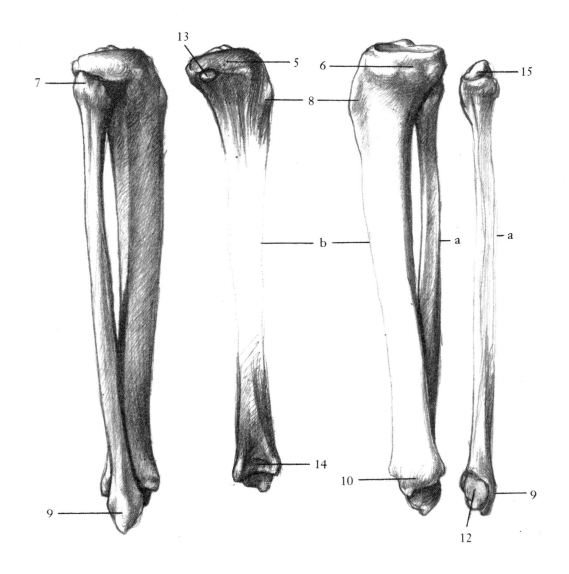

Lateral side

Medial side

BONES OF THE FOOT

The foot consists of three parts: the tarsus, the metatarsus, and the toes (Plates XXXIX and XL). The tarsus is the posterior part composed of seven bones (Plate XXXIX). The tarsal bones are bigger than those of the wrist, as they have to bear the weight of the whole body.

The uppermost tarsal bone is the *talus* (Plate XXXIX, 1). No other tarsal bone besides this articulates with the leg. It has a cubical body with an articular surface on its superior aspect (Plate XXXIX, 1a); in front, it has a head (1c) and a neck (1b). Its longer axis points obliquely forwards. The articular surface, becoming thinner posteriorly, is covered by cartilage on the superior aspect, as also on its two sides. On the lower side, there are three articular surfaces (Plate XXXIX, 1d, 1e, 1f).

The *calcaneum* (heel bone) (Plate XXXIX, 2) is the largest bone of the tarsus. Behind, it has a rough process (XXXIX, 2a) ending in two tuberosities on the plantar side (Plate XXXIX, inferior aspect, q), by which the bone touches the ground. On either side of this are the medial and lateral tuberosities. On the superior aspect there are three areas for the articulation with the talus (Plate XXXIX, 2b, 2c, 2d). In front of the talus, slightly medially, the navicular bone (tarsal scaphoid) is situated (Plate XXXIX, superior aspect, 3), forming a joint with the former. On the anterior surface, there are three surfaces for the articulation with the three *cuneiform bones* lying in front of it (Plate XXXIX, superior aspect, 5, 6, 7). Of the cuneiform bones the medial is the largest (5), the intermediate the smallest (6).

The *cuboid* is like an irregular cube (Plate XXXIX, superior aspect, 4). Located anterior to the calcaneum, it forms a joint with it.

The *metatarsals* are five curved shaft bones, the thickest of which is the one belonging to the great toe (Plate XXXIX, superior aspect, 8). Its neighbour is the longest. That of the little toe, having a tuberosity with a rough surface on its base, is the shortest (Plate XXXIX, superior aspect, 11). Their base is covered by a triangular, thick, smooth articular surface. Their heads are transversely flattened.

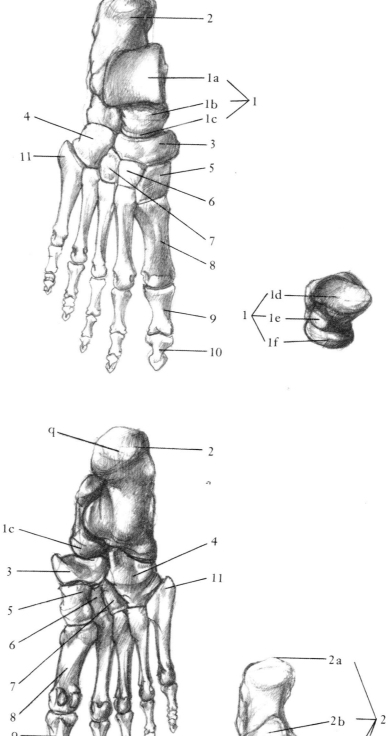

Superior aspect

2

1a

1b

1c

1

4

11

3

5

6

7

8

1d

1e

1

1f

9

10

Inferior aspect

q

2

1c

3

4

5

11

6

7

8

9

10

A

B

C

D

E

2a

2b

2

2c

2d

The *phalanges of the toes* are as many in number as those of the fingers. As to their size, they are smaller than the phalanges of the fingers (Plate XXXIX, inferior aspect, A, B, C, D, E), except those of the great toe (Plate XXXIX, inferior aspect, 9, 10). To the plantar aspect of the capitulum of the first metatarsal bone two sesamoid bones are related. Similar sesamoid bones may occasionally be found on the fifth and, rarely, opposite the second metatarsal bone.

The bones of the foot are seen from the side in Plate XL. They are provided with identical numbers.

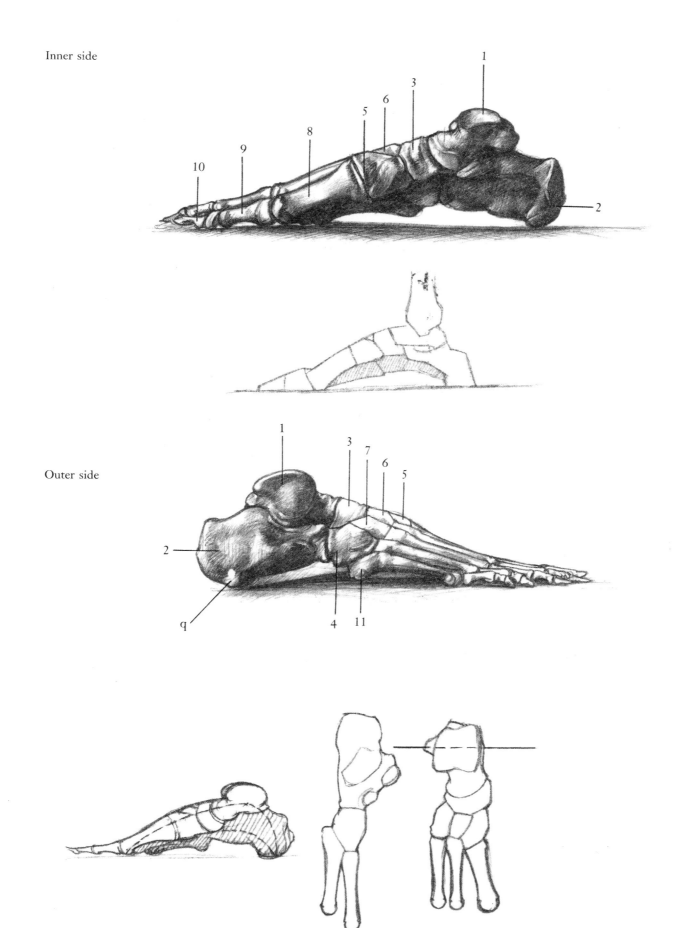

Inner side

Outer side

JOINTS AND MOVEMENTS OF THE BONES OF THE LOWER LIMB

XLI—XLIV

BONY STRUCTURE OF THE LOWER LIMB

The individual bones of the lower limb having been presented, their correlations are demonstrated by the figures in Plates XLI—XLIV. The complete bone system of the lower limb is shown in the figures from all sides.

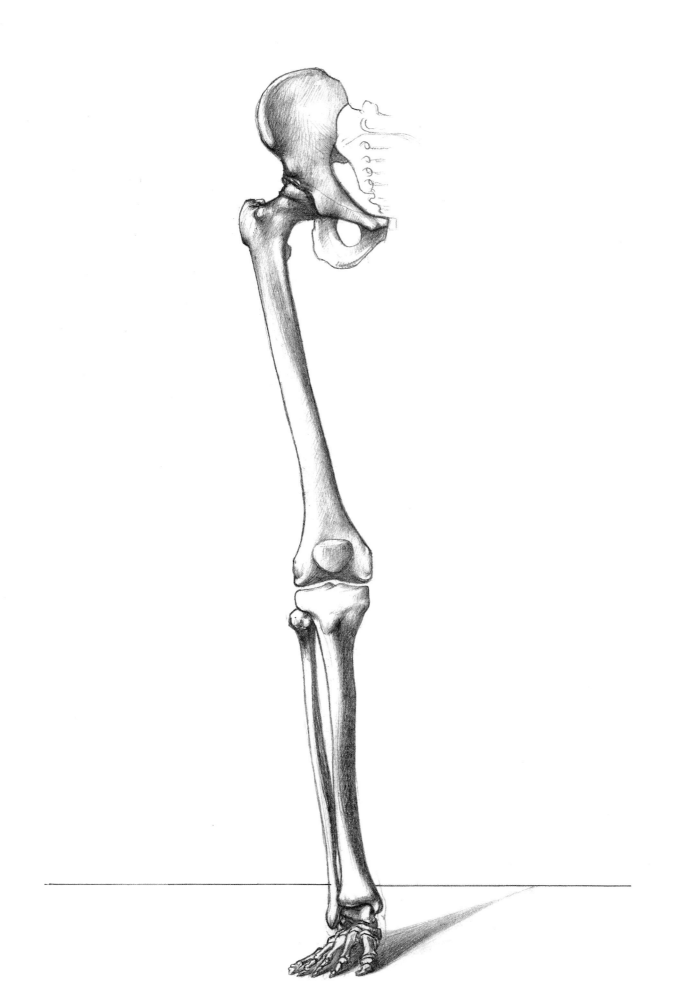

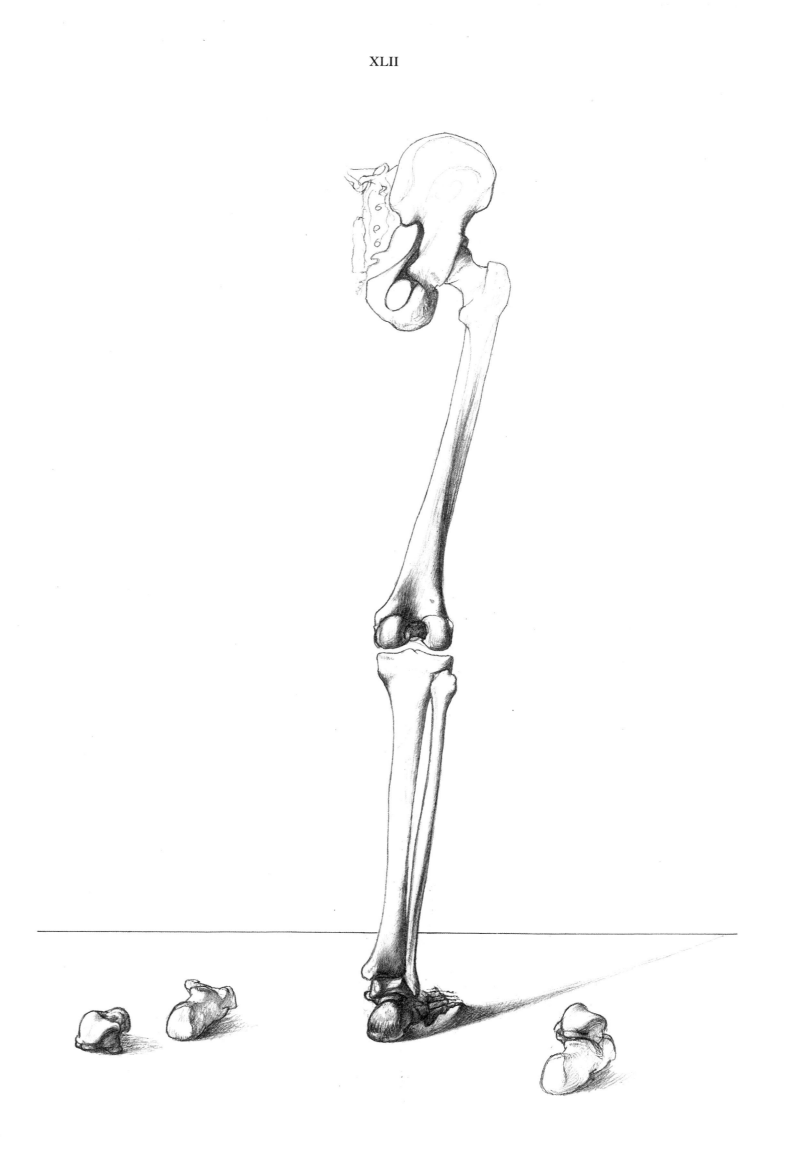

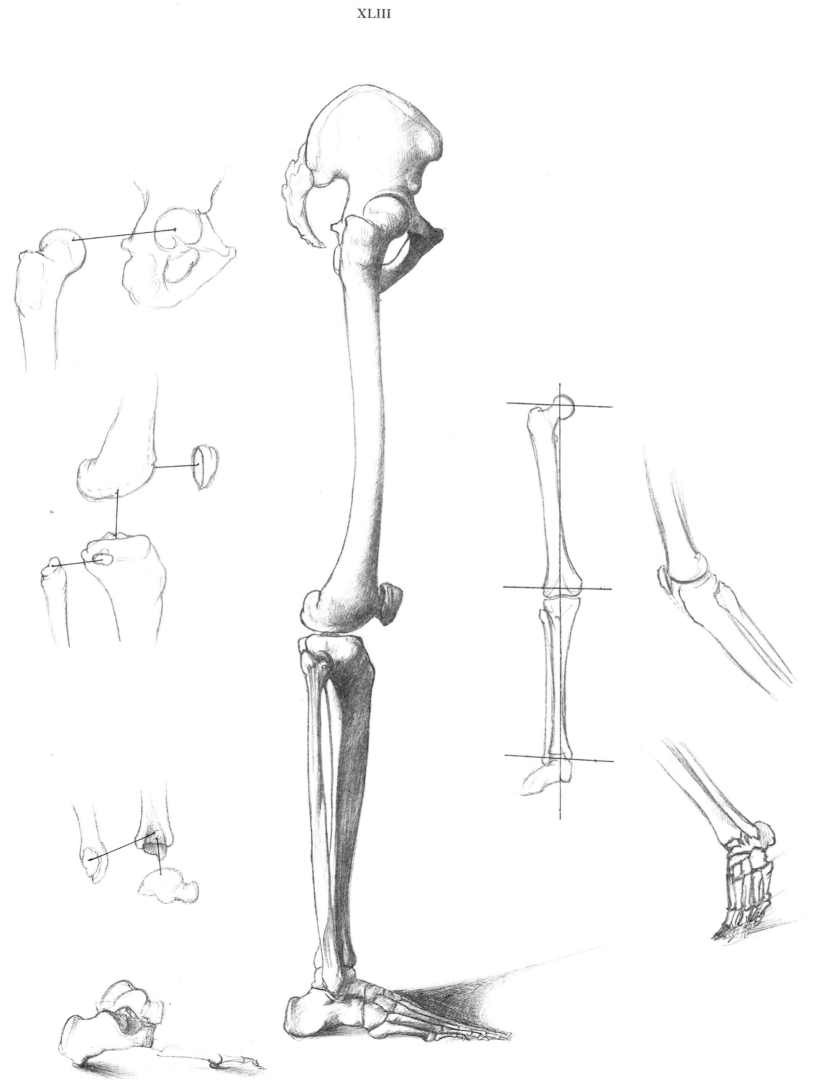

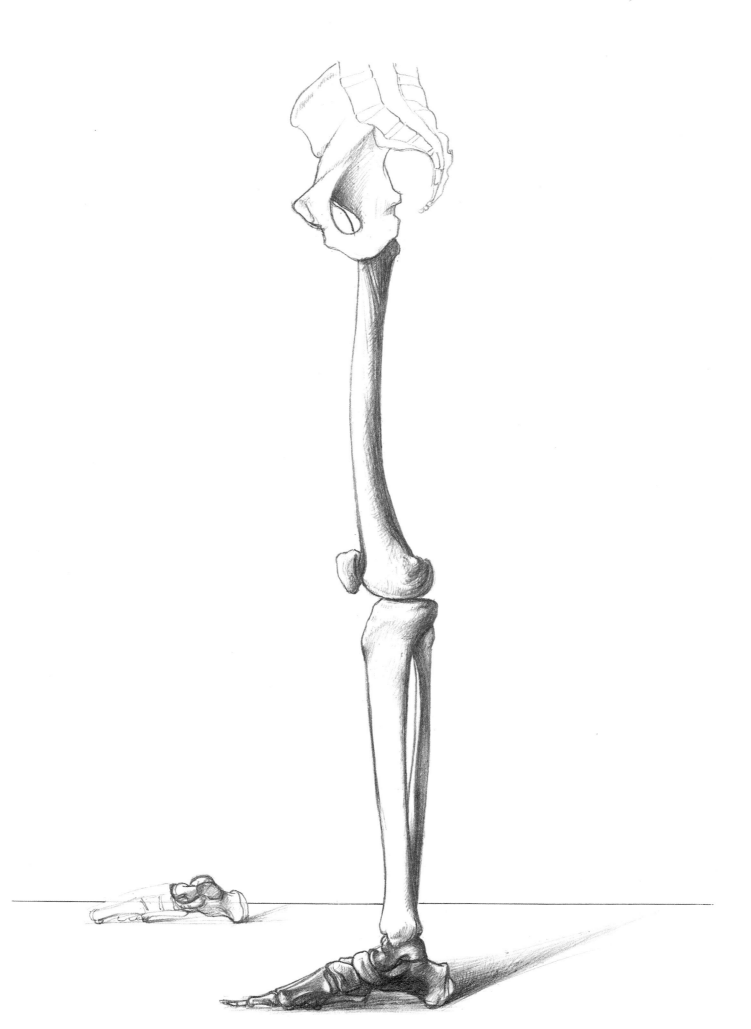

JOINTS OF THE GIRDLE BONES OF THE LOWER LIMB

PELVIS

The pelvis is formed by the sacrum (Plate XLV, lateral aspect, 2 a), the hip bones (1), and the coccygeal (caudal, tail) bones contiguous with the sacrum (2 b). It may be divided into an upper, greater, and a lower, lesser cavity: false and true pelvis. The two pelves are separated by a marked ridge well visible on both the sacrum and the ilium (Plate XLV, anterior aspect, 20). Here the difference between the male and female skeleton is most conspicuous, the female pelvis being wider, less high, and of a greater volume than that of man. The sacrum is wedged in between the two iliac bones (2 a). The body weight rests upon the sacrum. Under the weight of the pelvis it behaves like a two-armed lever. It is an elastic arch with the function of damping the force of jolts acting from above or below.

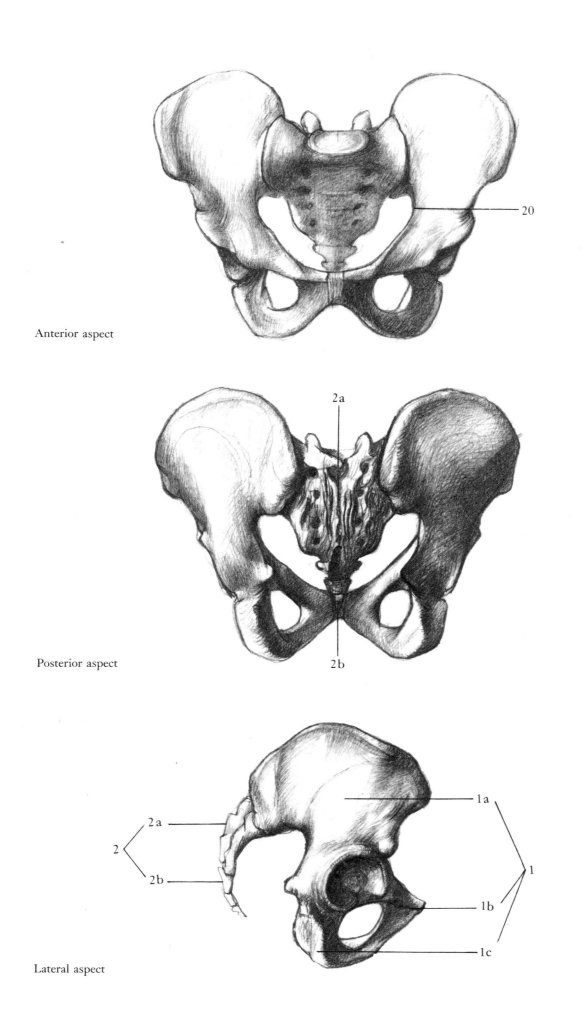

Anterior aspect

—20

2a

Posterior aspect

2b

2a

2

2b

Lateral aspect

1a

1

1b

1c

JOINTS AND MOVEMENTS OF THE LOWER LIMB

THE HIP JOINT AND ITS MOVEMENTS

The hip joint is formed by the deep excavation on the lateral surface of the iliac bone (Plate XLVI, 5 d), and the head of the femur (5 c). In this joint, the lower limb can move rather freely; the movements are, however, less free than those of the arm.

The movements of the femur are influenced by the depth of the articular fossa. Owing to the angle formed by the neck and the shaft, the rotation of the femur takes place round an axis connecting the centre of the head with the intercondyloid notch (4 c). The femur can take part in circular movements also, whereby a conic surface is described (1). Within this cone, all pendulum movements, such as flexion and extension (2), adduction and abduction (3), and slight twisting round its own longitudinal axis, are possible. Flexion and extension are carried out round a transverse axis connecting the right and left femoral heads (2 a).

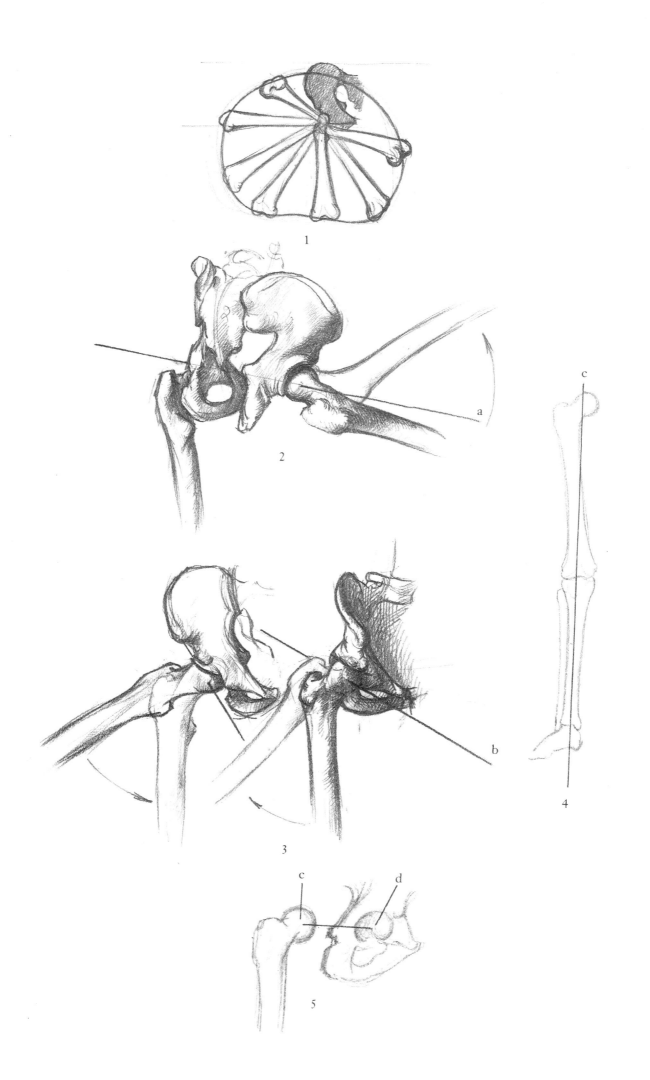

1

2

a

3

b

c

4

c

d

5

THE KNEE JOINT AND ITS MOVEMENTS

The knee joint is formed by the condyles of the femur (Plate XLVII, 5 b) and the corresponding articular surfaces of the tibia (5 c). The patella is also part of the constitution of the joint, the articular surface of which fits, in extension, to the patellar fossa of the femur (1, 2). It is a very strong joint. The head of the fibula is attached to the tibia by a separate joint (6 g, f). The inferior articular surface of the femur is similar to two half-cylinders. The chief movements of the joint, flexion (3, 4) and extension (1, 2), are performed round a transverse axis (5 a). The patella moves on the articular surface of the femur: it glides up and down, due to the patellar ligament, a prolongation of the quadriceps femoris muscle which, broadly attached to the patella, runs to the tuberosity of the tibia, the place of its insertion (1—4). On maximum extension, the patella is situated above the pulley-shaped condyle (1, 2). On right-angled flexion it lies in the groove between the condyles of the femur and the tibia, and the knee has a round shape (4). On obtuse-angled flexion the patella rests upon the superior portion of the articular surface (3).

The various positions and movements of the knee and its environment are shown in three plates (XLVIII—L).

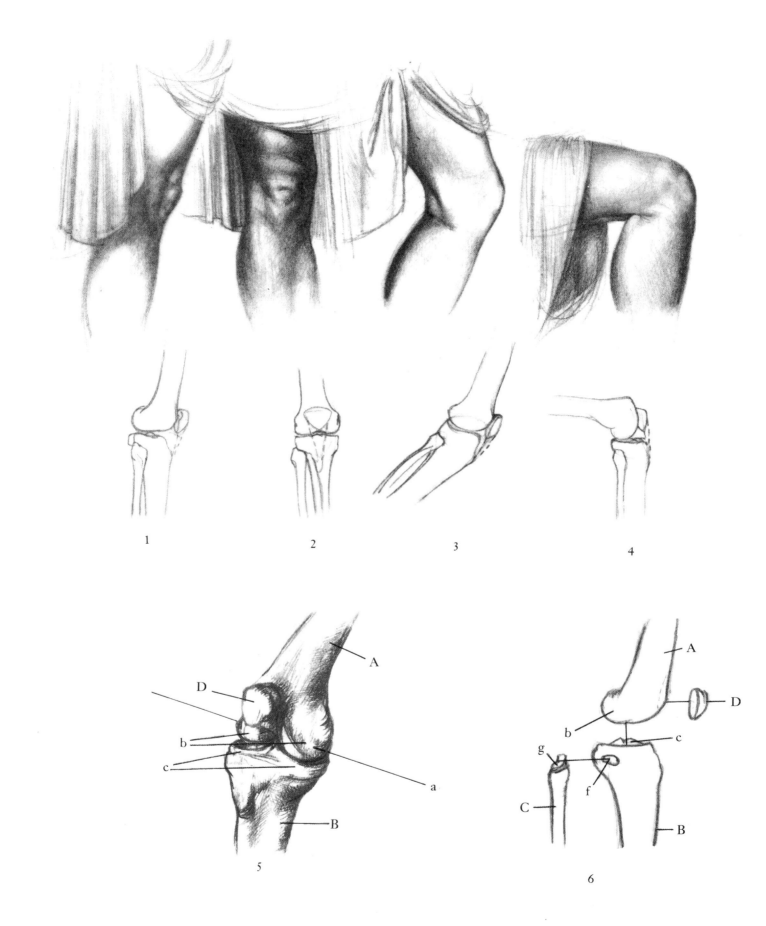

1

2

3

4

D

A

b

c

a

B

5

A

D

b

c

g

f

C

B

6

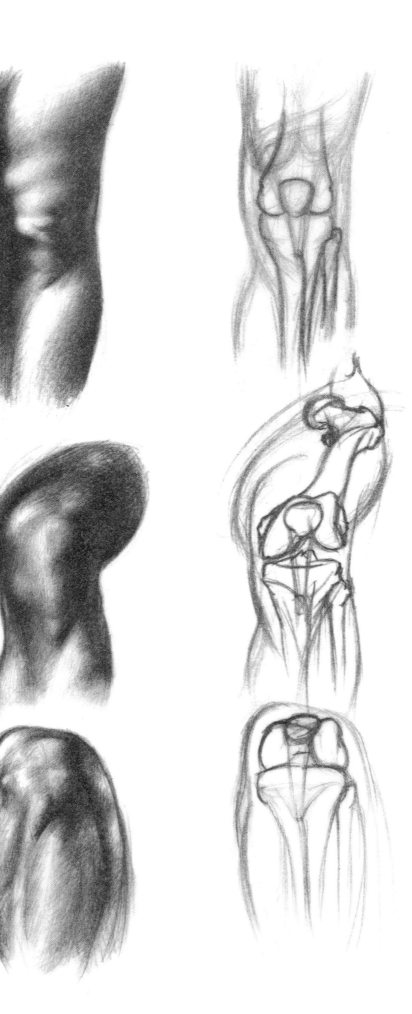

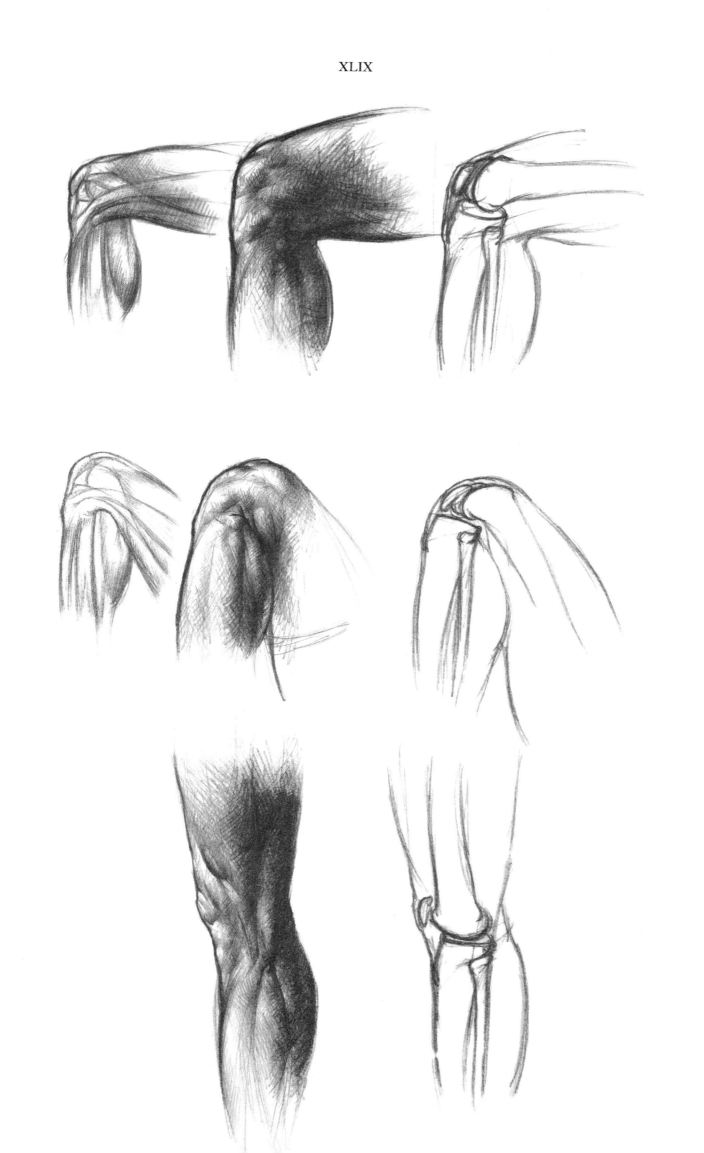

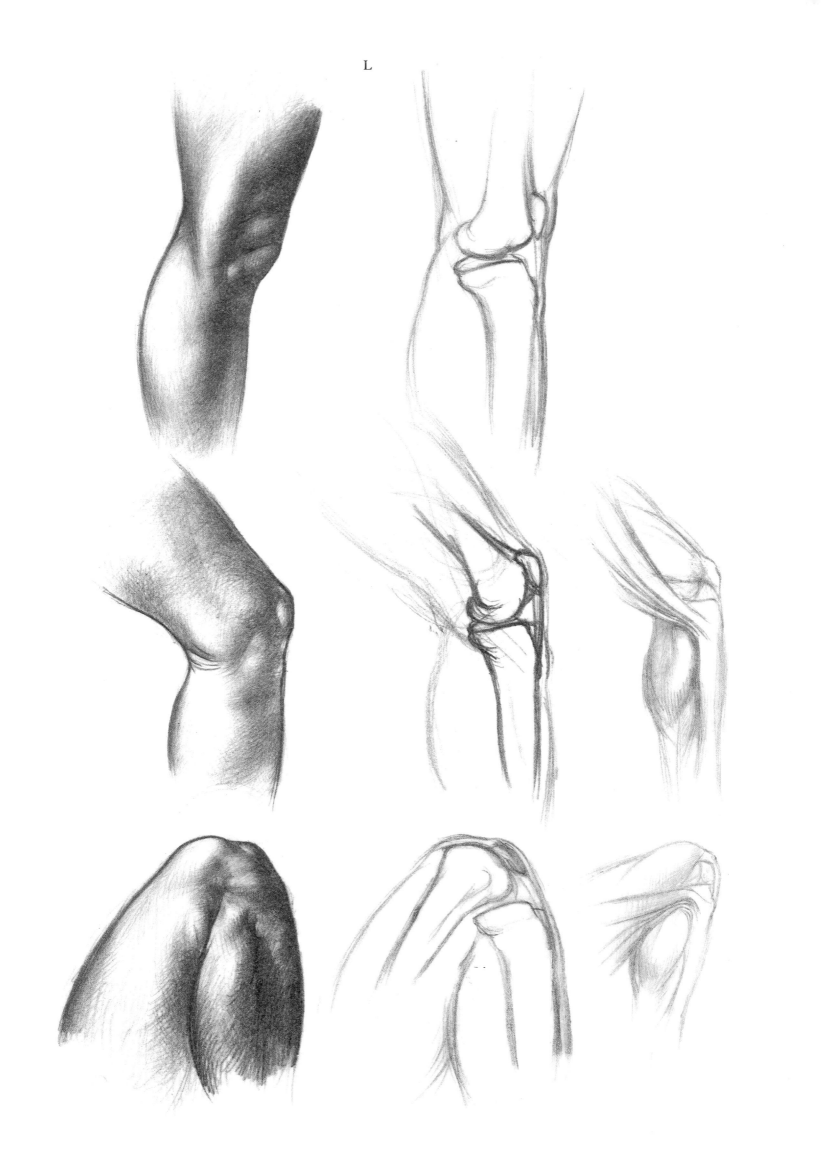

JOINTS OF THE BONES OF THE LEG

The joints between the tibia and fibula form, both above and below, rigid joints in which hardly any movement is allowed.

Ankle joint

This is formed by the bones of the leg, and the talus (6 g, h, j). The sides of the upper part of the talus are wedged in between the two malleoli (1, 2, 3).

The axis of the hinge joint starts from the centre of the lateral malleolus, and its exit lies below the medial malleolus (1 d, 2 d, 3 d). The foot can be flexed and extended. It works like a two-armed lever having its point of support in the ankle joint (4, 5). Even on extreme flexion, the foot still forms an obtuse angle with the leg (5 f). To a small extent, the foot may be rotated medially and laterally.

JOINTS OF THE BONES OF THE FOOT

Inter-tarsal, tarso-metatarsal, metatarso-phalangeal, and interphalangeal joints are distinguished. In the metatarso-phalangeal joints, the heads of the metatarsals articulate with the concave articular surfaces of the proximal phalanges. Sesamoid bones are found opposite the metatarso-phalangeal articulation of the great and the little toe.

The metatarso-phalangeal joints are of limited mobility which, for want of corresponding muscles, allow flexion and extension only. The interphalangeal joints are similar to those of the fingers.

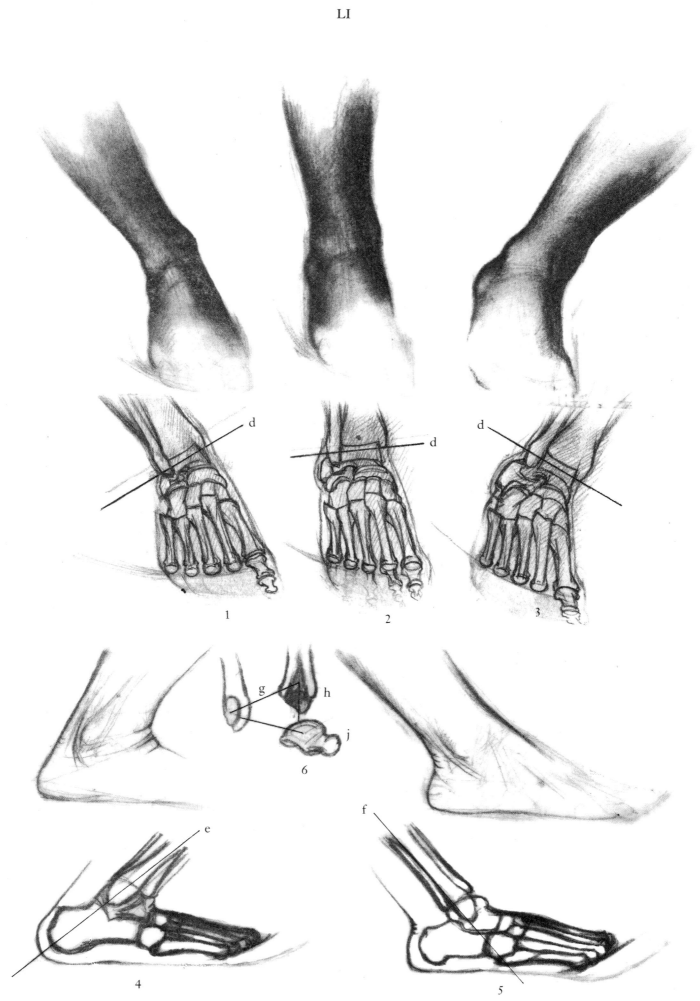

LII

THE FOOT IN MOVEMENT

The foot rests on three points of support: posteriorly, on the tuberosity of the calcaneus (Plate XXXIX, inferior aspect, q, and Plate XL, q), in front, on the heads (and the sesamoid bones) of the first and fifth metatarsal bones (Plate XXXIX, inferior aspect). If the body weight bears down on the instep, the latter behaves like a spring. Its convexity becomes diminished. After the pressure has ceased, it regains its convexity. First, the weight acts on the semicylindrical upper part of the talus. From here, the pressure spreads towards the points of support. The arch of the foot is preserved by several factors, for instance, the tendon of the tibialis anterior and posterior, and that of the peroneus longus muscle. Their function is important. The arch of the foot is, so to say, suspended on these muscles. Owing to its elasticity and weight-carrying capacity, the main role of the arch of the foot consists in diminishing the jolting which is due to walking, and thus conducting it in the cranial direction. Thus walking becomes a smooth, elastic movement. The toes, too, behave like springs. When the ends of the third phalanges rest on the floor, the plantar surface increases. The toes play a prominent role also in walking. They act like springs when the heel is raised, whereby the elastic removal of the foot from the ground is made possible.

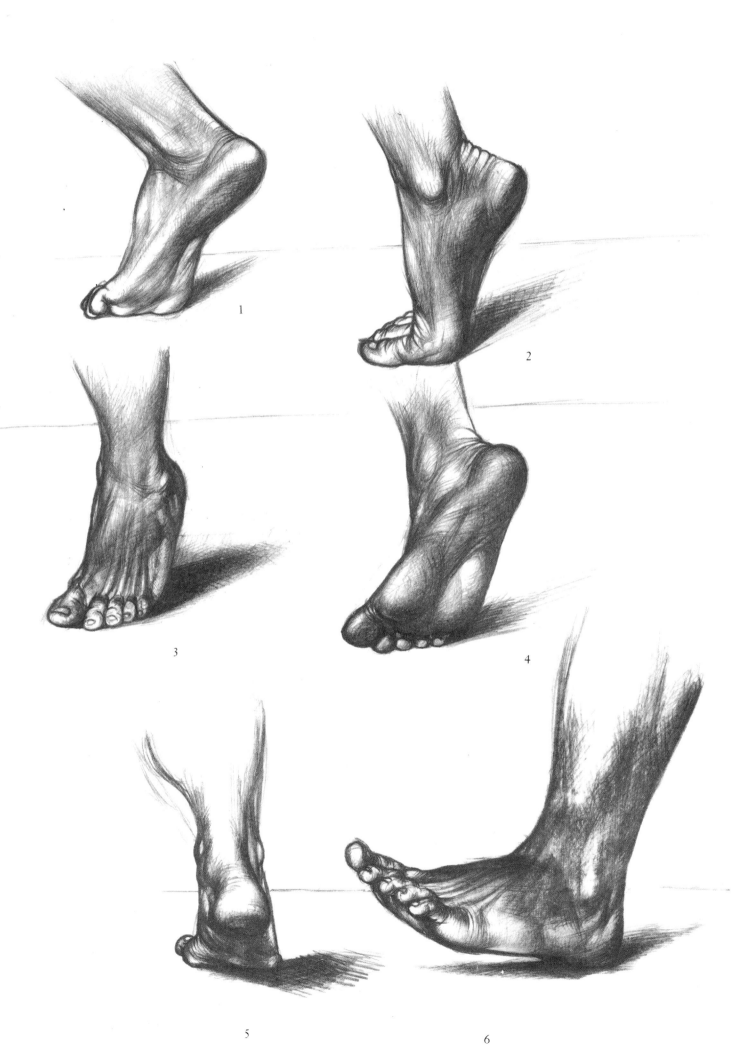

1

2

3

4

5

6

THE FORM OF THE LOWER LIMB IN GENERAL

LIII—LIV

The function of the lower limbs is to support the body, and to make walking possible. Their structure and the arrangement of their anatomical elements have developed in accordance with their function. The limb tapers off downwards. At the calf, it increases in bulk, but further down its volume decreases again. The slenderest part is above the ankle. If one observes the arrangement of the soft elements round the bones, it will be seen that they are, to a certain degree, twisted. This fact can be seen in Plate LIV presenting the limbs of the lying body and the cross sections. The axes sof the sections

a, b, c, d, e

reveal the following facts: the first inward twist lies between the upper part of the thigh and the knee. From the knee to the calf a slight outward twist, from the calf to the ankles again an inward twist may be seen. Thus, there are one outward and two inward twists.

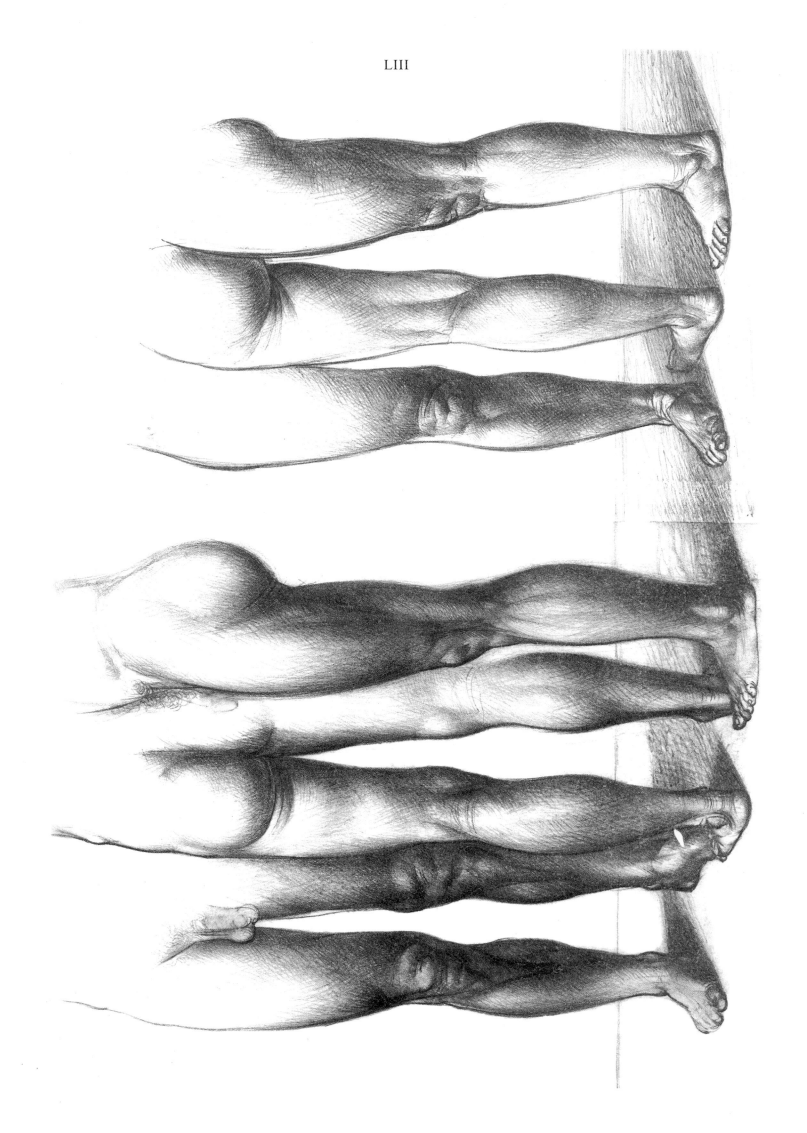

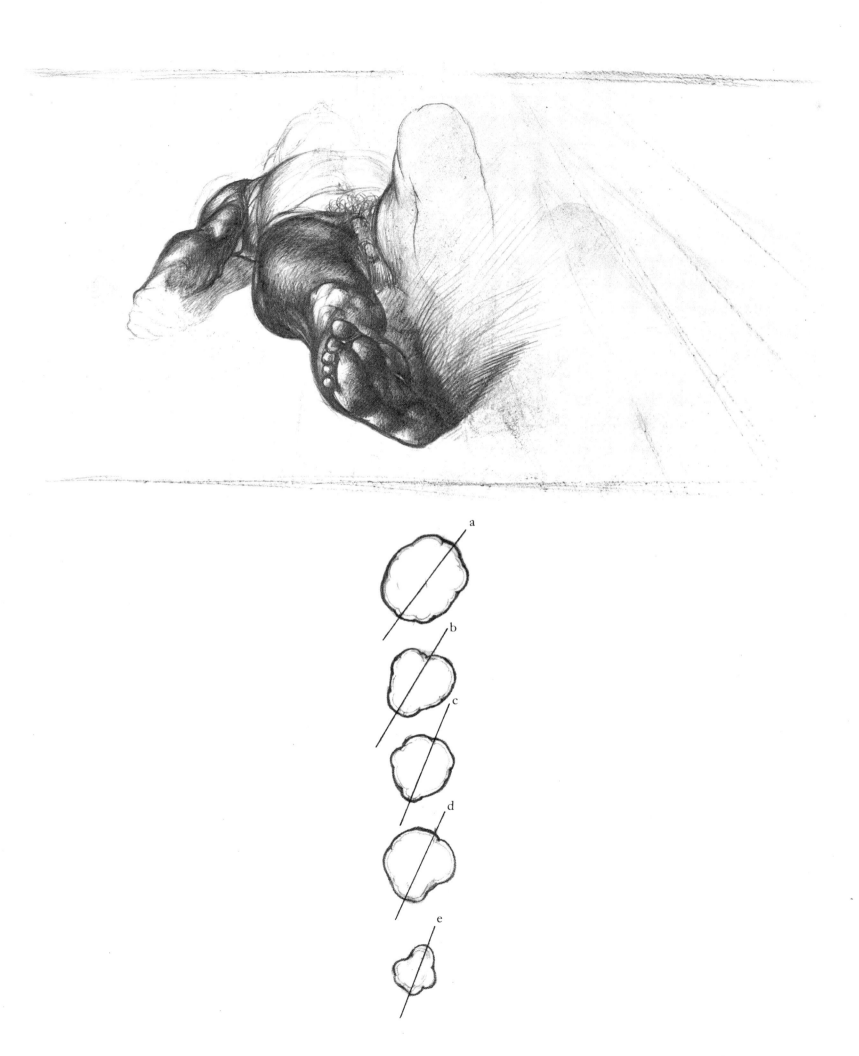

MUSCLES OF THE LOWER LIMB

LV

MUSCLES OF THE GIRDLE BONES OF THE LOWER LIMB

The description of the bones of the lower limb is followed by that of the muscles, the motors of these bones. The lower limb having a role different from that of the arm, its muscles have developed differently. Like the description of the bones, that of the muscles will also commence with the pelvic region.

A) INTERNAL ILIAC MUSCLES

Iliopsoas

This consists of two portions, (1) the iliacus and (2) the psoas muscle.

1. Iliacus

Origin: the iliac fossa.
Insertion: into the tendon of the psoas (c).

2. Psoas major

Origin: bodies of the twelfth dorsal and the upper four lumbar vertebrae and the bodies of all the lumbar vertebrae.
Insertion: into the lesser trochanter (c).
Function: if the trunk is fixed, flexion and medial rotation of the femur. With fixed limb, flexion of the trunk towards the thigh.

B) EXTERNAL ILIAC MUSCLES

3. Quadratus femoris

Origin: ischial tuberosity.
Insertion: trochanteric crest.
Function: lateral rotation of the thigh.

4. Gemellus superior and gemellus inferior

Origin of the superior: spine of the ischium, that of the inferior: ischial tuberosity. Both pass laterally and run on both sides of the tendon of the obturator internus muscle.
Insertion: medial surface of the greater trochanter.
Function: lateral rotation of the thigh.

5. Obturator internus

Origin: the margin of the obturator foramen and the membrane closing it.
Insertion: medial surface of the greater trochanter.
Function: lateral rotation of the thigh.

6. Piriformis

Origin: front of the second, third and fourth sacral vertebrae.
Insertion: upper border of the greater trochanter.
Function: lateral rotation and a moderate abduction of the thigh.

7. Gluteus minimus

Origin: outer surface of iliac bone between middle and inferior gluteal lines.
Insertion: greater trochanter.
Function: abduction and medial rotation of the thigh.

8. Gluteus medius

Origin: outer surface of the iliac bone, between the iliac crest and posterior gluteal line above and the middle gluteal line below.
Insertion: lateral aspect of the greater trochanter.
Function: abduction and medial rotation of the thigh.

9. Tensor fasciae latae

Origin: anterior superior iliac spine and femoral fascia. Its fibres radiate into this fascia.
Function: stretching of the fascia, elevation and abduction of thigh.
In Plate LXIV a strong ligamentous portion of the broad femoral fascia (35) is seen. This portion, forming the direct prolongation of the muscle, is attached to the lateral condyle of the tibia.

10. Gluteus maximus

Origin: posterior area of lateral surface of the iliac bone, lateral border of sacrum and coccygeal bone, the ligaments between sacrum and iliac bone.

Insertion: broad femoral fascia (Plate LXIV, 35), rough area of the femur serving the attachment of this muscle. The thick bundles of the rhombus-shaped muscle turn laterally and downwards.

Function: extending the thigh on the fixed trunk. When the limb is fixed, the trunk is bent backwards by its contraction. It extends the hip joint when the subject climbs stairs or rises to the erect posture after stooping.

The actions of most of the above muscles include the maintenance of posture by balanced contraction. Thus the lateral rotators prevent excessive medial rotation during flexion of the femur.

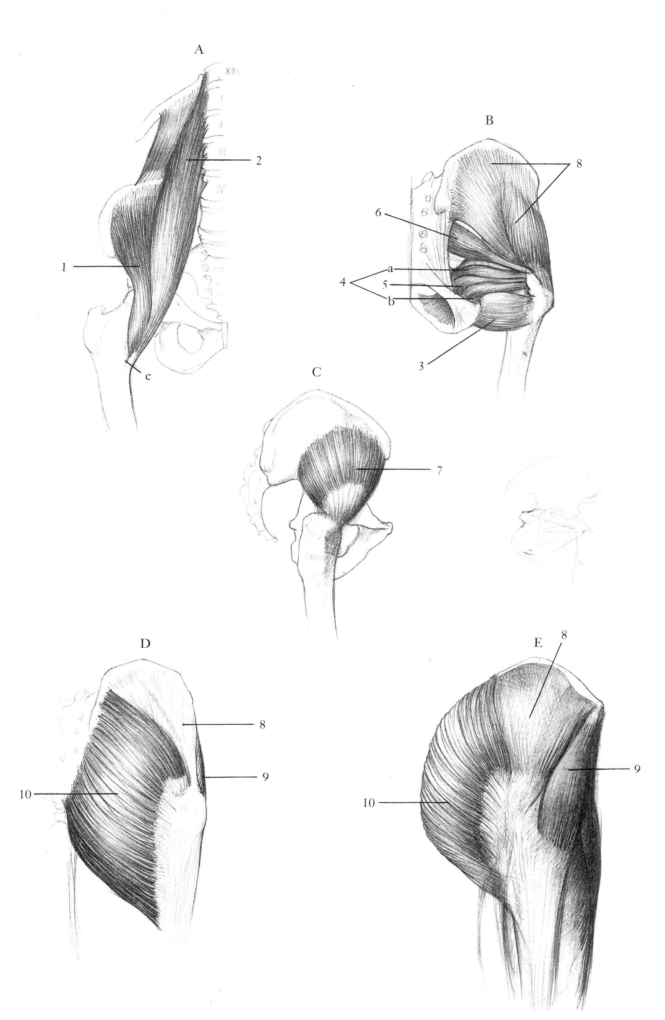

MUSCLES OF THE THIGH

The muscles of the thigh are divided into anterior, posterior, and middle muscles. The anterior group consists of the rectus and the three vastus muscles. Together, they are called the quadriceps femoris muscle. On the posterior surface are the flexors; between the two groups the adductor muscles are located. In front and medially, the most superficial muscle, the *sartorius* (tailor's muscle), runs down towards the medial condyle of the tibia.

A) ANTERIOR GROUP

11. Vastus lateralis

A strong, flat, long muscle situated on the lateral surface of the femur.
Origin: below the greater trochanter, posteriorly on the upper half of the lateral edge of the linea aspera.
Insertion: lateral border of patella.

12. Vastus medialis

Origin: along the medial edge of the linea aspera, starting from the lesser trochanter, down to the lower third of the femur. Its fibres cover the inner surface of the femur, then its bundles unite with those of the rectus and vastus intermedius muscles.
Insertion: medial border of the patella.

13. Vastus intermedius

This lies below the rectus femoris muscle.
Origin: anterior aspect of femur, down to its lower third.
Insertion: base of patella.

14. Rectus femoris

It joins the muscles 11—13. Among the four muscles its origin has a central position.
It is clearly visible on the surface. The upper end of the muscle is covered by the sartorius.

Origin: anterior inferior iliac spine and a groove above the hip joint.
Insertion: after union with the three others, base of patella.
The quadriceps is one of the strongest muscles. The femur shaft is embedded in its portions. The united tendons insert into the base of the patella, and, by its ligament, are attached to the tuberosity of the tibia.
Function: extension of the knee joint.

15. Sartorius

It is narrow and flat, the longest muscle of the body.
Origin: anterior superior iliac spine.
Insertion: the upper part of the medial surface of the shaft of the tibia. Having surrounded the anterior surface of the femur by a twisting course, it runs to the inner side of the knee joint.
Function: help in the abduction and flexion of the thigh, lateral rotation of the thigh, flexion of the leg on the thigh.

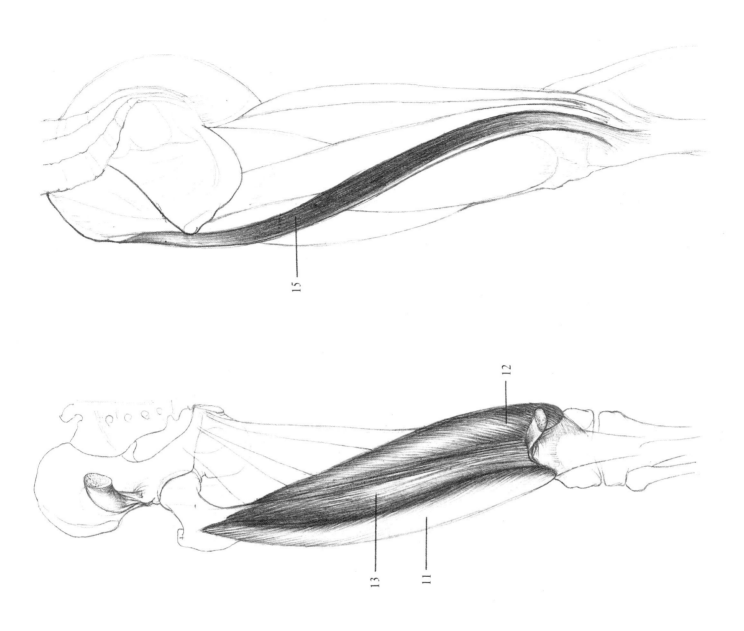

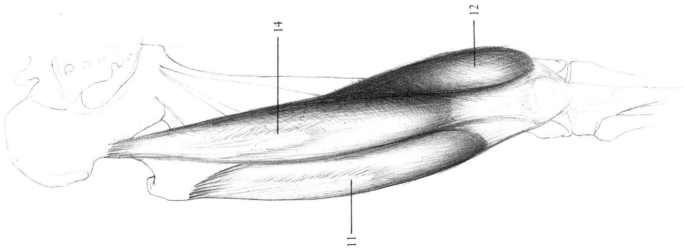

LVII

B) POSTERIOR GROUP

16. Semimembranosus

Origin: ischial tuberosity.
Insertion: medial condyle of the tibia.
Function: flexion and, afterwards, medial rotation of leg.

17. Semitendinosus

Origin: ischial tuberosity.
Insertion: upper part of the medial surface of the tibia.
Function: flexion and, after flexion, medial rotation of leg.

18. Biceps femoris

Origin: the long head on the posterior surface of the sciatic tuber, next to the semitendinosus and semimembranosus muscles; the short head on the middle third of the linea aspera.
Insertion: head of fibula.
Function: flexion and, thereafter, medial rotation of leg.

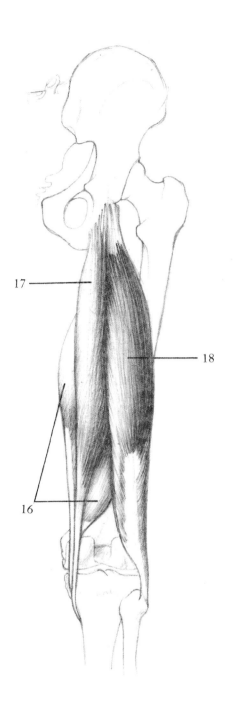

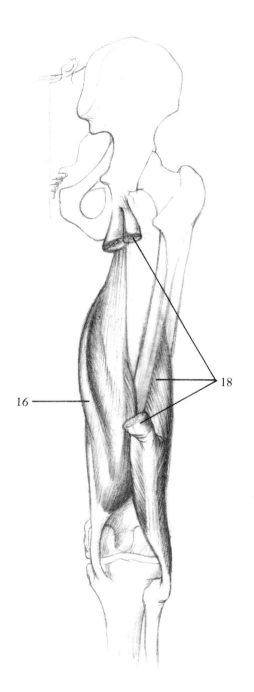

LVIII

C) ADDUCTORS

19. Adductor magnus

Origin: inferior ramus of the pubic bone, ramus of the ischium, ischial tuberosity.
Insertion: medial border of linea aspera, from the lesser trochanter to the medial condyle.

20. Adductor brevis

Origin: inferior ramus of pubic bone.
Insertion: upper third of the medial margin of the linea aspera.

21. Adductor longus

Origin: at the junction of the body and inferior ramus of the pubic bone.
Insertion: medial margin of the linea aspera in the middle third.
Function: simultaneous contraction of the muscles (19—21) results in the adduction of the thigh.

22. Gracilis

Origin: body and inferior ramus of pubic bone.
Insertion: united with the tendons of the sartorius and semitendinosus muscles, below the condyle, on the upper part of the medial surface of the tibia.
Function: flexion and medial rotation and adduction.

23. Pectineus

Origin: pectineal line of pubic bone.
Insertion: below the lesser trochanter, on the oblique line connecting the trochanter with the medial margin of the linea aspera.
Function: adduction and flexion of thigh.

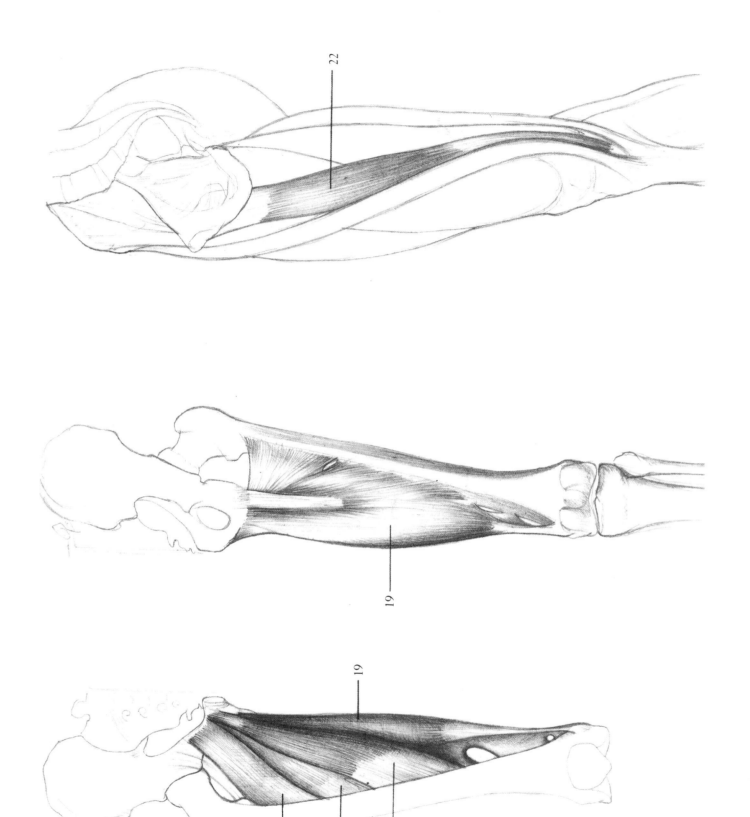

LIX

MUSCLES OF THE LEG

The muscles of the leg are divided into flexors, extensors, and peroneal muscles.

A) EXTENSORS

24. Extensor digitorum longus

Origin: upper three-fourths of anterior surface of shaft of fibula, and the lateral condyle of tibia.
Insertion: the tendon splits at the level of the ankle into five branches. Of these, those running to the four lesser toes unite with the thin tendons of the extensor brevis muscle. The flat tendon splits, at the head of the proximal phalanx, into three branches. The two marginal tendons insert to the base of the distal phalanx, the middle one to the base of the middle phalanx. The most lateral tendon, acting as a third peroneal muscle, is attached to the dorsal surface of the fifth metatarsal bone (Plate LXIV, 34).
Function: extension of the four lesser toes; the third peroneal muscle raises the lateral margin of the foot.

25. Extensor hallucis longus

Origin: interosseous membrane, middle two-fourths of fibula.
Insertion: base of distal phalanx of great toe.
Function: extension of great toe.

26. Tibialis anterior

Origin: lateral condyle of tibia and the upper half, interosseous membrane.
Insertion: medial surface of medial cuneiform bone, base of first metatarsal bone.
Function: extension (dorsiflexion) of foot, raising of the foot arch.

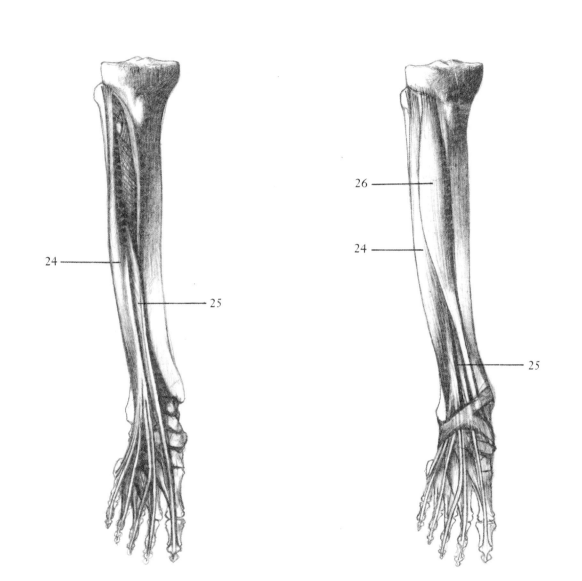

LX

B) FLEXORS

Deep Layer

27. Popliteus

Origin: lateral condyle of femur.
Insertion: posterior surface of tibia, above the oblique line running below the condyle.
Function: flexion and, afterwards, medial rotation of leg.

28. Flexor hallicus longus

Origin: lower two-thirds of posterior aspect of fibula and interosseous membrane.
Insertion: distal phalanx of great toe.
Function: flexion of hallux and, through this, of foot. Takes part in the rotation of the foot.

29. Tibialis posterior

Origin: posterior surface of tibia, interosseous membrane. Its tendon turns forwards behind the medial malleolus.
Insertion: tuberosity of navicular bone, other tarsal bones.
Function: flexion of foot, inversion (medial rotation) of foot, support of the foot arch.

30. Flexor digitorum longus

Origin: posterior surface of the shaft of the tibia.
Insertion: behind the medial malleolus its tendon is crossed by the tendon of the tibialis posterior, on the sole by the flexor hallucis longus. Then, the tendon divides into four parts which, at the level of the proximal phalanges of the four lesser toes, pass through the fissures of the flexor brevis tendons running above them, and insert into the distal phalanges.
Function: flexion of the second to fifth toes, and help in flexion of the foot.

31. Triceps surae

Origin: with two superficial heads, i.e., the gastrocnemius muscle of the leg, on the posterior surfaces of the condyles of the femur. The two heads unite in the middle line. The third (lower) head, i.e., the soleus muscle (31a), is deeper seated; it originates from the upper third of both bones of the leg.
Insertion: posterior surface of the calcaneum. The union of the three heads results in the strong *tendo calcaneus* (Achilles tendon, 36).
Function: plantar flexion of foot.

C) PERONEAL MUSCLES

32. Peroneus brevis

Origin: lateral surface of lower half of fibula, down to the lateral malleolus.
Insertion: tuberosity of fifth metatarsal bone.
Function: eversion of foot (raising of its lateral edge).

33. Peroneus longus

Origin: upper half of lateral surface of fibula.
Insertion: medial cuneiform bone, base of first metatarsal bone (behind the lateral malleolus the tendon covers that of the peroneus brevis and turns to the sole where it passes obliquely forwards).
Function: flexion and eversion of foot, support to the arch of foot at its lateral part. It steadies the leg on the foot, especially when standing on one leg.

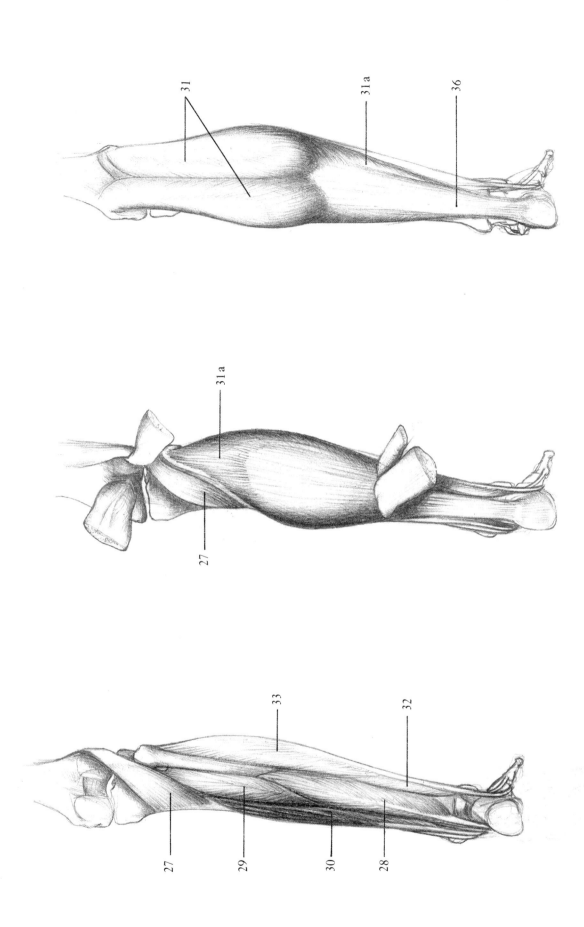

LXI

MUSCLES OF THE FOOT

On the foot, dorsal and plantar muscles are distinguished.

A) DORSAL MUSCLES

1. Extensor digitorum brevis

Origin: upper surface of calcaneum. One tendon (the extensor hallucis brevis) inserts into the base of the proximal phalanx of the great toe. The other three thin tendons unite with the corresponding tendons of the long extensors.
Function: extension of toes.

B) PLANTAR MUSCLES

Dorsal interossei

Origin: the adjacent sides of metatarsal bones.
Insertion: their thin tendons are attached to the sides of proximal phalanges.
Function: abduction from the mid-line of the second toe. Deep-seated muscles.

Plantar interossei

Origin: tibial side of third, fourth and fifth metatarsal bones.
Insertion: aponeurosis of the extensor tendons, and into the medial sides of the bases of the corresponding proximal phalanges.
Function: adduction of the third, fourth and fifth toes towards the second toe, and flexion of the proximal phalanges. Deep-seated muscles.

1. Lumbricals

They are four in number.
Origin: tendons of the flexor digitorum longus.
Insertion: aponeuroses of the extensor tendons to the second to fifth toes.
Function: flexion of proximal phalanges. They are invisible from the surface.

2. Quadratus plantae (flexor digitorum accessorius)

Origin: plantar surface of calcaneum.
Insertion: tendons of flexor digitorum longus.
Function: help in flexion of toes.

3. Flexor digitorum brevis

Origin: medial tuberosity of calcaneum.
Insertion: with four tendons passing to the second to fifth toes. Above the heads of the metatarsal bones they are perforated by the tendons of the flexor digitorum longus.
Function: flexion of the second to fifth toes.

4. Opponens digiti minimi

Origin: long plantar ligament.
Insertion: the distal half of the fifth metatarsal bone.
Function: pulling of fifth metatarsal bone towards the sole.

5. Flexor digiti minimi brevis

Origin: base of fifth metatarsal bone.
Insertion: base of proximal phalanx of little toe.
Function: flexion of little toe.

6. Abductor digiti minimi

Origin: lateral and plantar surface of calcaneum.
Insertion: base of proximal phalanx of little toe.
Function: abduction of little toe.

7. Adductor hallucis

Origin: the oblique head on the bases of the second, third and fourth metatarsal bones, the transverse head on the capsules of the second, third and fourth metatarso-phalangeal joints.
Insertion: with united heads on the base of the proximal phalanx of the great toe.
Function: adduction of great toe.

8. Flexor hallucis brevis

 Origin: cuboid and lateral cuneiform bones, and ligaments.
 Insertion: with two heads, each with a sesamoid bone, into the base of the proximal phalanx.
 Function: flexion of great toe.

9. Abductor hallucis

 Origin: medial tuberosity of calcaneum, and ligaments.
 Insertion: medial side of the base of the proximal phalanx.
 Function: abduction of great toe.

A

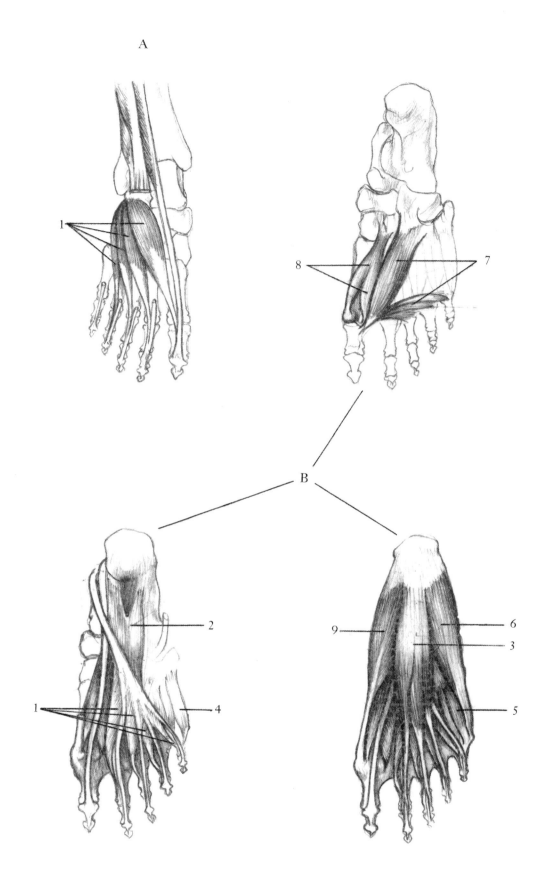

B

MUSCULAR SYSTEM OF THE LOWER LIMB

LXII—LXV

In the following plates the correlations of the muscles of the lower limb are demonstrated. The muscle system is exhibited from anterior, posterior, lateral and medial aspects. The index numbers and letters are identical with those of the preceding figure. No. 37 indicates the inferior extensor retinaculum.

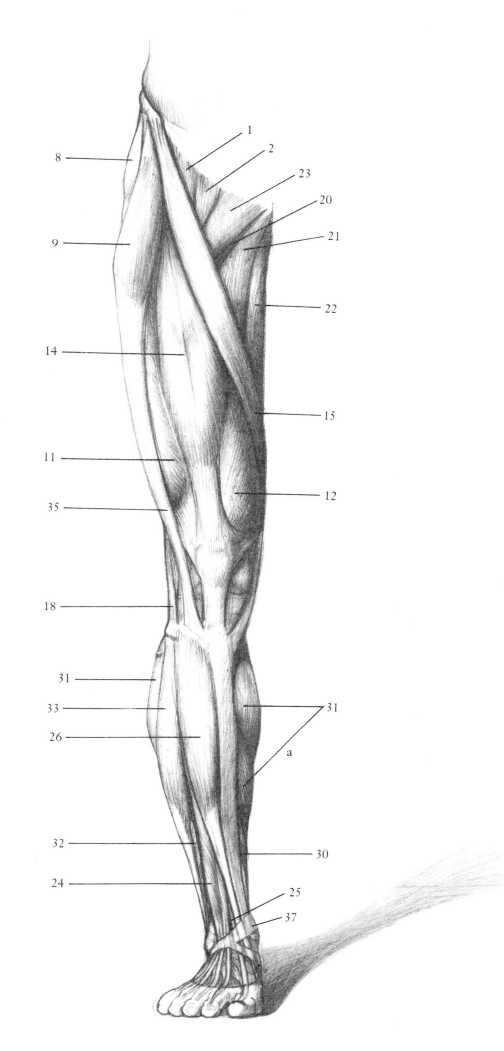

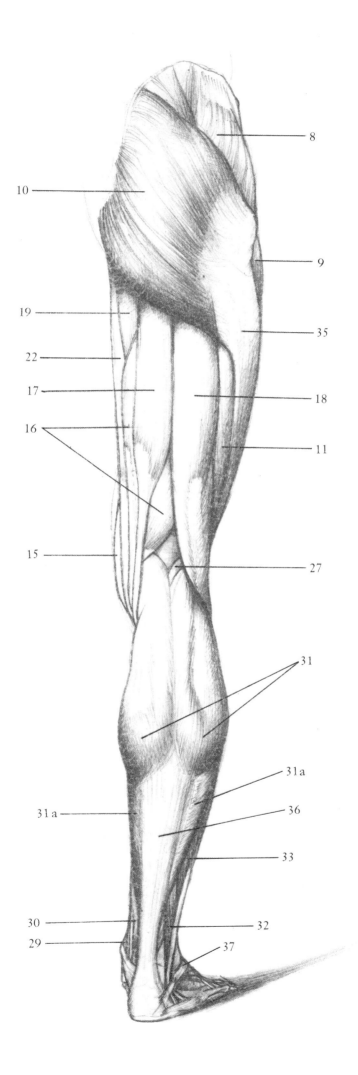

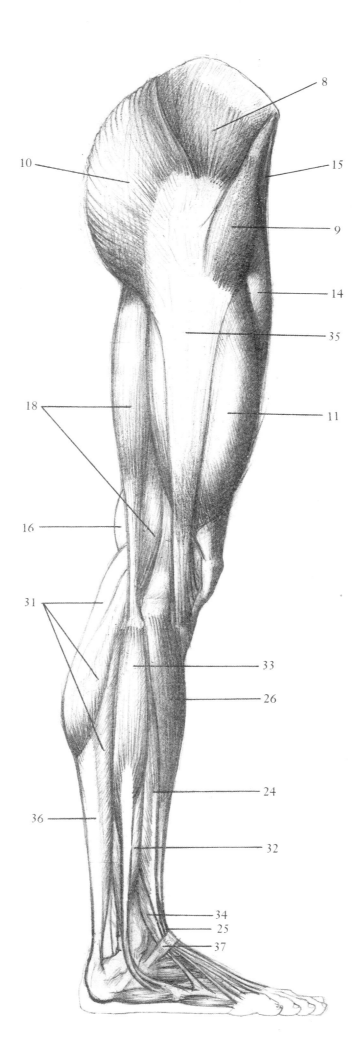

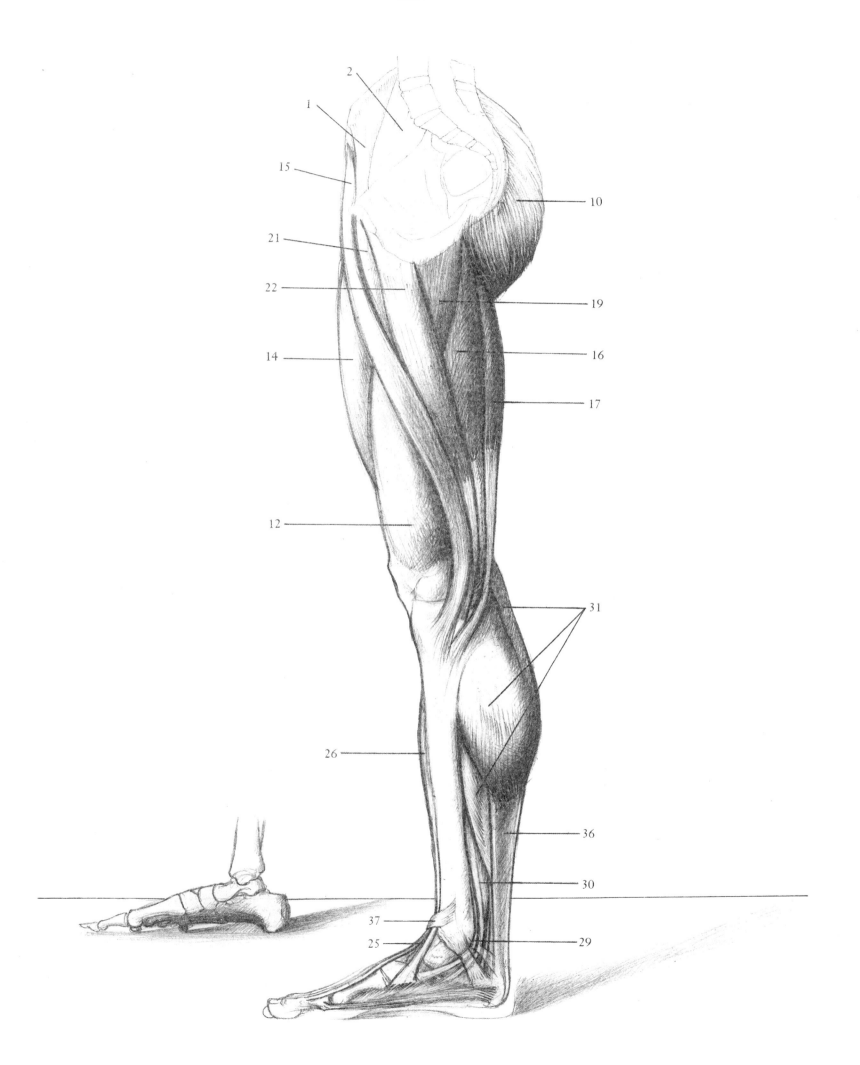

BONES OF THE TRUNK

The bones of the trunk form three groups:
1. Vertebrae (Plate LXVI, A, B; Plate LXVII, A, B, C).
2. Ribs (Plate LXVIII, B).
3. Sternum (Plate LXVIII, A).
Together, vertebrae, ribs and sternum form the thoracic cage.

LXVI—LXVII

VERTEBRAE

The spinal column is composed of 24 true and 9 to 11 false vertebrae (Plate LXIX). Twelve of them, the thoracic vertebrae, articulate with ribs (Plate LXIX, B). Between the skull and the thoracic vertebrae seven cervical vertebrae are located (Plate LXIX, A), below the thoracic ones five lumbar vertebrae follow (Plate LXIX, C). Five false (fused) vertebrae form the sacrum (Plate LXIX, D). With the sacrum articulates the coccygeal bone deriving from the fusion of four to six rudimentary vertebrae (Plate LXIX, E).

The ring-shaped vertebrae protect the spinal cord located within. Each vertebra consists of a thick frontal body (Plate LXVI, A 2), and an arch surrounding the spinal canal, behind the body (Plate LXVI, A 1). From the arch, several processes project. The process projecting from the middle plane backwards is the spinous process (Plate LXVI, A 4). Two others starting from the arch towards both sides are termed transverse processes (Plate LXVI, A 3). To the processes ribs and muscles are attached. The intervertebral articulations take place by the superior and inferior articular processes (Plate LXVI, A 5, 8). The base of the spinal column is the triangularly shaped sacrum, with the apex directed downwards (Plate LXVI, C). It is wedged in between the two iliac bones and forms the posterior wall of the pelvis.

The distance between the first cervical and fifth lumbar vertebra is about one-third of the whole body length.

The bodies of the vertebrae are linked together by the intervertebral disks, and the arches and processes by ligaments. The ligamenta flava connect the arches, the intertransverse ligaments the transverse processes, and the interspinous ligaments the spines. The apices of the spines are connected by the supraspinous ligament; in the neck this is thickened to form the ligamentum nuchae, which attaches to the external occipital protuberance.

166

The body of a *cervical vertebra* (Plate LXVII, A, B, C) is less high (C 1, lateral aspect), the arches are of medium height, the foramen is triangular (C 6), the articular processes, situated behind the transverse processes, project obliquely (C 2, 3, lateral aspect) between the frontal and horizontal plane. The spinous process is generally bifid at the extremity (C 4). All cervical vertebrae are characterized by the flat, short, and perforated transverse process (C 5).

The first and second cervical vertebrae are quite different from all others. The first vertebra called *atlas* (Plate LXVII, A) has no body, but an anterior and posterior arch, with a tubercle on the shorter flat anterior arch (A 1), and a rough prominence at the site of the spinous process on the posterior arch (A 4). Between the anterior and posterior arches are found the lateral masses, from which the transverse processes project (A 3). On each lateral mass there is an oval-shaped concave articular surface on the superior, and a round, slightly concave one on the inferior aspect (A 2, 5).

The second cervical vertebra, called *axis*, is entirely different (Plate LXVII, B). Its spinous process is large and strong, projecting backwards (B 5). From the upper surface of its body a thick, cylindrical process termed the odontoid process projects upwards. The apex of this is blunt, its anterior and posterior surfaces are cartilaginous (B 1). On each side of the odontoid process there is a round, convex, laterally projecting upper articular surface on the body (B 2) for the atlas. Below this, a process passing obliquely backwards is found. Here, an articular surface facing forwards (B 4) constitutes the articulation with the third vertebra. The rounded end of the transverse process is also directed obliquely, slightly downwards (B 3).

The transverse processes of the *seventh cervical vertebra* are longer, its spinous process is undivided and rather long compared with the others, whereby it is more prominent than the spinal processes one to six. On the lower edge of the body there are two lateral articular surfaces.

In the upper and lower parts of the *thoracic section*, the bodies of the vertebrae are bean-shaped (Plate LXVI, A), in the middle portion heart-shaped. They have a smooth surface (A 2). The spinal foramen is round and narrow (A 1). The articular processes project straight upwards and downwards (A 5 for the upper, and A 8 for the lower articular processes). The spinous process is long, triangular, pointed, facing downwards (A 4). The spinous processes cover each other like tiles. The transverse processes project laterally and backwards (A 3). On each of them, there is, at the posterior end of the lateral surface of the body, in front of the origin of the arch, a small articular surface for the ribs (A 6, 7, lateral aspect).

The *lumbar vertebrae* (Plate LXVI, B) are larger than the thoracic or cervical ones. Their bodies are higher and thicker, bean-shaped, their surfaces are smooth (B 2). The foramen is triangular (B 1). The articular processes are nearly vertical (B 3, 4). The articular surface of each upper process is concave, facing medially, that of each lower one convex, facing laterally. The spinous process is broad, flattened, almost horizontal, directed backwards. The transverse processes are shorter than those of the thoracic vertebrae, and as their function is different from that of the latter, their shape has also developed in a different way (B 6).

SACRUM

This is the broadest and strongest bone of the spinal column (Plate LXVI, C). It has developed from the fusion of five vertebrae. Its upper edge, termed *promontory*, projects anteriorly (C 2). Its upper end is the base (C 1) on which two upwards pointing articular surfaces are formed (C 6), with which the lowest lumbar vertebra articulates. On the inferior end there is an articular surface (C 5) for the coccygeal bone. The anterior surface is concave. In the middle region of the anterior surface horizontal lines which are due to the fusion of the vertebral bodies are seen (C 4, anterior aspect). On each side there are four wide openings, each continuing in a groove (C 3, anterior aspect). The posterior surface is convex, rough, uneven. On it, five vertical rows of eminences can be distinguished. Of these, the most conspicuous are the spinous tubercles (C 9, posterior aspect). Next to them laterally the row of the articular (C 8, posterior aspect) and transverse tubercles are seen.

Between the two latter rows the posterior sacral foramina (openings) are found (C 3). Laterally to the foramina are the so-called lateral masses. At the posterior surface of the sacrum, below, the sacral canal opens (C 10). Above, the lateral masses are wide, provided with a lateral auricular articular surface (C 7). Behind the auricular surface a very rough area is present.

COCCYX (COCCYGEAL BONE)

The bone (Plate LXVI, C 11) has developed through the fusion of four to six rudimentary vertebrae. On the first, the constituents of the vertebrae can still be recognized, such as the rudimentary articular processes directed upwards (C 12).

A

Superior aspect

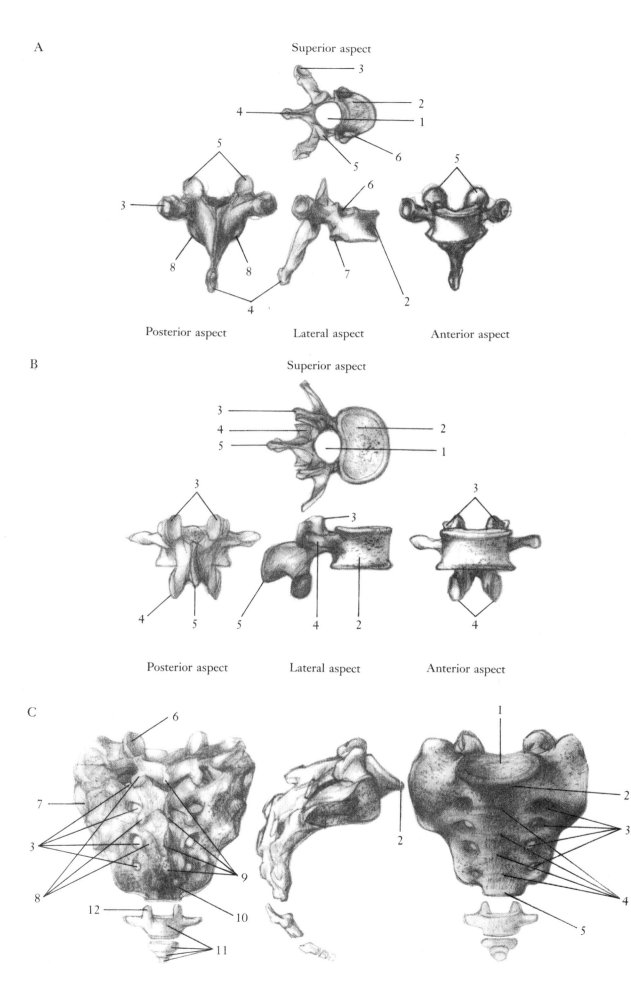

Posterior aspect Lateral aspect Anterior aspect

B

Superior aspect

Posterior aspect Lateral aspect Anterior aspect

C

Posterior aspect Lateral aspect Anterior aspect

A

Superior aspect

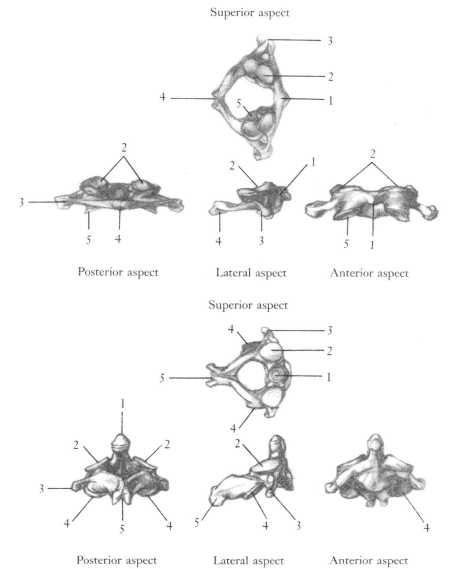

Posterior aspect Lateral aspect Anterior aspect

B

Superior aspect

Posterior aspect Lateral aspect Anterior aspect

C

Superior aspect

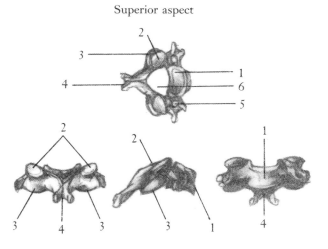

Posterior aspect Lateral aspect Anterior aspect

LXVIII

RIBS
(Costae)

The ribs are long, flat, curved bones of the thickness of the finger. Their number is twenty-four. Those ribs which have their cartilage connected with the sternum are termed *true ribs* (seven pairs, Plate LXXII, 1 a). The cartilage of the others has fused with that of the neighbouring ribs, and they are termed *false ribs* (Plate LXXII, 1 b). The cartilage of the two last pairs is not attached to the sternum or the other rib; they are termed *floating ribs* (Plate LXXII, 1 c).

The end of every rib is provided with an articular head (Plate LXVIII, B 1), behind which the neck of the rib (B 2), and a small tuberosity with an articular surface (B 3), are seen. At the junction of the posterior and middle portions an obtuse angle termed the costal angle is formed (B 4). The middle portion curved like a sickle is flat. The upper edge is rounded (B 5). The anterior end portion is thin, but somewhat thicker than the middle one. The anterior end is thickened, excavated for the articulation with the costal cartilage (B 6). The upper ribs are more, the lower ones less curved, their anterior end portions pass upwards and inwards (Plates LXXII, LXXIII).

STERNUM

The sternum (Plate LXVIII, A) is situated in the middle of the anterior part of the chest, with a posterior inclination, and at the level of the thoracic vertebrae three to nine. Its upper part narrowing downwards is the manubrium (A 1 a) having a convex anterior surface and a notched upper margin (A 2). Lateral to the notch, there is an articular groove, one on each side (A 3). The middle, longest portion of the bone, termed body, is broadest at the middle part; inferiorly it becomes narrower (A 1 b); the lowermost portion is the xiphoid (ensiform, sword-shaped) process (A 1 c). On both sides of the body, there are seven small notches (A 4) for the costal cartilage. The manubrial notch lies at the height of the second thoracic intervertebral disk, the xiphoid process at the level of the eighth thoracic vertebra.

LXVIII

A

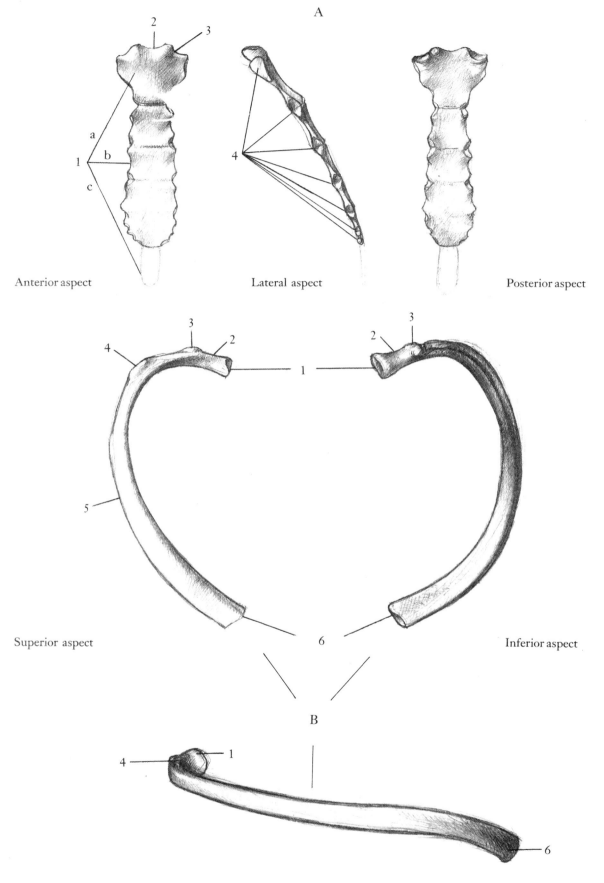

Anterior aspect

Lateral aspect

Posterior aspect

B

Superior aspect

Inferior aspect

Lateral aspect

ARTICULATIONS AND MOVEMENTS
OF THE BONES OF THE TRUNK

LXIX—LXXI

ARTICULATIONS AND MOVEMENTS OF THE
BONES OF THE VERTEBRAL COLUMN (SPINE)

The vertebrae are, from the second cervical vertebra to the sacrum, separated by intervertebral disks. The inferior articular process of each vertebra forms a rigid joint with the superior articular processes of the underlying vertebra. Besides these, there are muscles and ligaments between the arches, and the other processes.

The intervertebral disk is closely adherent to the surface of the vertebral bodies.

From the front, the spinal column seems to be straight. Viewed laterally, the spinal column presents several curves. The cervical and the lumbar curves are convex anteriorly. The thoracic and the pelvic curves, contrary to the previous ones, are concave anteriorly. These curvatures, together with the intervertebral cartilages, are buffers in counteracting the effects of violent jars or shocks.

The vertebral column can rotate round its own axis, and perform forward (Plate LXX, c, and Plate LXXI, d), backward (Plate LXX, b, and Plate LXXI, e), and sideward flexions (Plate LXXI, f). The greatest flexion can be carried out in the cervical and the lumbar segments (Plate LXX, b 1, b 3), the slightest in the thoracic ones (Plate LXX, b 2).

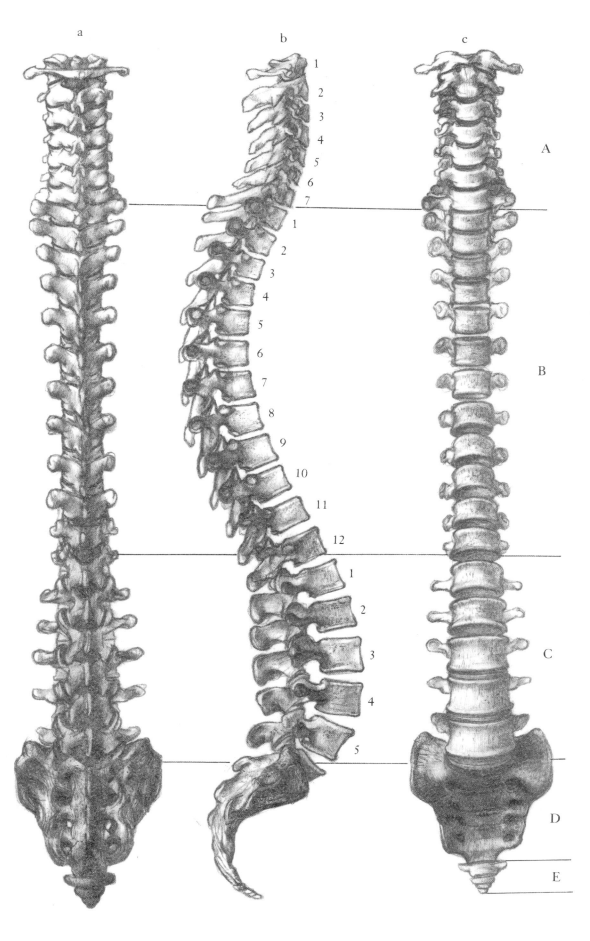

a

b

c

1
2
3
4
5
6
7

A

1
2
3
4
5
6
7
8
9
10
11
12

B

1
2
3
4
5

C

D

E

Posterior aspect

Lateral aspect

Anterior aspect

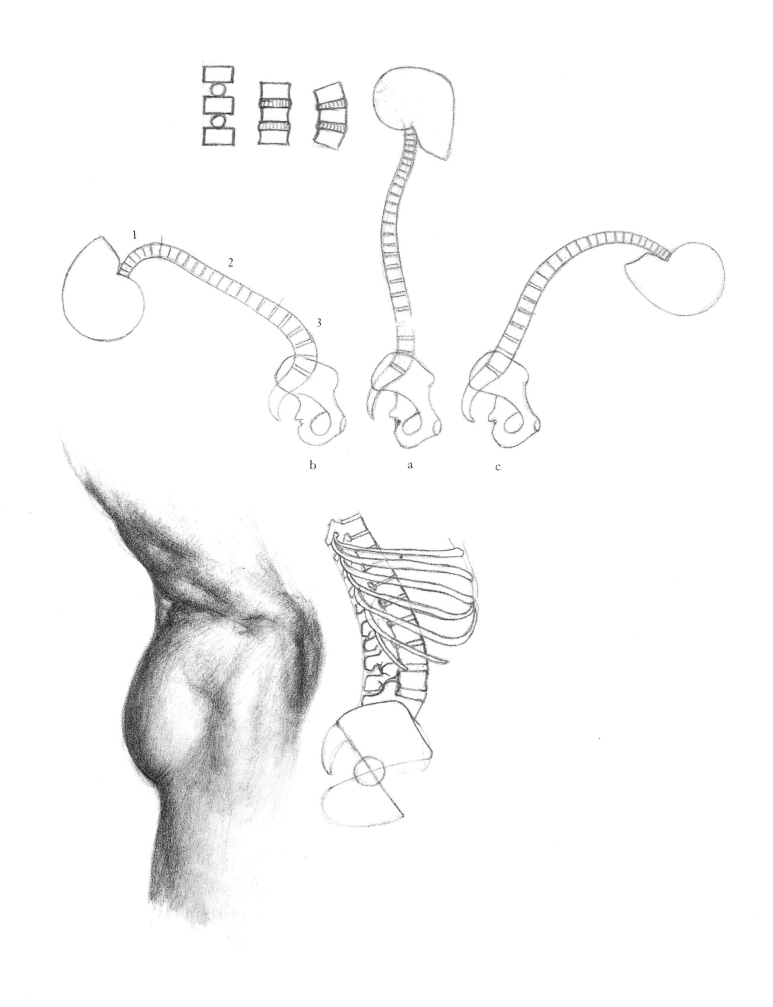

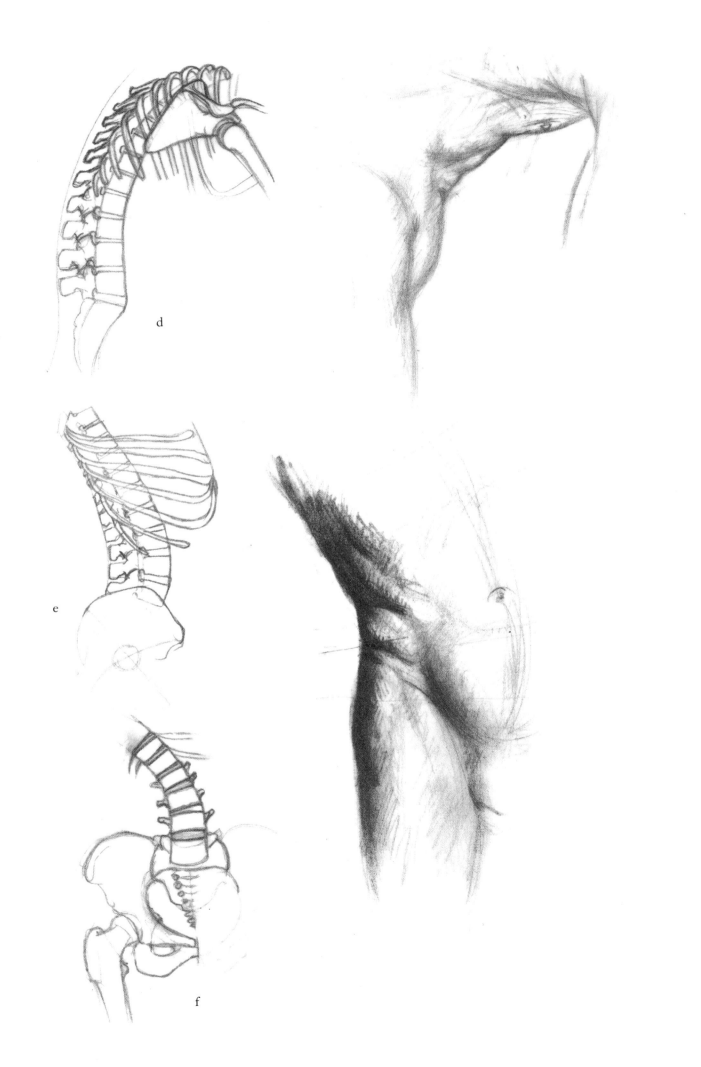

d

e

f

ARTICULATIONS OF THE BONES OF THE CHEST
(THORAX)

The thoracic cage is composed of the ribs, vertebrae and sternum, articulating with each other (Plate LXXIII, 2 b, 2 c, 2 d). The posterior end of every rib articulates behind with one or two vertebrae, in front with the sternum. With the vertebrae, the rib forms a double articulation, the head of the rib with the body, the tuberosity with the transverse process (Plate LXXIII, 2). The two facets of the head are generally in contact with the costal excavations of two adjacent vertebrae, with the exception of ribs one, eleven and twelve, which are in contact with one vertebral body only.

The anterior cartilaginous ends of the upper seven ribs are connected to the sternum (Plate LXXII, 1 a). The ends of the ribs from seven to ten are in a cartilaginous articulation with each other (1 b). The ends of ribs eleven and twelve terminate freely in the abdominal wall (1 c).

The thoracic cage is conic or barrel-shaped. Its inlet is narrower than its outlet. The widest part is that below the middle. The transverse diameter is longer than the sagittal one (Plates LXXII and LXXIII). The anterior wall of the chest is formed by the sternum and the cartilages of the true ribs. The sternum is slightly inclined, whereby its lower end is at a greater distance from the vertebral column than the upper one (Plate LXXII, 1, 2). The posterior wall of the chest is composed of the dorsal vertebrae and the portion of the ribs between the head and the angle (Plate LXXIII, 1). Downwards from above, the posterior wall of the chest is convex. Along its middle line, the vertebral bodies and the heads of the ribs protrude deep in the thorax (Plate LXXIII, 2), while on both sides a backward protrusion of the wall is seen. The lateral walls are markedly convex; they are formed by the main body of the ribs. Above and below, the chest is open. Between the ribs there are spaces termed intercostal spaces. The shape of the chest depends on age and sex, and may also be influenced by the occupation of the individual. The male chest is like a barrel; its surface is more convex, and the ribs are more elevated than in woman. The female chest is narrower, shorter, conic, the costal angles are more convex, the sternum is smaller and comparatively slender.

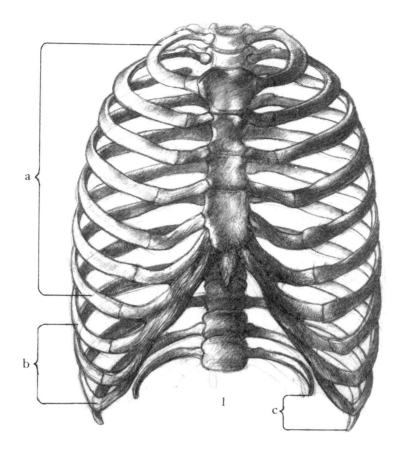

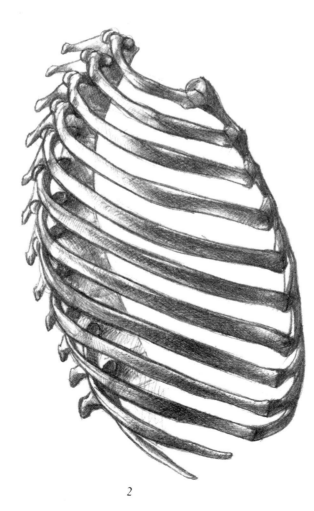

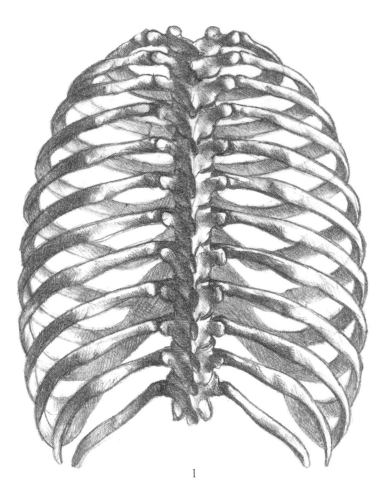

1

2

LXXIV

THE CHEST IN MOVEMENT

As has been described, between a rib and the vertebral column there are two articulations, that of the head with the body of the vertebra, and that of the costal tuberosity with the transverse process. The joints always act simultaneously. On respiration, the vertebral section of the rib performs a rotation round an axis connecting the head and the tuberosity of the rib. i.e., running in a slightly oblique direction laterally (1 a, 1 b). On respiration, ribs and sternum ascend and descend. At the same time, the form of the thorax changes in all, transverse, sagittal, and coronal diameters (1, 2, 3). All these dilatations of the chest are rendered possible by the elasticity of the costal cartilage.

a b

1

2

3

THE BONY STRUCTURE OF THE TRUNK

The figures in these two plates show the correlations of the bones of the trunk from the front, behind, and the side. On the right half of each plate the bones of the trunk are presented, on the left, in identical position, the forms as seen on the living.

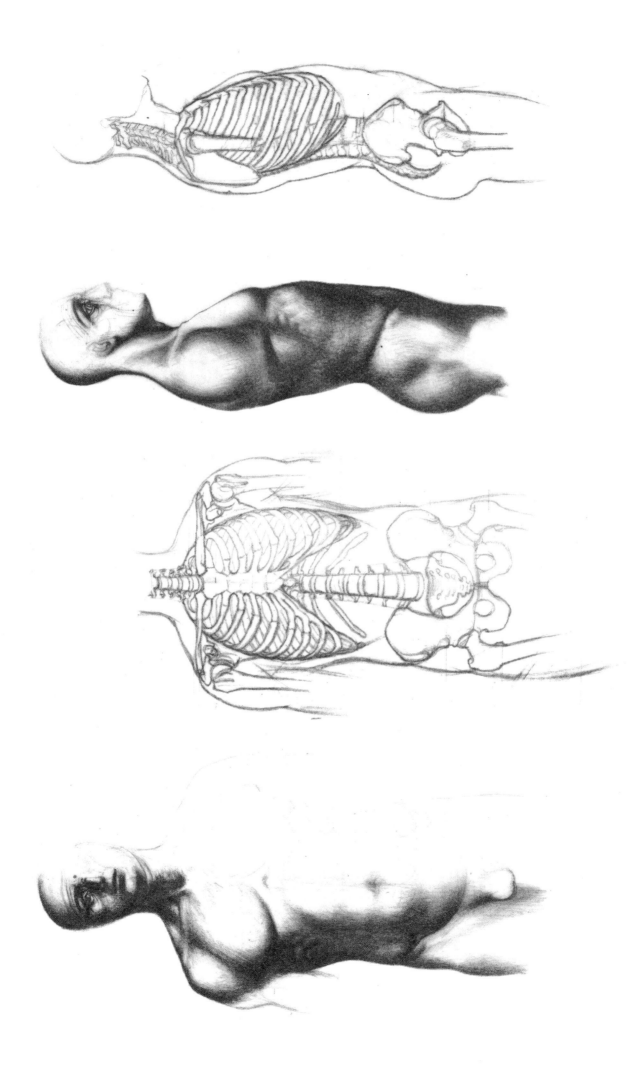

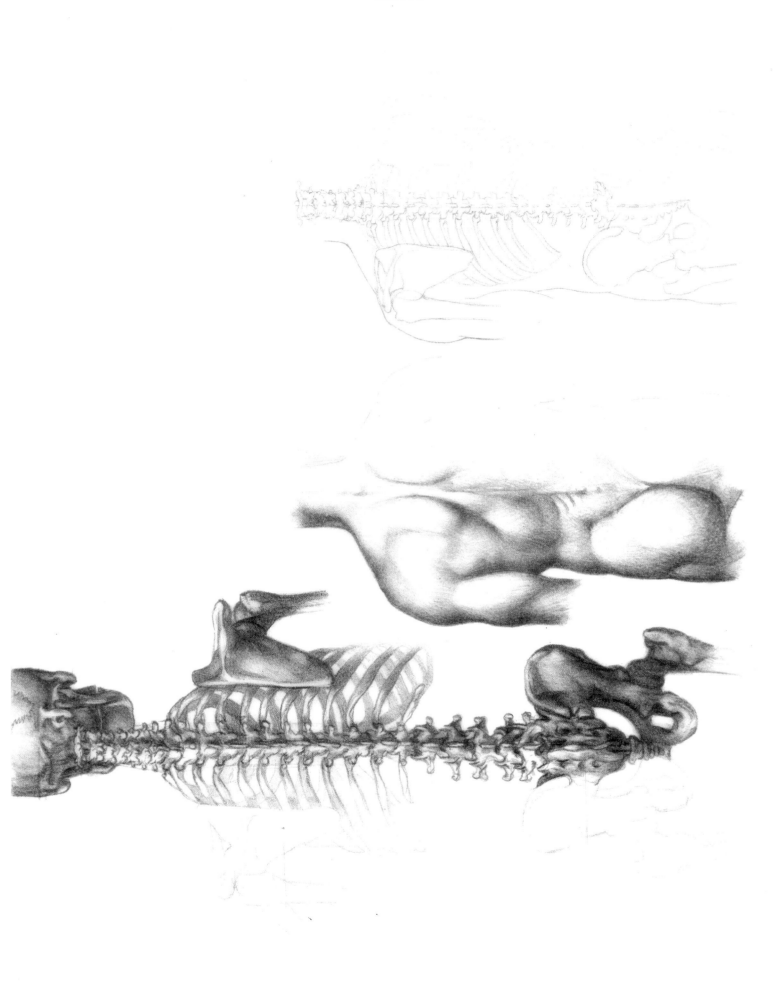

FORM OF THE TRUNK IN GENERAL

LXXVII—LXXIX

Like the limbs, the trunk, too, has a construction corresponding to its function. These conditions are demonstrated by Plates LXXVII and LXXVIII, and the cross-sections (Plate LXXIX). The broadest part of the body is at the level of the shoulders, between the greatest protrusion of the deltoid muscles (Plate LXXIX, 2 a). Above this, at the level of the clavicles, the trunk is somewhat narrower (1 a). In the pelvic region, the longest transverse diameter is that between the great trochanters (4 a), while that between the iliac spines, above the former, is slightly shorter. Thus, the trunk becomes broader at the places where the limbs are attached to it. The slenderest part is the waist (3 a).

The shortest sagittal diameter of the trunk is that passing through the manubrium of the sternum (1 b). Downwards, the diameter rapidly increases but again becomes shorter at the waist (3 b). These proportions may undergo changes with aging.

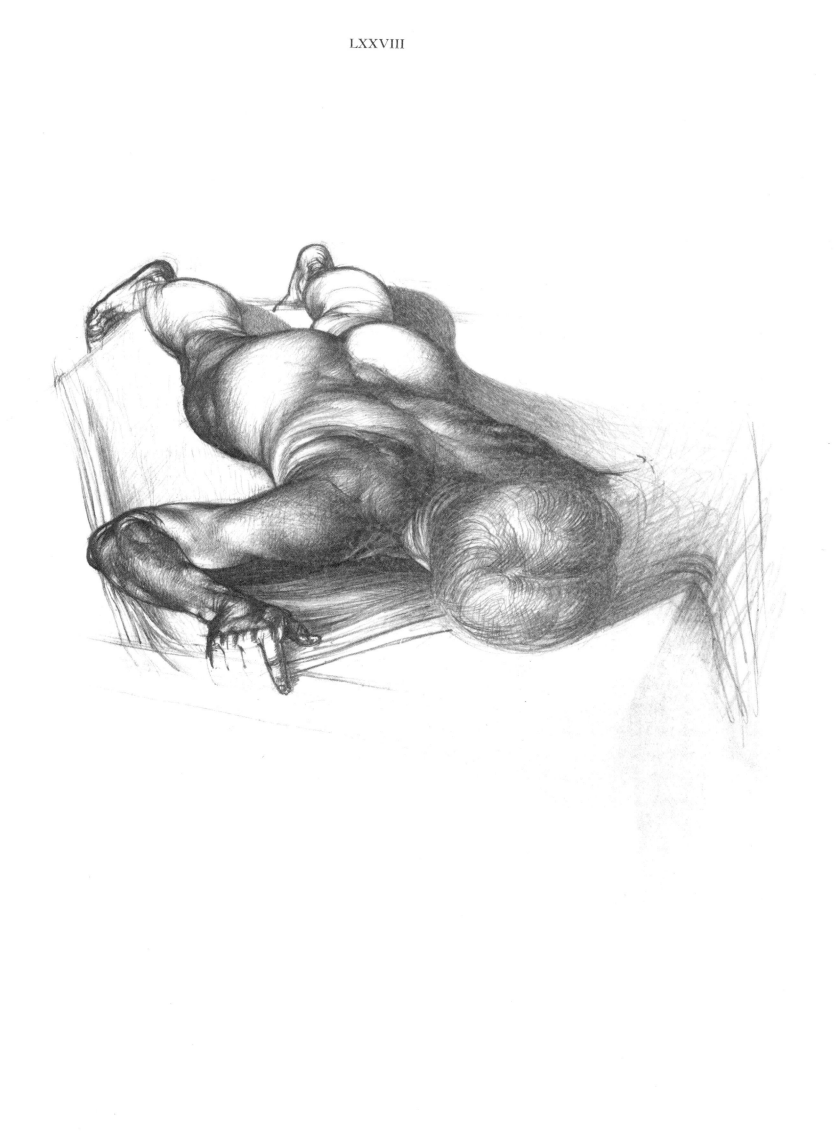

MUSCLES OF THE TRUNK

LXXX

The surface of the trunk is covered by large, broad muscles. However, at the places where the limbs are linked to the trunk, i.e., the shoulder and the pelvic region, the surface displays a great variety. The description of the muscles will start with the anterior upper region of the trunk. Here, the anterior and lateral wall of the chest is covered by muscles, with the exception of the middle part of the sternum. The muscles of the breast connect the thorax with the shoulder and the arms.

MUSCLES OF THE BREAST

1. Pectoralis major

It is a triangular muscle composed of three parts: a minor part originates on the middle and lateral third of the clavicle, a second, greater part, on the anterior surface of the sternum and the cartilages of the true ribs, the third on the aponeurosis of the obliquus externus abdominis muscle. The bundles of these parts pass laterally by folding over each other so that the abdominal part is covered by the sternal, the latter by the clavicular part. Near the arm, the muscle becomes thick and is inserted, with a tendon of the thumb's thickness, below the greater tuberosity. The pectoralis minor muscle, part of the coracobrachialis, and the origin of the biceps, are covered and compressed by the pectoralis major. At the shoulder joint, the muscle is partly covered by the deltoid.
Function: adduction of the arm and traction of the raised arm downwards.

2. Subclavius

Origin: sternal end and cartilage of first rib.
Insertion: lower surface of the clavicle.
Function: fixates and pulls the clavicle downwards and anteriorly.

3. Pectoralis minor

Origin: third, fourth and fifth ribs.
Insertion: medial border of coracoid process.
Function: pulling of shoulder downwards and forwards; raising of ribs if the shoulder is fixed.

4. Serratus anterior

Large, flat muscle.
Origin: with eight or nine digitations (slips) on the first eight or nine ribs.
Insertion: after a backward turn, on the whole medial border of the scapula.
Function: traction of scapula forwards; by pulling its lower angle forwards, it helps the trapezius in elevation of the arm above the horizontal plane.

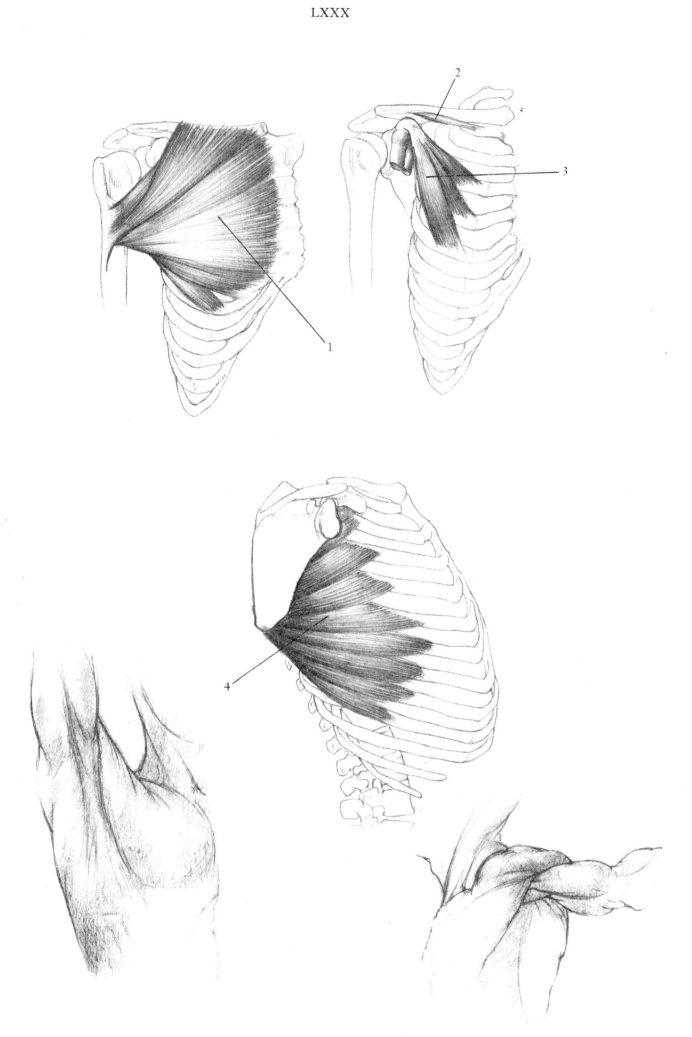

LXXXI

MUSCLES OF THE ABDOMEN

The abdominal muscles are situated in three layers covering, and also crossing, each other. The deepest layer is formed by the transversus abdominis, invisible from the surface.

5. Obliquus internus abdominis

This flat muscle, also invisible on the surface, covers the transversus abdominis muscle. Its fibres pass from the iliac crest obliquely up- and medianwards.
Origin: anterior two-thirds of the middle line of the iliac crest, lateral part of inguinal ligament, lumbar fascia.
Insertion: the upper fibres insert at the margin of the seventh to ninth ribs, while the others form a broad aponeurosis which bifurcates at the outer margin of the rectus abdominis muscle, so that one of its sheets passes before, the other behind the rectus muscle. These sheets form the sheath of the rectus muscle: they unite in the middle line of the abdomen where the linea alba is formed (1).
Function: essentially similar to that of the following muscle, i.e., flexion of the trunk and compression of abdomen.

6. Obliquus externus abdominis

Its fibres are crossed by those of the underlying oblique muscle.
Origin: superficial surfaces of seven or eight lower ribs, with digitations. The four lower digitations meet with those of the latissimus dorsi muscle, the four upper ones with those of the serratus anterior muscle, whereby a serrated line arises.
Insertion: the lowest fibres insert on the outer line of the iliac crest, while a broad aponeurosis is formed by the others; passing anterior to the rectus abdominis muscle, the aponeurosis reaches the linea alba. The lower, thick edge of the aponeurosis, between the iliac crest and the attachment of the linea alba to the pubis, is termed the inguinal ligament (b).
Function: it co-operates with the other abdominal muscles. Simultaneous contraction of the muscles of both sides results in forward bending of the trunk. If the chest is fixed, the pelvis is brought in flexion. Unilateral contraction is followed by the flexion and rotation of the trunk to the side of the contracting muscle. Besides this, it constricts the abdominal cavity, and the ribs are compressed and pulled downward.

200

7. Pyramidalis

Small triangular muscle at the lower end of and superficial to the rectus abdominis. The apex of the triangle is uppermost.

Origin: anterior surface of pubis.

Insertion: passing upward along the linea alba (1), it terminates in it.

Function: pulling of linea alba, assists the rectus abdominis muscle.

8. Rectus abdominis

Long, flat, thin muscle.

Origin: outer surfaces of costal cartilages five, six and seven.

Insertion: with its tendon on the pubic symphysis and the pubic bone. The muscle is traversed by tendinous intersections. The first of them (above) is parallel to the lowest costal cartilages. The upper and middle are located above, the lowest at the level of the umbilicus (navel).

Function: forward flexion of trunk, constriction of abdominal cavity.

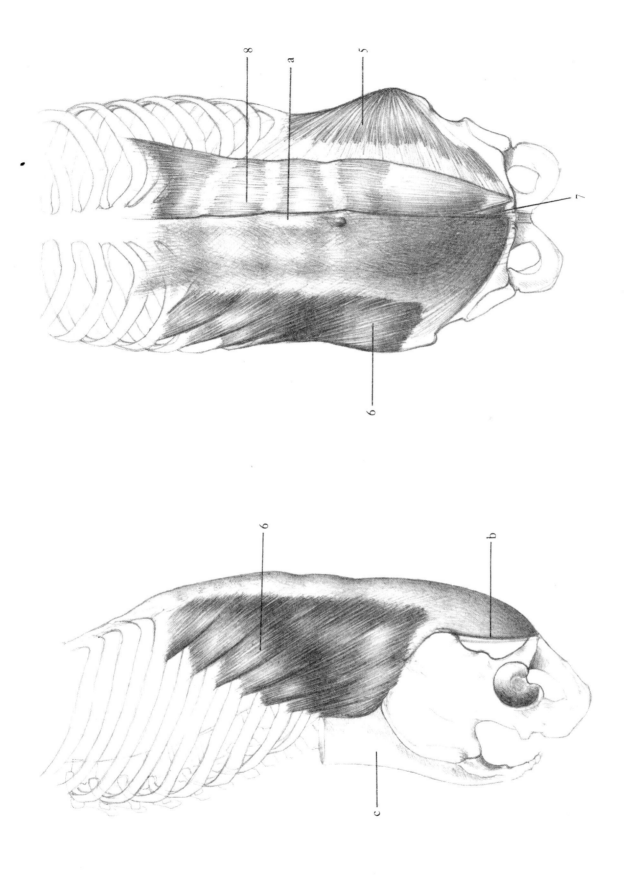

MUSCLES OF THE BACK

Deep Layer

Sacrospinalis

It passes from below upwards over the entire length of the back. It starts with a thick, fleshy belly from the posterior middle surface of the sacrum, the posterior section of the iliac crest, and the spinous processes of the lumbar vertebrae. At its origin, the muscle is invested by a strong fascia composed of two sheets (Plates LXXXI and LXXXII, c). Above the ribs, the muscle divides into two portions: the longissimus dorsi located nearer to the vertebral column (9), and the lateral portion termed the iliocostalis muscle (10). Although invisible, these muscles exercise a great influence on the form of the body surface. They fill the long groove between spinous processes and costal angles.

9. Longissimus dorsi (LXXXII)

While passing upwards it divides into short digitations.
Insertion: tuberosities of the ribs from two to ten, and the transverse processes of the cervical and thoracic vertebrae.
If the muscle contracts along with the iliocostalis muscle, the vertebral column is extended.

10. Iliocostalis (LXXXII)

A long, flat muscle divided into twelve digitations inserting to the angles of the ribs and the transverse processes of the fourth to seventh cervical vertebrae.

11. Deep muscles of the neck

These do not appear on the surface.

12. Spinalis muscle (LXXXII)

This does not appear on the surface.

13. Serratus posterior inferior (LXXXIII)

Origin: spinous processes of the two lower thoracic and the two upper lumbar vertebrae.
Insertion: ribs nine to twelve. The fibres pass upwards and laterally.
Function: pulling down of the ribs on expiration.

14. Serratus posterior superior (LXXXIII)

Origin: spinous processes of the lowest cervical and the upper thoracic vertebrae.
Insertion: ribs two to five. The fibres pass downwards and laterally.
Function: raising of the ribs on inspiration.

15. Levator scapulae (LXXXIV)

Origin: transverse processes of the cervical vertebrae one to four.
Insertion: medial border of scapula.
Function: steadying the scapula during movement of the arm.

16. Rhomboideus major and minor (LXXXIV)

Origin: spinous processes of the lower cervical and upper thoracic vertebrae (minor muscle above).
Insertion: the whole medial border of scapula.
Function: pulling of shoulders toward each other and upward, and steadying scapulae during movement of the arm.

17. Semispinalis capitis (LXXXIV)

Origin: transverse and spinous processes, from the third cervical down to the sixth or seventh thoracic vertebrae.
Insertion: on occipital bone, between superior and inferior nuchal lines.
Function: backward traction of head.

18. Splenius capitis (LXXXIV)

Origin: spinous processes, from third cervical to third thoracic vertebra.
Insertion: below superior nuchal line on occipital bone.
Function: backward and sideward traction of neck, rotation of head.

19. Splenius cervicis (LXXXIV)

Origin: spinous processes of third to sixth thoracic vertebrae.
Insertion: transverse processes of upper three cervical vertebrae.
Function: pulling of neck back- and sidewards, rotation of atlas along with the head.

20. Latissimus dorsi (LXXXV)

Broad and flat muscle.

Origin: six lower thoracic, all lumbar and sacral vertebrae, posterior section of iliac crest. Its bundles pass upwards and interdigitate with the corresponding fascicles of the obliquus externus muscle. Then the muscle passes round the posterior and lateral wall of the chest, and over the inferior angle of the scapula which is pressed down by the muscle.

Insertion: with a gradually narrowing but still broad and flat tendon passing in front of the teres major muscle into the bottom of the bicipital groove of the humerus, medial to the tendon of pectoralis major.

Function: traction of the raised arm downwards (a 20, b 20, c 20); drawing backward of the upper limb (a 20), medial rotation of arm. If the shoulders are fixed, the muscle raises the trunk and suspends it.

21. Trapezius muscle (LXXXVI)

Flat muscle.

Origin: external occipital protuberance and superior nuchal line of occipital bone, ligamentum nuchae, spinous process of the seventh cervical and all thoracic vertebrae.

Insertion: lateral third of clavicle, acromion, spine of the scapula. The muscle consists of three portions. The cervical portion is the strongest; its fibres run to the clavicle and the acromion (b I). The fibres originating in the vicinity of the seventh cervical vertebra run more or less horizontally (b II), those starting from the thoracic vertebrae, obliquely upwards to the spine of the scapula (b III).

Function: backward traction of shoulder girdle with fixed head and trunk (d 21/II). The cervical portion raises the shoulder (c 21/I), while the part marked (b III) in the plate pulls the scapula downwards (a 21/III). A co-operation of all three parts draws the scapulae towards the vertebral column (d 21/II) and steadies the scapula during movement of the arm.

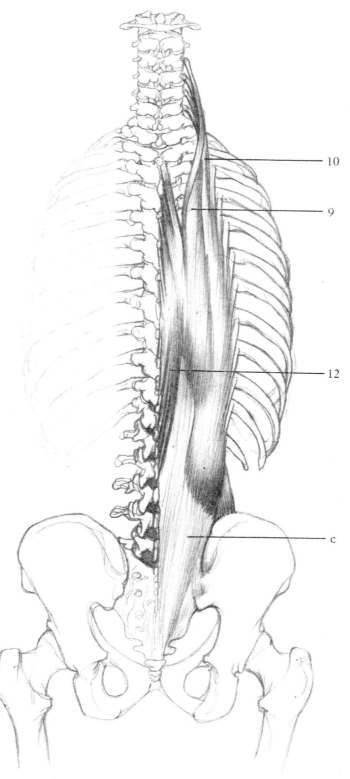

10

9

12

c

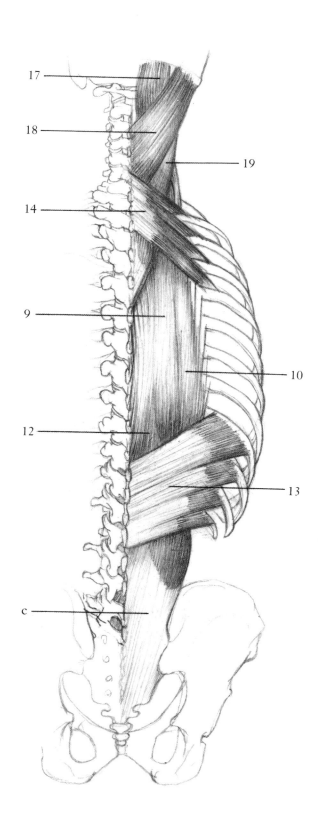

17

18

19

14

9

10

12

13

c

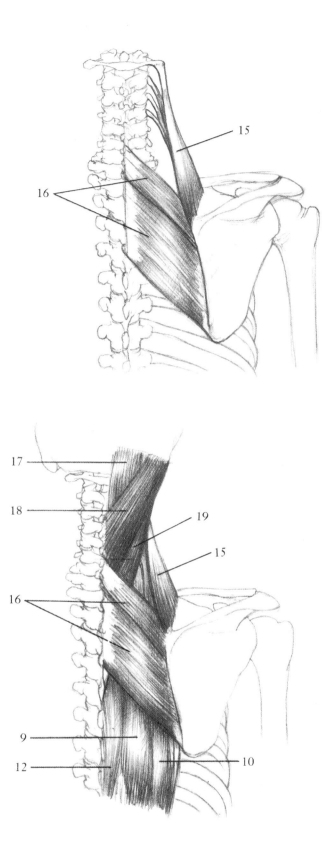

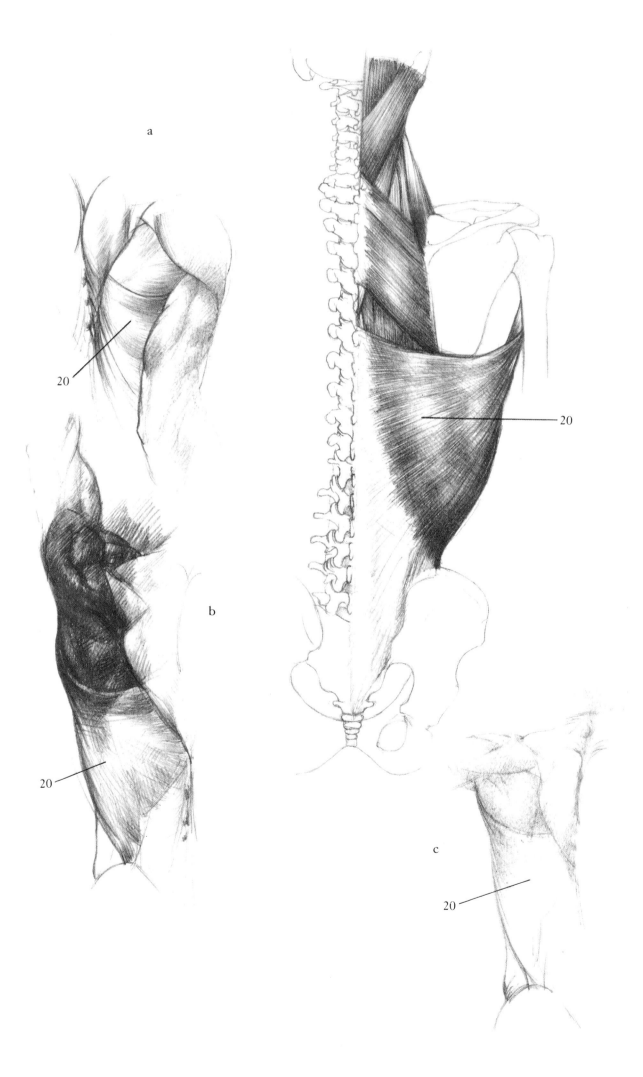

a

20

b

20

20

c

20

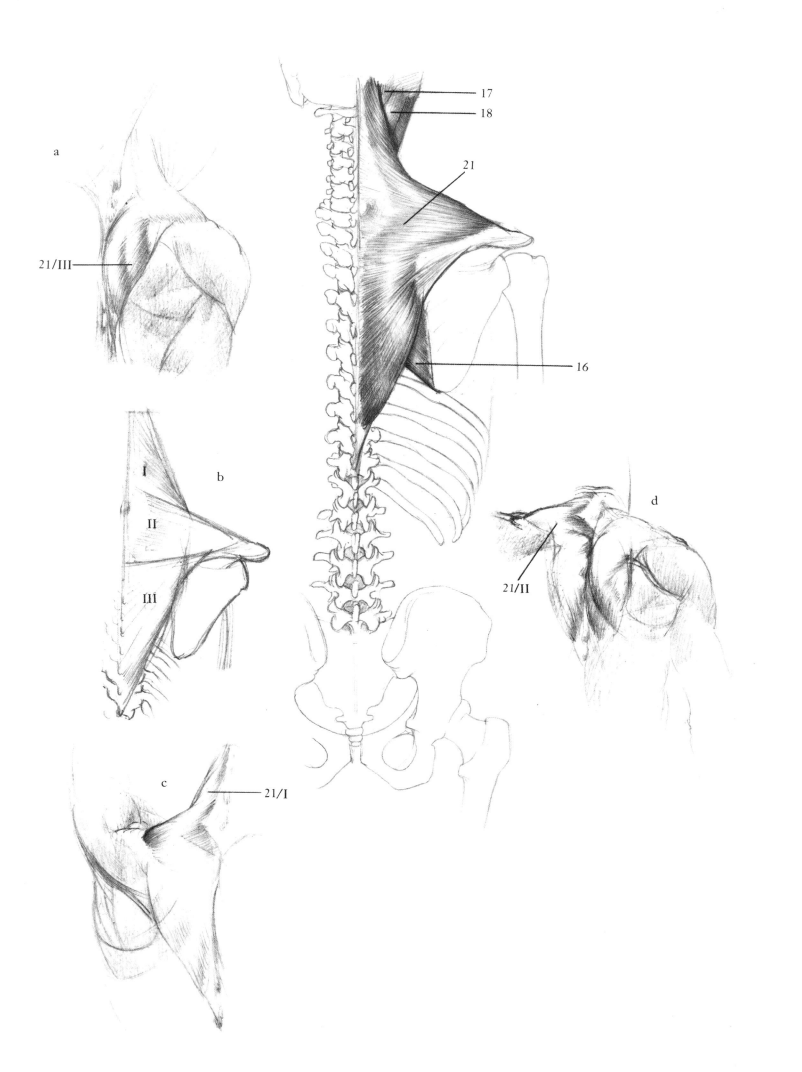

MUSCULAR SYSTEM OF THE TRUNK

LXXXVII—LXXXIX

The figures in these three plates exhibit the muscle system of the trunk as a unit. The muscles are shown from the front, the back and the side. The identifying numbers are identical with those in the previous plates.

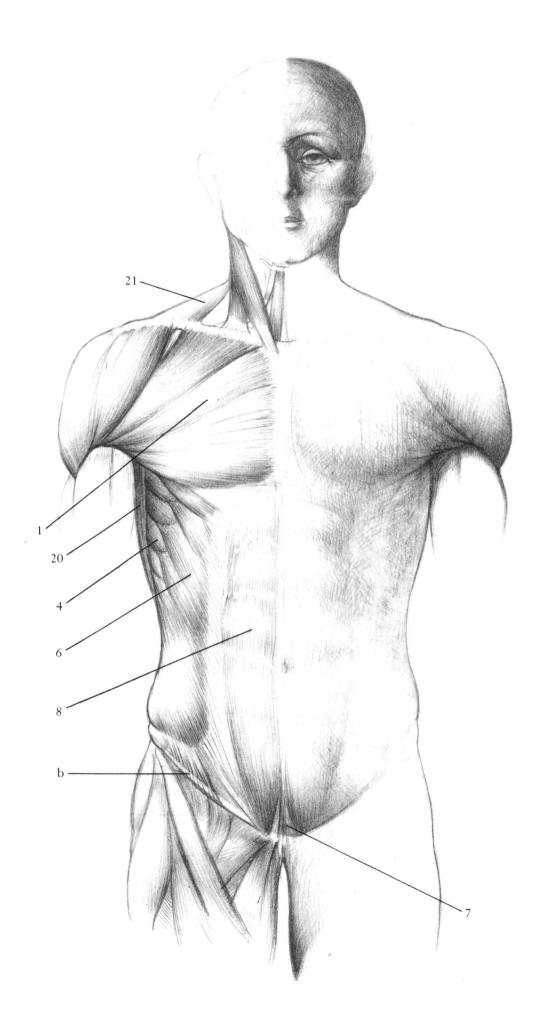

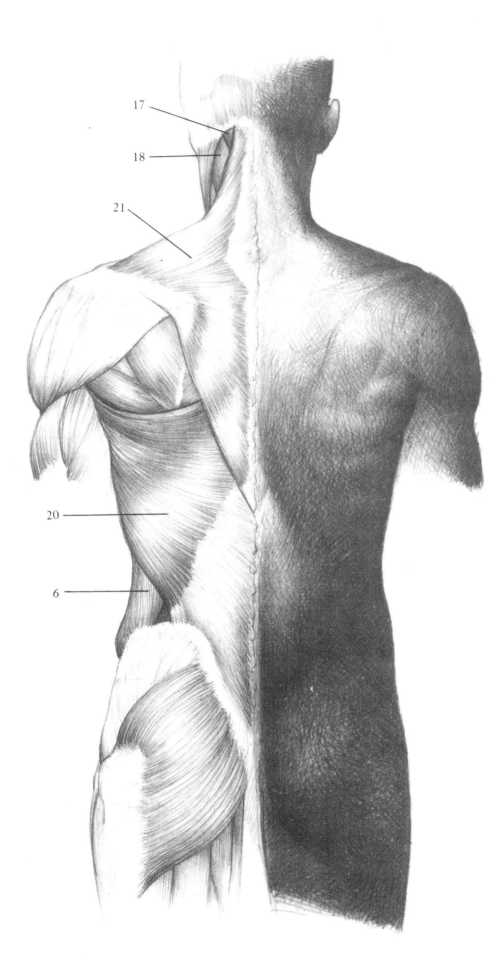

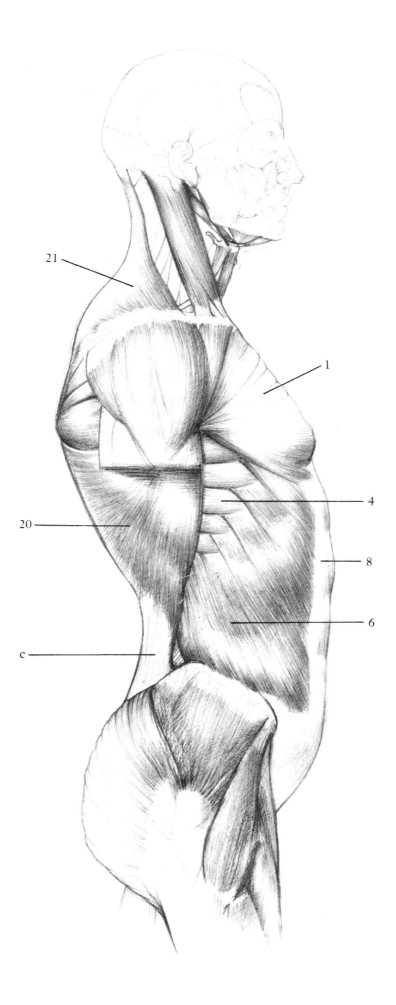

21

1

4

20

8

6

c

THE TRUNK IN MOVEMENT

XC—XCVI

According to their different functions, the muscles of the trunk differ in their shape from the muscles described above. The greatest work is performed by the muscles connecting trunk and arms. These facts are shown by the plates.

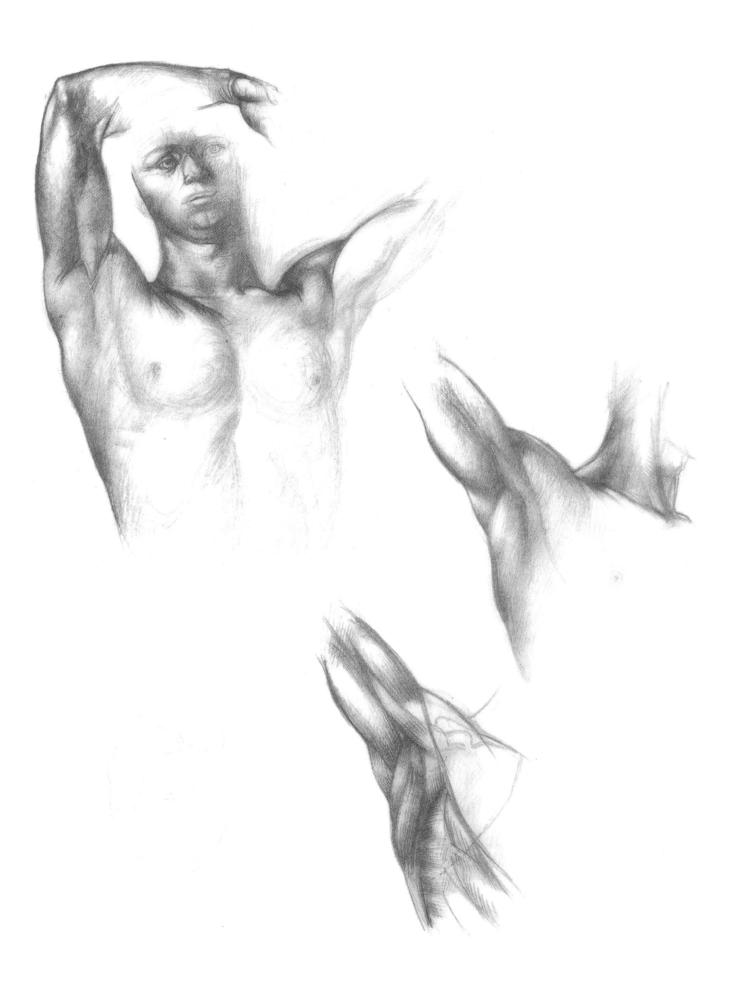

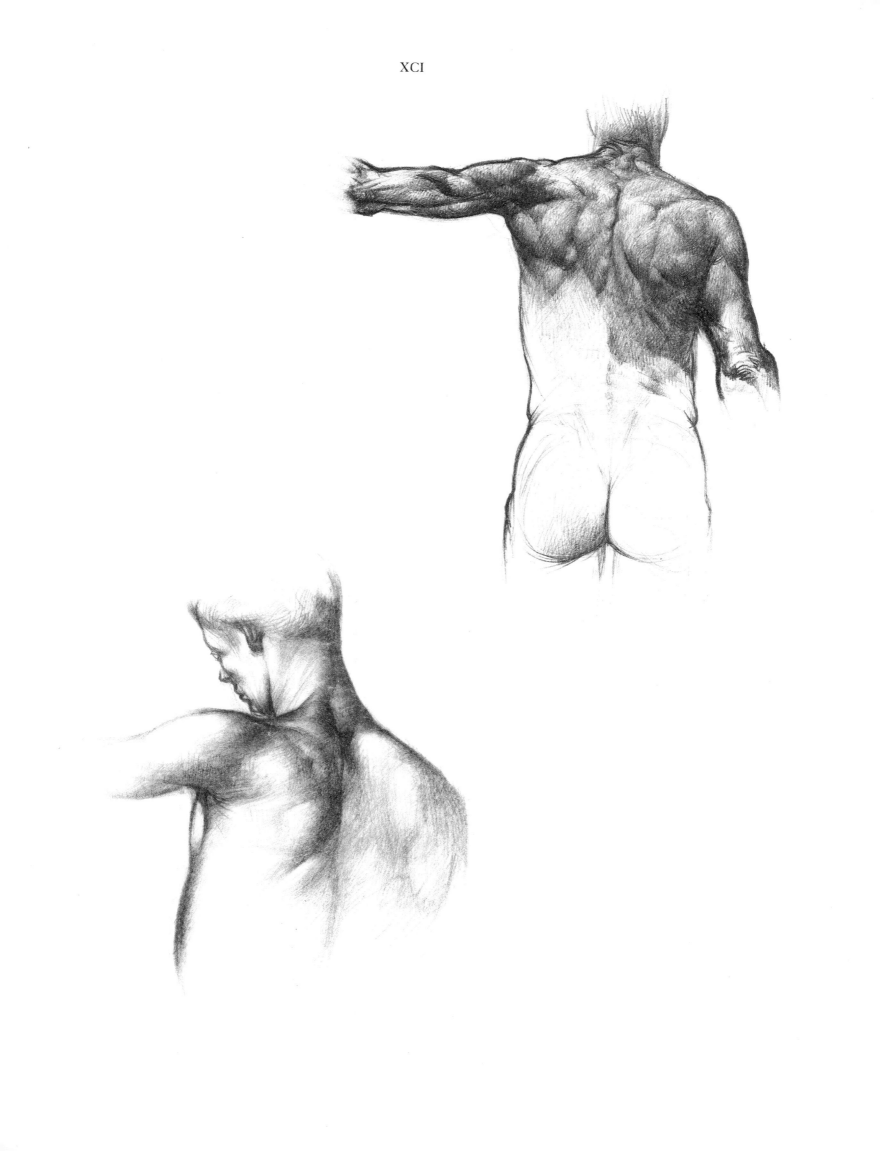

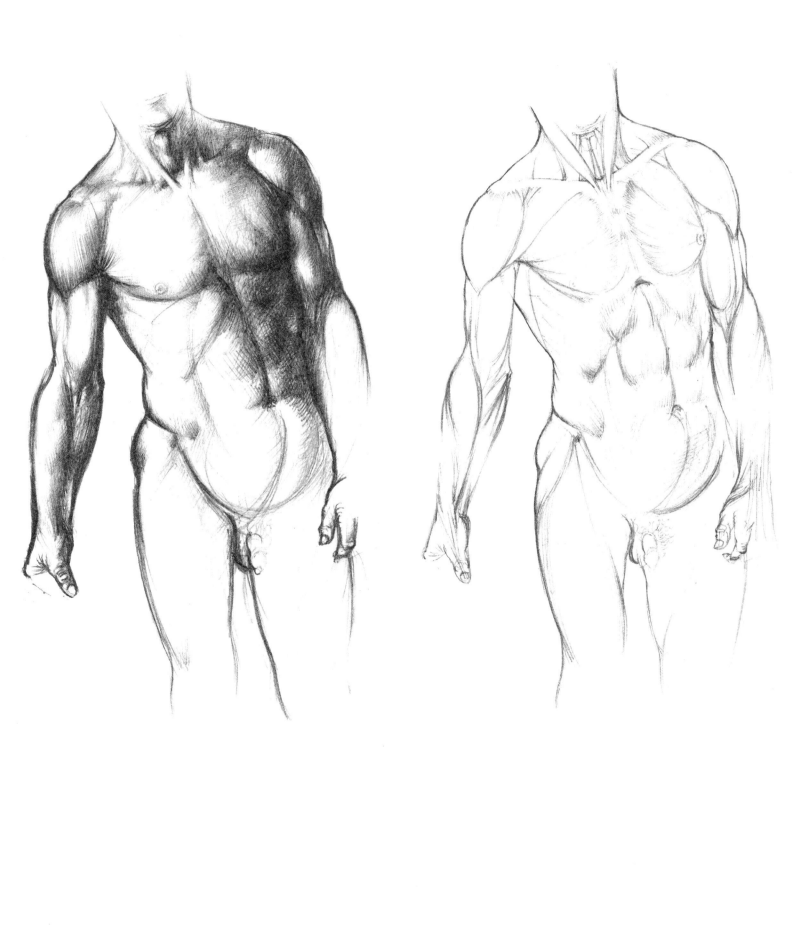

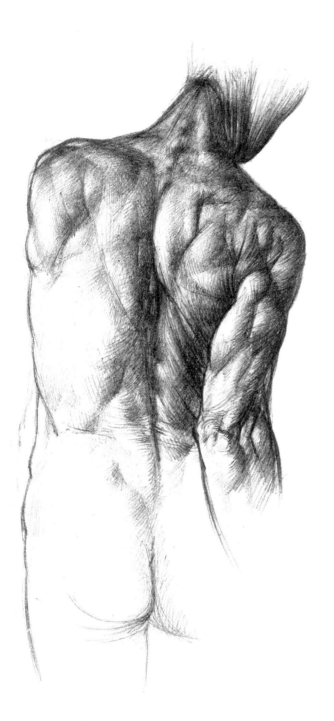

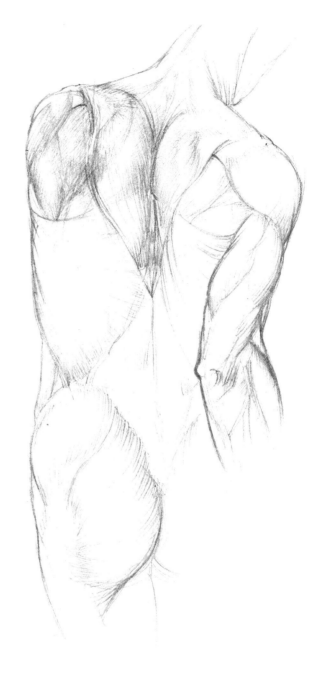

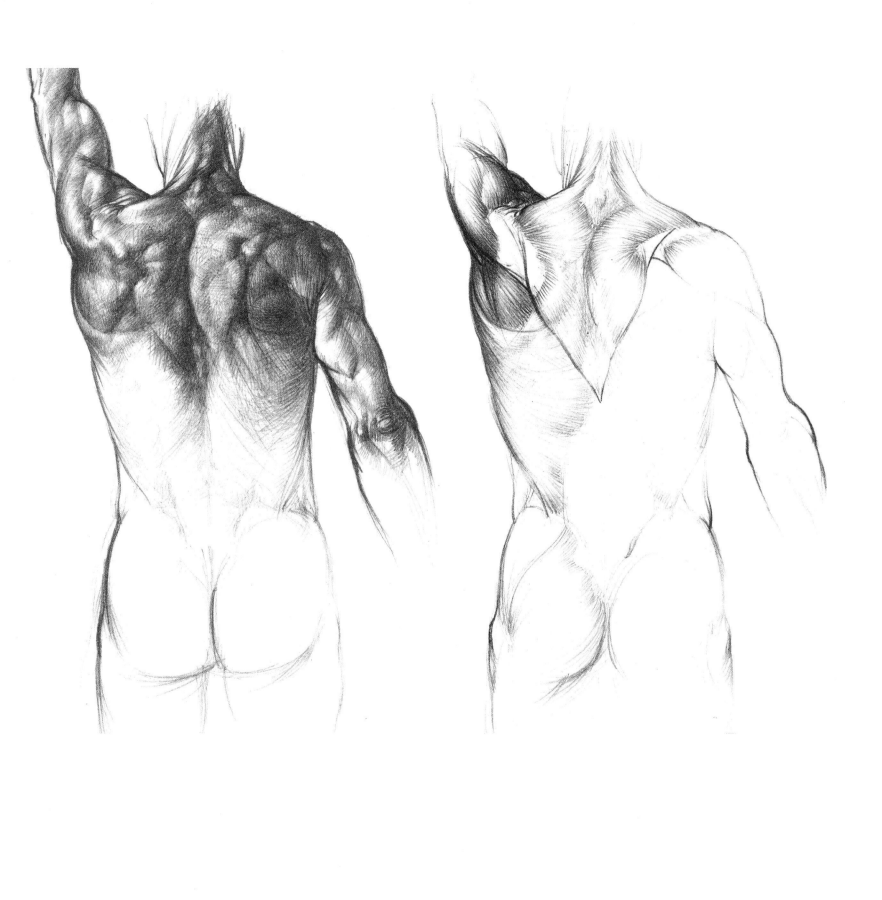

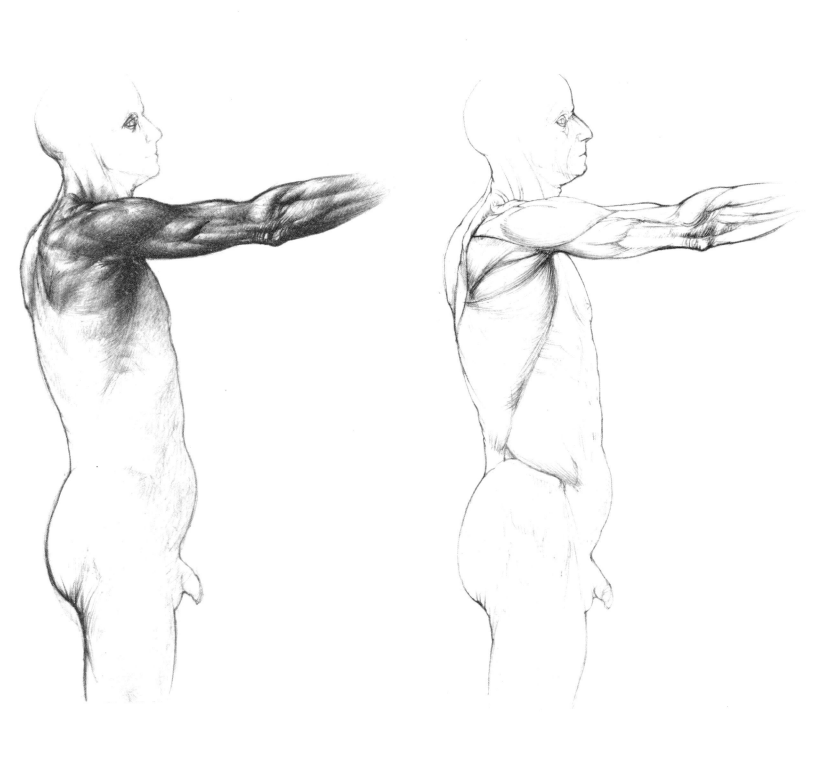

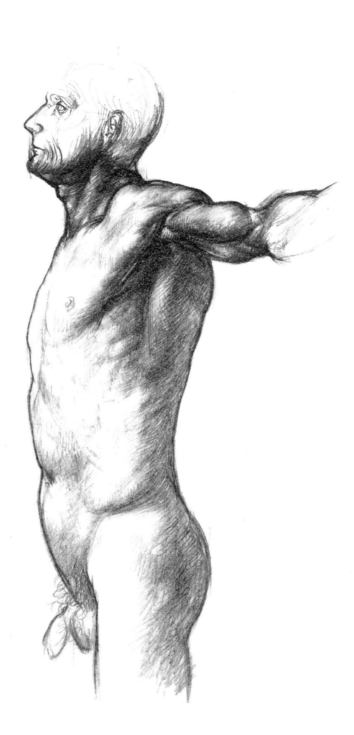

MUSCLES OF THE NECK
(CERVICAL MUSCLES)

XCVII—XCVIII

The neck is like a cylinder slightly compressed in the sagittal diameter. From the front, a characteristic V-shaped groove, the suprasternal notch (Plate XCIX), is seen. The sternomastoid muscles passing from behind the ears (Plate XCVIII, A 8) to the manubrium constitute a characteristic feature of the anterior surface of the neck. Above the clavicle, there is a triangular excavation termed supraclavicular fossa (Plate XCVIII). On the posterior aspect the nuchal furrow is seen in the middle region, the depth of which gradually ceases at the spinous processes of the sixth and seventh cervical vertebra (Plate XCIX).

In the superior anterior region of the neck the hyoid bone is found (Plate XCVIII, A 9). Having no contact with any other bone, it is held in position by muscles only. Below the hyoid bone, the thyroid cartilage (Plate XCVIII, B 10) is seen. This is connected with the cricoid cartilage, the latter with the trachea (windpipe).

A) SUPRAHYOID MUSCLES

1. Digastric muscle (Plate XCVII, A)

> Origin: the posterior belly in the mastoid fossa of the temporal bone, the anterior belly from a depression on the inner side on the lower border of the mandible. The two bellies end in an intermediate tendon which is held by a fibrous loop to the hyoid bone.
>
> Function: contraction of both bellies results in elevating hyoid bone and larynx.

2. Stylohyoid (Plate XCVII, B)

> Origin: styloid process of temporal bone.
> Insertion: body and greater horn of hyoid bone.
> Function: pulling of hyoid bone up- and backwards.

236

3 . Mylohyoid (Plate XCVII, A)

Thin, flat, triangular muscle situated in the second layer.
Origin: oblique line on inner surface of the mandible.
Insertion: body of hyoid bone and the median raphe between the two muscles.
Function: up- and forward traction of hyoid bone.

B) INFRAHYOID MUSCLES

4 . Sternohyoid (Plate XCVIII, A)

Origin: manubrium, posterior aspect of clavicle.
Insertion: body of hyoid bone.
Function: on deglutition, downward pulling of hyoid bone and larynx.

5 . Sternothyroid (Plate XCVII, A)

Origin: manubrium, posterior aspect of first rib.
Insertion: thyroid cartilage.
Function: downward pulling of hyoid bone and larynx.

6 . Thyrohyoid (Plate XCVII, A)

Origin: at the insertion of the former muscle.
Insertion: body and great horn of hyoid bone.
Function: if the larynx is fixed by the sternothyroid, this muscle will pull the hyoid bone downwards. If the hyoid bone is fixed by the suprahyoid muscles, the thyrohyoid elevates the larynx.

7 . Omohyoid (Plate XCVII, A)

Origin: lower and outer border of hyoid bone. While passing downwards, it changes its direction and turns laterally. At this place it is covered by the sternomastoid muscle.
Insertion: notch on the upper border of scapula.
Function: downward traction of hyoid bone.

8. Sternomastoid (Plate XCVIII, A)

Origin: with two heads separated by a triangular groove. The anterior, thinner head starts from the manubrium, the lateral, flat head from the sternal end of the clavicle. After union the bundles run obliquely up- and backwards.
Insertion: mastoid process and joining section of superior nuchal line on occipital bone.
Function: contraction of both flexes the head. Forward flexion of the head cannot take place before the face has been lowered to such a degree that the insertion of the muscle lies in front of the joint. Unilateral contraction of the muscle turns the head to the opposite side (Plate CII).

Platysma (Plate CVIII, d)

Flat, thin muscle under the skin of the neck and adhering to it.
Origin: fascia below the clavicle.
Insertion: it radiates into the skin and muscles of the face.
Function: tension of the skin of the neck whereby the normal position and tension of the skin is guaranteed.

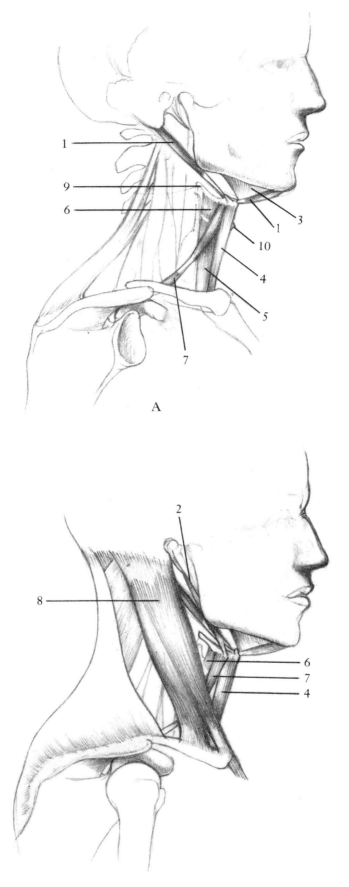

A

B

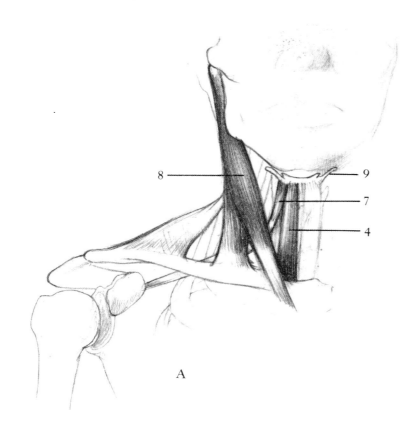

8 ——— 9

——— 7

——— 4

A

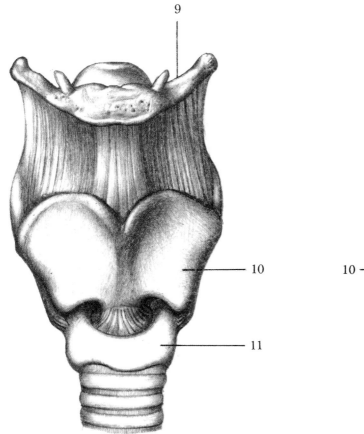
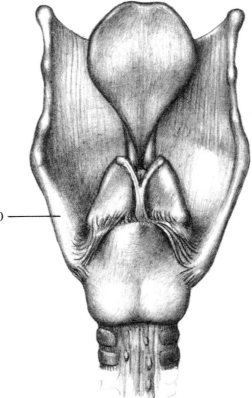

9

10 ——— 10

11

B

THE NECK IN MOVEMENT

XCIX—CII

These plates exhibit the moving neck. In Plates XCIX, C and CI the cervical muscles are covered by skin. In Plate CII the chief motors are seen during action.

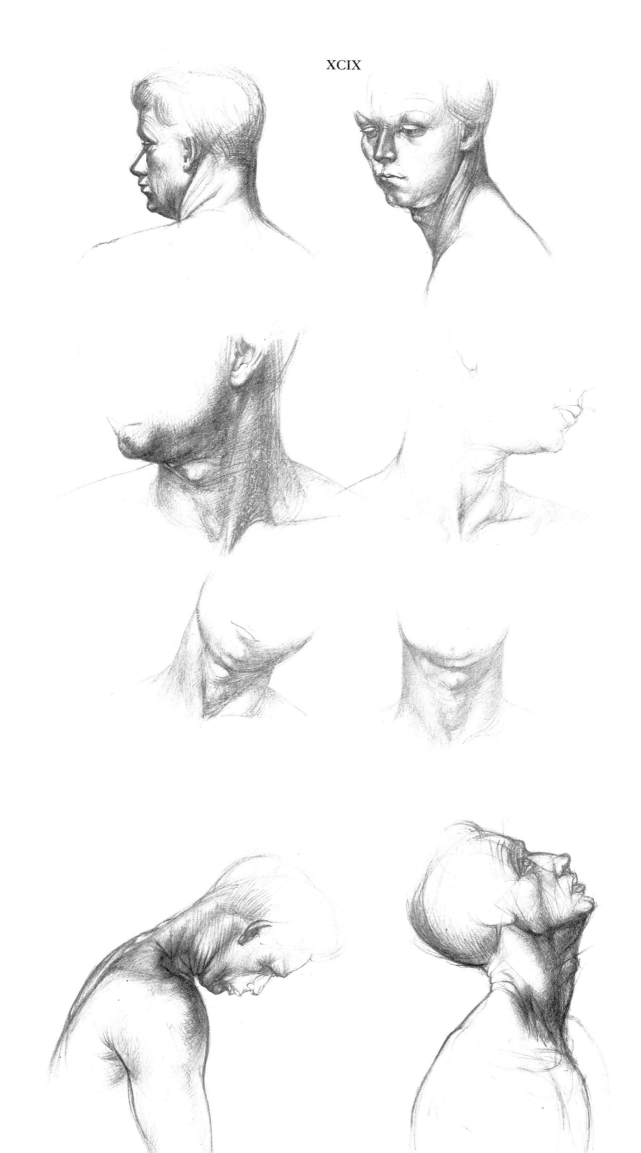

C

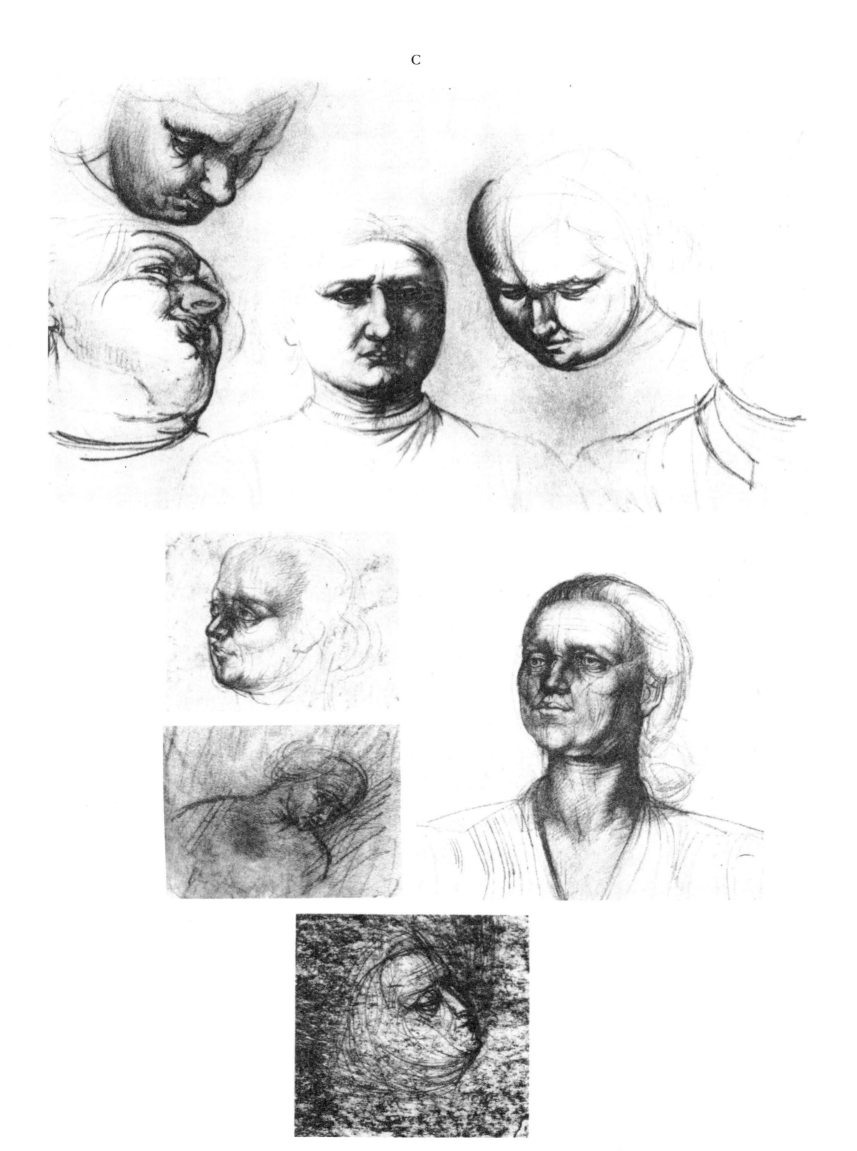

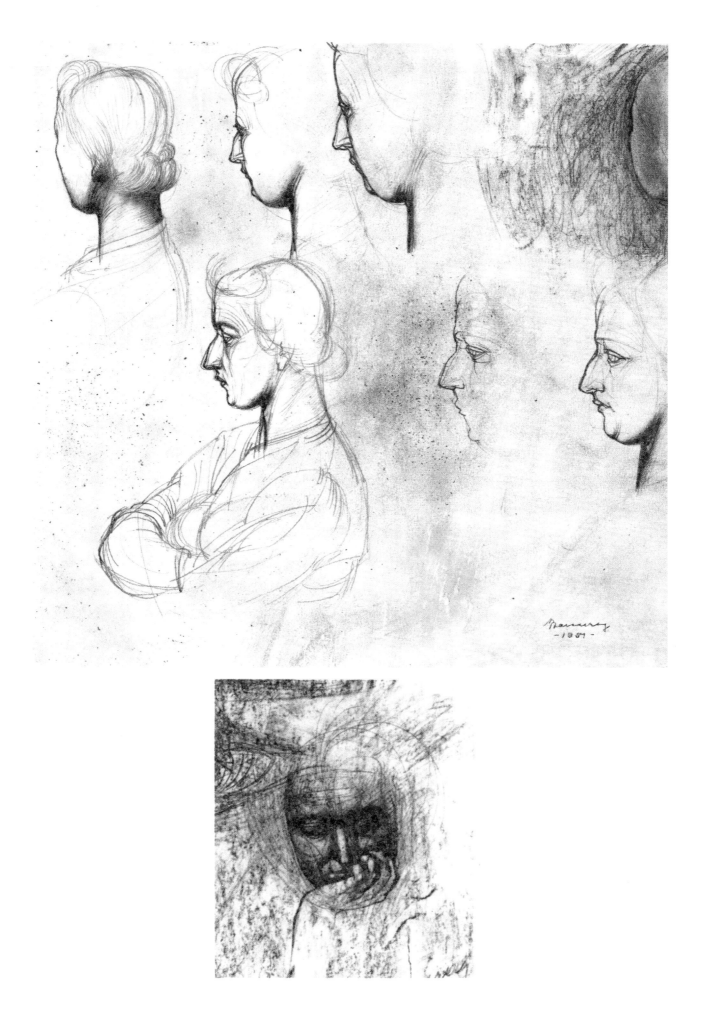

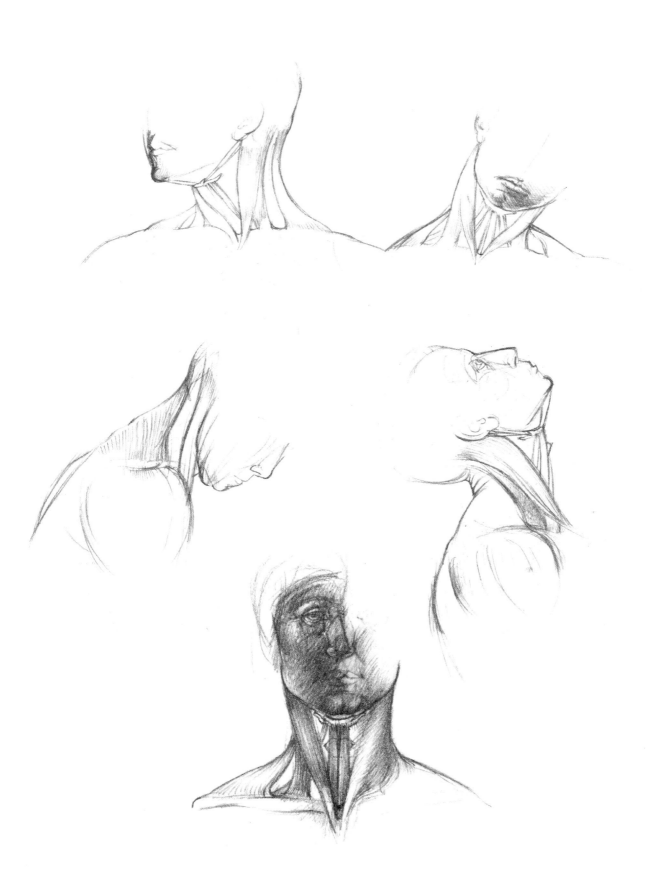

THE BONES OF THE SKULL

CIII—CIV

The bones of the skull are divided into two groups, one of them forming the calvaria, the other the face.

The former, serving the protection of the brain, is composed of several parts. In front, it is linked to the bones of the face serving the protection of the sense organs (for instance, the bones constituting the orbit).

As seen from above, front, or side, the skull is oval-shaped. From behind it is more spherical.

The skull consists of bones which, except the mandible, cannot be moved. Below, only the bones characteristic of the form of the head will be treated.

A) BONES OF THE CALVARIA

1. Frontal

It has a frontal, nasal and orbital part. On the surface, there are two frontal eminences (Plate CIII, anterior aspect, 1a) and two superciliary (eyebrow) arches (anterior aspect, 1b). The eyebrow arches have an oblique axis running to the root of the nose. From the point of view of form and structure, attention should be called to the initial part of the temporal line (anterior aspect, 1c) which continues on the parietal bones. A true suture unites the lateral margins with the sphenoid bone, and the posterior margin with the parietal bones (lateral aspect, 9).

2. Parietal

Quadrangular bones constituting the upper and lateral part of the calvaria. On their surface, the continuation of the temporal line is seen. Their anterior border joins the frontal bone along the coronal suture (Plate CIV, superior aspect, 9). Their medial (upper) margin joins the contralateral bone along the sagittal suture (superior aspect, 10). Behind, the two parietal bones join the occipital bone along the lambdoid suture (posterior aspect, 11).

3. Occipital

A shell-shaped bone, consisting of four parts: the squamous, basilar, and two condylar parts. On the squamous part the external occipital protuberance is situated (Plate CIV, 3a). From this start the highest, and below it, the superior (3b), nuchal lines running laterally, and the external occipital crest, running towards the foramen magnum; from the crest the inferior nuchal lines (3c) run laterally.

Where the four parts meet, the foramen magnum, the exit to the spinal canal, in seen (inferior aspect, 3d). On each side of the foramen magnum, there is an articular condyle (inferior aspect, 3e) for the corresponding articular of the atlas.

Sphenoid

Its name is due to its wedged-in situation, the bone being in contact with several bones of the skull. As only a small part of the bone appears on the surface, it is, from the point of view of form, unimportant.

4. Temporal

This bone of most intricate structure harbours the acoustic organ and the organ of equilibrium. It is in contact with the parietal, and on the base of the skull, with the occipital bone. The squamous part is located above the external auditory meatus (Plate CIII, lateral aspect, 4c). On its lower surface there is an articular groove for the mandible (Plate CIV, inferior aspect, 4e). The zygomatic process runs forward from the squamous part to join the zygomatic bone, forming the zygomatic arch. Between this arch and the temporal line (1c) lies the temporal fossa. On the lateral side of the mastoid part, the downward projecting mastoid process (Plate CIII, lateral aspect, 4b), and in front of the latter the styloid process, are seen (Plate CIII, lateral aspect, 4d).

B) BONES OF THE FACE

5. Maxilla (upper jaw)

Its upper part participates in the constitution of the nasal cavity, the inferior wall of the orbit, and the palate. From the body of the bone four processes start: frontal, zygomatic, palatal and alveolar. The last provides sixteen sockets for the teeth. The two maxillas unite in the mid-line by a suture.

251

6. Zygomatic (cheek-bone)

This is a symmetrical bone with three surfaces and three processes. It connects the frontal and temporal bone, and the maxilla. The characteristic lateral eminence of the face is due to this bone.

7. Nasal

Small, longish, quadrilateral bone united in the mid-line with the opposite one. It unites above with the frontal and ethmoid bones, below with the temporal process of the maxilla.

8. Mandible (lower jaw)

The only movable bone of the skull. It has a body and two rami. From below it is horseshoe-shaped. As in the maxilla, there are sixteen alveoli in the mandible for the teeth.

The mental tubercles (Plate CIII, 8e) and the angle of mandible (Plate CIII, 8d) are prominent parts of the body. Both rami have an anterior (coronoid) process (Plate CIII, 8b) and a posterior articular process (head) (Plate CIII, 8a). The cartilaginous end of the latter fits into the articular groove of the temporal bone (Plate CIV, inferior aspect, 4e). Between the two processes there is a semilunar notch (Plate CIII, 8c). The palatal, lacrymal, ethmoid and turbinate bones, being invisible on the surface, have no influence on the forms.

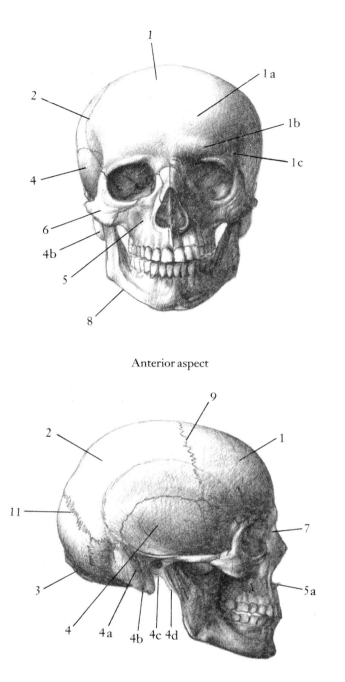

Anterior aspect

Lateral aspect

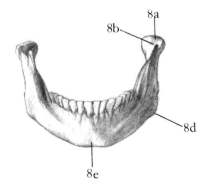

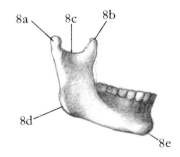

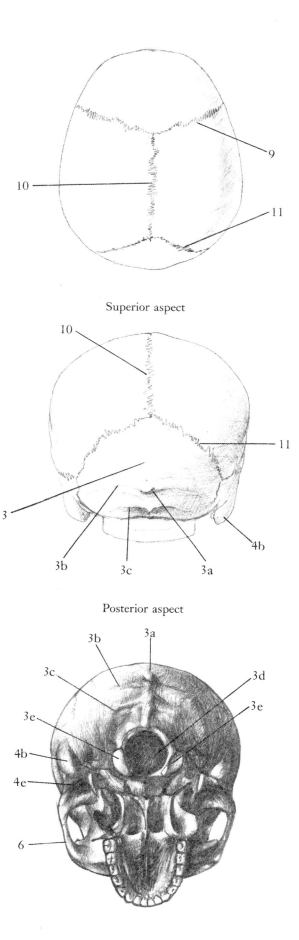

Superior aspect

Posterior aspect

Inferior aspect

CONNECTIONS AND MOVEMENTS OF THE SKULL BONES

CV

Apart from the joint of the mandible, all bones of the skull form a single mass.

THE TEMPORO-MANDIBULAR JOINT

It is formed by the articular process of the lower jaw (B, a), and the articular groove of the temporal bone (B, b). It is a limited free joint allowing movements round a transverse and a vertical axis: opening and closing, pushing and pulling, and lateral movements (B). Some of these movements are shown in Plate CV, A.

CV

A

B

THE FACIAL ANGLE

CVI

The size of this angle depends on the type to which a person belongs. There are also individual differences, so the angle should always be accurately observed. Determination of the angle is simple: if a tangent is laid to the most prominent points of the forehead and the upper jaw, and a straight line is drawn in the direction of the nasal spine and the outer auditory meatus, various acute angles, or occasionally a right angle (a—b), will arise. By means of proper skill and practice, this angle can also be observed on living persons.

(The facial angle has been described by Camper.)

ARTICULATIONS AND MOVEMENTS
OF THE SPINAL COLUMN AND THE SKULL

CVII

The articulation between the skull and the atlas, and that between the atlas and the second cervical vertebra (axis), are different from the other intervertebral joints. The mobility of the head is due to these peculiar joints.

The movements are determined by the different form and articular surfaces of atlas and axis. There are two joints in this section: the atlanto-occipital (8, A) and the atlanto-axial (8, B) joints. The upper is formed by the occipital bone and the atlas, the lower by atlas and axis.

The upper is a hinge-joint. The axes of the two joints run forwards and medially. Round them the head is bowed or raised, as seen in figures 1, 2, 7.

The rotating joint between atlas and axis (8, C) is constituted by the odontoid process of the axis and the anterior arch of the atlas. In this joint, rotations to both sides are carried out (5). The head rotates round an almost vertical axis—i.e., the axis of the odontoid process (8, C). The rotation of the atlas is closely followed by the head. The movements can be completed by those of the cervical vertebral column.

Figs. 1—6 of this plate demonstrate different movements of the vertebral column and the skull.

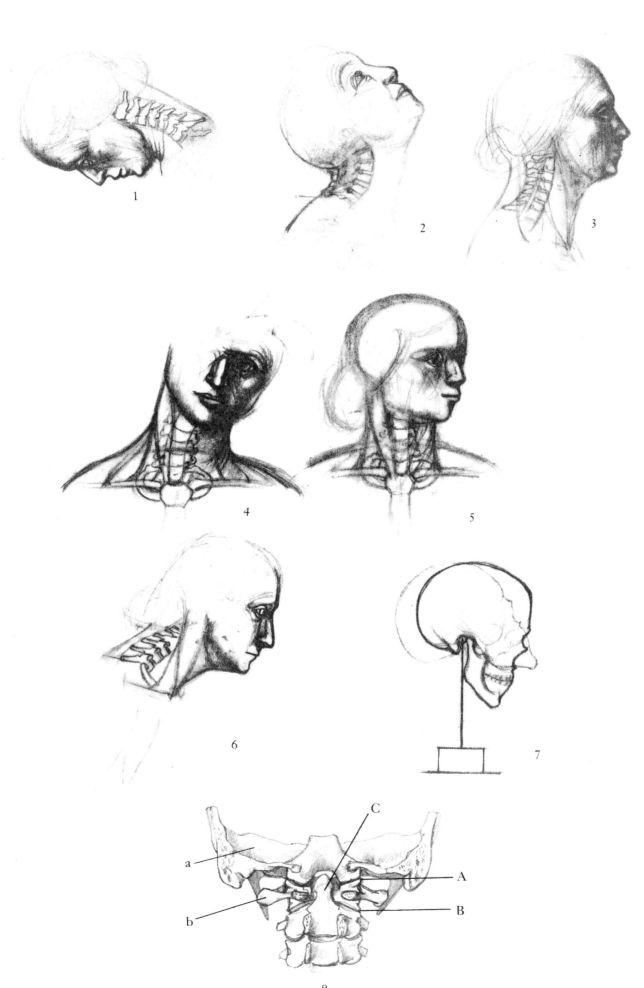

1

2

3

4

5

6

7

C

a

A

b

B

8

MUSCLES OF THE HEAD

CVIII

They are divided into three groups: muscles of the scalp, face, and mastication. The muscles of the face frequently act as closing muscles (sphincters). Generally, the fibres of neighbouring muscles are interlacing.

A) MUSCLES OF THE SCALP

1. Occipitalis

> Origin: lateral half of highest nuchal line, down to the base of the mastoid process. The fibres pass upwards and insert to the galea, the thick aponeurosis (membrane-like tendon) covering the calvaria like a cap. The galea moves on the skull along with the adhering skin.
> Function: backward traction of galea and skin.

2. Frontalis

> This is a broad, flattened muscle.
> Origin: in muscles superior to the eye. The fibres cover the frontal eminences, and radiate into the galea.
> Function: it moves galea and skin.

B) FACIAL MUSCLES

3. Orbicularis oculi

> Originating from the bones and a ligament at the medial angle of the eye, its fibres occupy both eyelids and surround the orbit, to interlock at the lateral angle of the eye.
> Function: closing the eyes.

4. Corrugator

Originates on the nasal part of frontal bone and inserts, after passing outwards, to the medial end of the eyebrow.
Function: it approximates the two eyebrows to each other.

5. Compressor nasi

Flat triangular muscle originating from the alveolar process of the maxilla. It is almost completely covered by the quadratus labii superioris.
It is attached partly to the anterior edge of the nasal septum, and intermingles to some extent with its partner.
Function: narrowing of nostrils, downward traction of nose.

6. Orbicularis oris

It encircles the mouth.
The muscle originates on the maxilla and mandible, near the mid-line, on the eminences due to the incisor and canine teeth, but many fibres are derived from the buccinator and other adjacent muscles. Its fibres surround the oral aperture.
Function: closing of mouth and pursing of lips.

7. Quadratus labii superioris

Flat, quadrangular muscle.
It originates with three heads from the frontal process of the maxilla, the lower margin of the orbit, and the zygomatic bone.
Insertion of the united heads: on the upper lip and nose.
Function: raises upper lip.

8. Levator anguli oris

Origin: maxilla.
Insertion: angle of mouth, orbicularis oris muscle.
Function: raises angle of mouth.

9. Zygomaticus major

Origin: outer surface of temporal process of zygomatic bone.
Insertion: angle of mouth.
Function: energetic upward traction of angle of mouth.

10. Risorius

Origin: on the fascia of the masseter muscle.
Insertion: angle of mouth.
Function: lateral pulling of angle of mouth.

11. Depressor anguli oris

Origin: lower margin of mandible.
Insertion: angle of mouth.
Function: downward traction of angle of mouth.

12. Depressor labii inferioris

Origin: base of mandible. The fibres pass to the mid-line.
Insertion: angle of mouth, lower lip.
Function: energetic downward pulling of lower lip.

13. Mentalis

Short muscle originating below each of the incisor teeth of the mandible. The fibres originating from the two sides turn towards each other.
Function: moving of the skin of the chin.

14. Buccinator

Origin: alveolar processes of jaws and a ligament extending from the mandible to the sphenoid bone. The fibres run to the angle of the mouth and interlace with those of the orbicularis oris muscle.
Function: lateral traction of angle of mouth, evacuation of fluid or air from between teeth and cheeks.

C) MUSCLES OF MASTICATION

15. Masseter

Short, thick muscle consisting of two layers, the fibres of which cross each other.
Origin: lower edge of anterior and middle portion of zygomatic arch.
Insertion: coronoid process, ramus, and angle of mandible.
Function: upward traction of lower jaw, energetic closing of mouth.

16. Temporalis

Origin: temporal fossa.

Insertion: with converging tendinous bundles passing below the zygomatic arch, the muscle inserts to the coronoid process of the mandible.

Function: similar to that of the preceding muscle. The other, deep-seated, muscles of mastication will not be described.

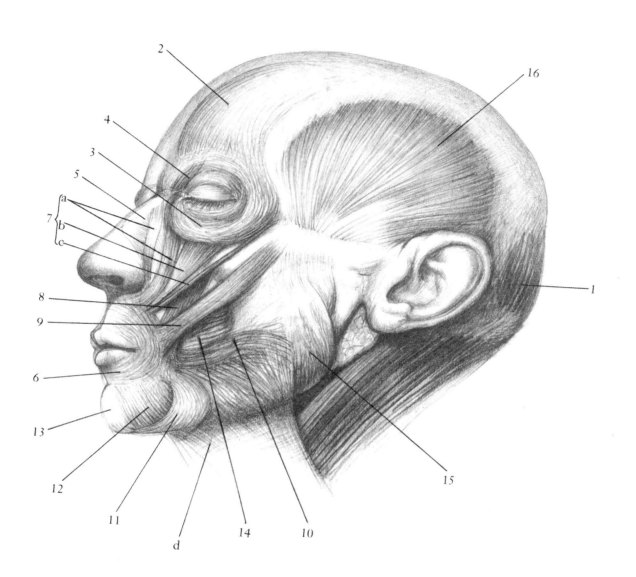

EYE, MOUTH, NOSE AND EAR

CIX

EYE (A and B)

The organ of sight is the eye-ball. On its anterior surface, the cornea (B 1) protrudes more than the eye-ball covered by the white sclera. The colour of the eye is produced by the iris (B 2) located behind the transparent cornea.

In the centre of the iris, the pupil, reacting to light by constriction, is seen as a black opening. Light passes through the pupil to the retina, the inner coat of the posterior half of the eye-ball.

The eye-ball is located in the orbit nearer to its nasal wall.

The eye is protected by the orbit, a pyramidal bony compartment. On its upper edge the edge of the eyebrow is seen, the hairs of which are directed laterally.

The eye-lid (A 1) is a strong, shell-like cartilaginous cover. Of the angles of the eye, the medial one is deeper situated. Here, a small flesh-coloured prominence is seen. The hairs (A 2) termed eye-lashes grow from the anterior edge of the lid. They form two or three rows directed, if seen from above, towards the centre of the eye-ball. The hairs are longer in the middle than at the ends of the lid. When the eye is closed, the borderline of the upper eye-lashes forms an arch convexing downward. The lateral end of the arch, corresponding to the lateral angle of the eye, lies in closed position considerably lower. These conditions are represented by the axes a and b.

MOUTH (C)

The form of the mouth is mainly determined by the lips. The lips are, by their inner border, attached to the anterior surface of the dental alveoli. Their red, thick outer borders surround the opening of the mouth and meet at a slightly deeper point, the angle of the mouth. The upper lip is longer and more projecting than the lower one. Below the nasal septum a groove, the filtrum, is seen. Below the latter there is a central part of the upper lip (C 1) intervening between the two lateral portions.

NOSE (D)

The upper angle of the nose is called the root, the face angle is the apex. The lateral surfaces end below as the alae nasi. Starting from the root, the breadth of the nose increases. The tip is sometimes double, due to the bilateral alar cartilages (D 3). Above the alar cartilages the lateral walls consist of triangular cartilages (D 2) attached to the nasal bone (D 1).

EAR (E)

The external ear (auricle) is situated at the level of the zygomatic arch, at about the same distance from the chin and the top of the head. The auricle can be placed in an ellipse, the long axis of which is parallel to the back of the nose. In its centre the concha (E 8) and the intertragic notch (E 6), located between the anterior part and the lobule (E 5), are seen. The parts of the auricle are shown in figure E:

1. helix,
2. scaphoid fossa,
3. antihelix,
4. antitragus,
5. lobule,
6. intertragic notch,
7. tragus,
8. concha,
9. two branches of antihelix, separated by the
10. triangular fossa.

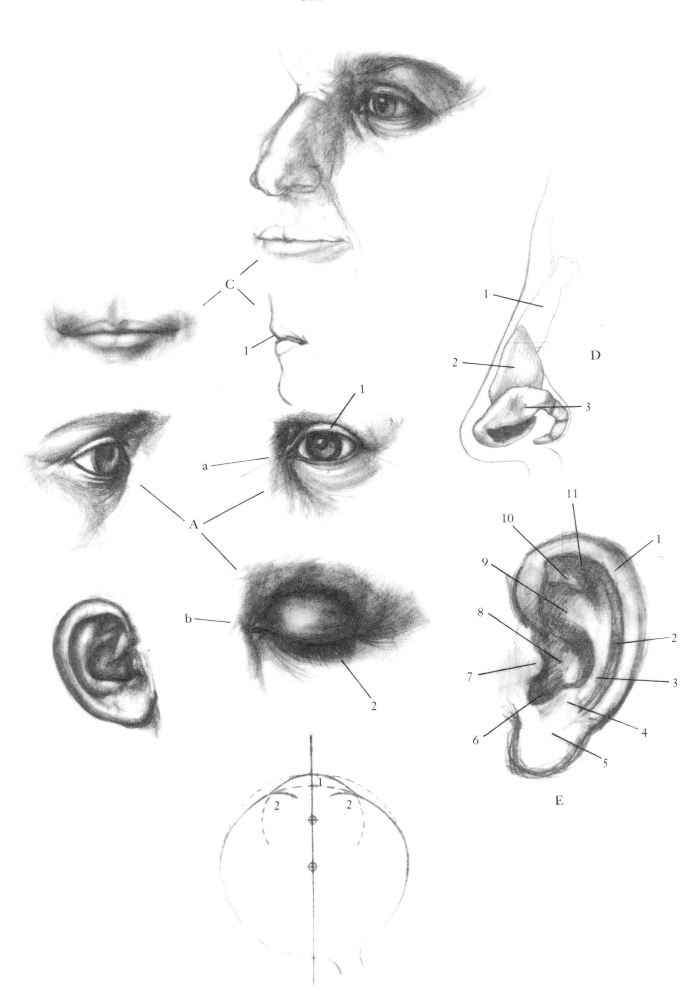

C

1

D

1

2

3

1

a

A

b

2

A

1

2

11

10

9

8

7

6

5

4

3

2

1

E

B

PROPORTION OF THE PARTS OF THE BODY

CX—CXI

On examining the proportions of the body, only average values can be taken into consideration, as these are most frequently met with. The average height of man varies according to type.

In measuring the proportions, an important problem is, which of the parts should be used as a unit. Much advantage results from employing the head or the foot, the index, the length of the vertebral column, etc., as a unit size.

Leonardo da Vinci collected numerous data to calculate the average size of the parts of human body. His method is still applicable in our age. He was the first to adopt the head as a unit of measure. He used, however, the length of the face only, instead of the length of the entire head. Albrecht Dürer started from the length of the whole head.

Numerous valuable measurements were performed by the French anatomist Richer. The statement that the body length is equal to seven and a half head lengths (Plate CX, B) is a result of Richer's research. Starting from above, the head length should be marked off four times. Then the measuring out of the fifth unit is to be commenced one half length higher, whereby the body length is determined to be, instead of eight, seven and a half times that of the head.

The measuring of the upper limb is started from the phalanges. Hand and wrist together are as long as the head. The hand itself is three-fourth of this size. The middle point of this distance should be found on the dorsal surface, above the capitulum of the third metacarpal bone.

The measurements based on the eightfold division of the body are simpler than those based on the ratio 1 : 7½. In the first case, the length of the head may be simply laid eight times end to end over the body length, as in Plate CX, A. The most important point of the eightfold measure is the fourth point designating the boundary of trunk and lower limbs. Here, at the same time, lies the middle point of the body length. The second head length ends at the nipples, the third at the navel, the fourth at the pubic symphysis, the fifth at the mid-thigh, the sixth at the lower border of the knee, the seventh at the mid-tibia, the eighth at the ground. The upper limbs reach, in erect posture, down to the mid-thigh. Similarly important are the transverse measures, which emphasize the sex differences.

From this point of view, the measurements of pelvis and shoulders should be examined in the first place. A division of the head into five small units will facilitate accurate transverse measurements. The shoulders are broadest between the prominences of the deltoid muscles; the distance between these points in men is two head lengths plus two small units, while that between the iliac crests is one head length plus two small units. The difference between the lengths of the two distances is therefore precisely one head length. The depth of the body at the highest point of the chest and pelvis is one head length plus one small unit. The pelvis in females is larger and broader than that in males; this is a conspicuous difference between the two sexes, as, apart from this, all other measurements in females—including the height of the body—are smaller than those in males.

272

Applying the aforesaid five small units, then—in given cases—we may determine exactly the transverse measurements, too, as we did for males.

Though the musculature of children is, on the whole, similar to that of adults, their bodies—being 'padded'—have a different appearance, while their proportions are vastly different from those of adults.

The height of newborn children is slightly more than four times the length of the head; Dürer adopted a proportion of one to four. The relative size of the head of children is greatly different from that of adults. Compared to other parts of the body, the head of newborn children is rather large, so much so that its length nearly equals the biacromial distance (Plate CXI, A). The neck is so short that the head almost rests on the shoulders. The shortness of the lower limbs is a further characteristic feature of babies. While the mid-height of adults is in the neighbourhood of the pubic symphysis, it is at about the level of the navel in the newborn child. When, with advancing age, the lower limbs become longer, the proportions of the body alter correspondingly. This is illustrated in figs. A, B, C and D of Plate CXI.

Fig. A shows a one-year-old child. The body is less than five times as long as the head, and the mid-height (m) is near the navel.

Fig. B demonstrates the proportions in a five-year-old child. Its body is slightly longer than five and a half times the length of the head. The mid-height of the boy (m) lies between the pubic bone and navel; the breadths of shoulders and pelvis are approximately equal. The extended arm is somewhat longer than the double length of the head.

Fig. C shows the body proportions in a boy of ten years. The height of the body exceeds six head lengths; its mid-height is above the pubic bone. The bi-iliac and biacromial distances are approximately equal. The length of the arm is slightly more than two and a half head lengths.

Fig. D shows a boy of fourteen years. The body height is somewhat below seven head lengths; the mid-height is near, but still above the pubic joint; the extended arm has a length of about three head lengths.

Comparisons show the body-arm proportion to be approximately equal in children and adults: when hanging, the arm reaches to the middle of the thigh. Nor is there any great difference in the relative breadths of shoulder and pelvis.

The average height of the newborn amounts to 20 in.; at 5 years man reaches a height of 43 in., and attains the average body length of 67½ in. at the age of 21 years.

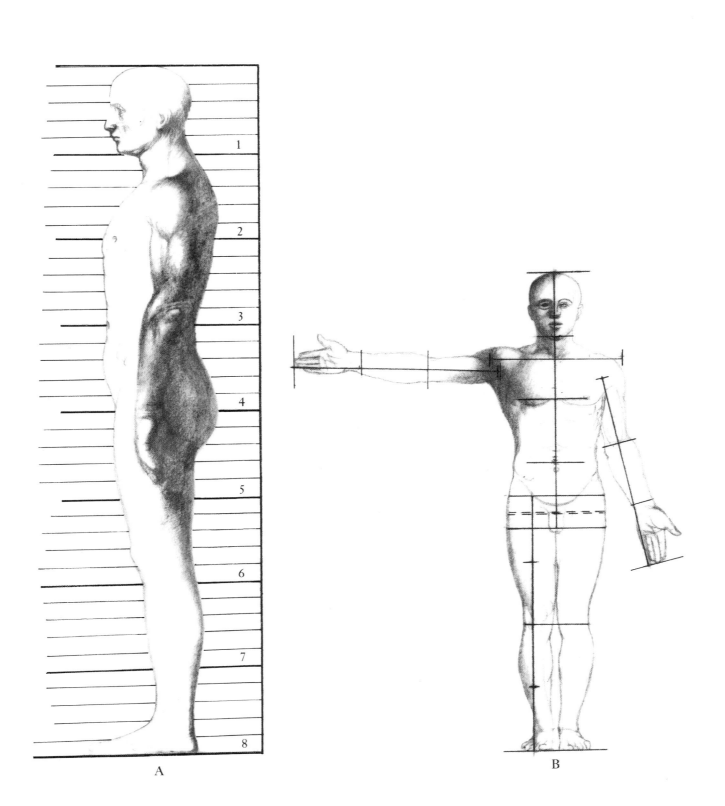

A

B

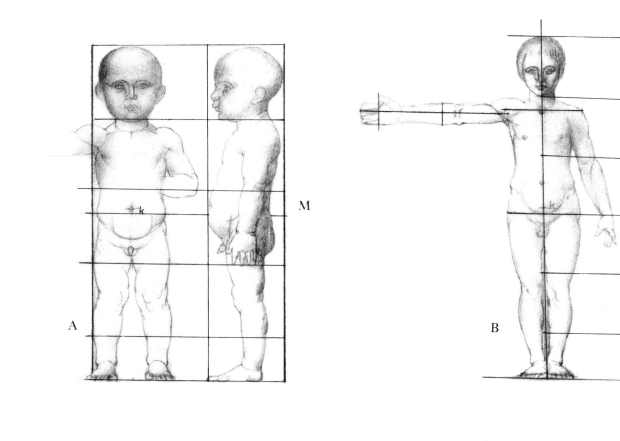

M

A

M

B

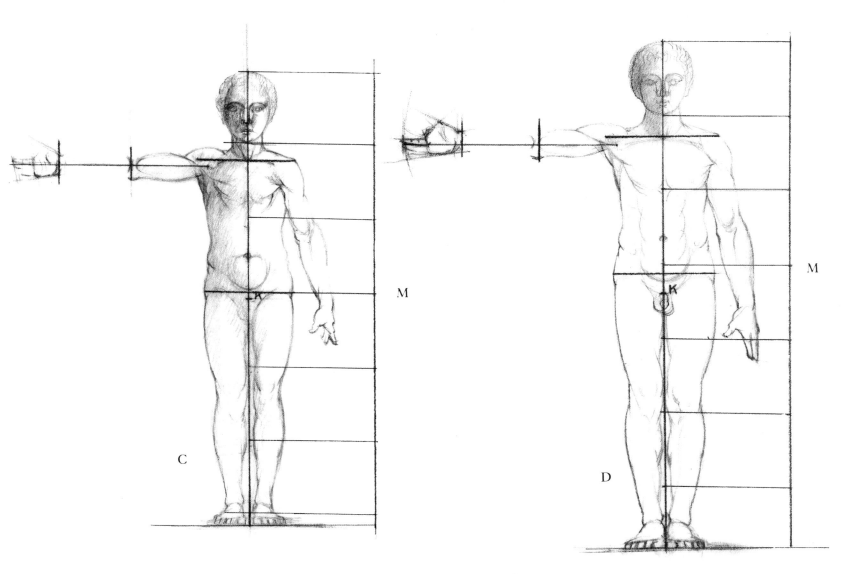

M

C

M

D

OSSEOUS AND MUSCULAR SYSTEM
OF THE HUMAN BODY

CXII—CXIV

These plates exhibit the structure of the whole human body. From the front and behind, the bones are seen on the left, the muscle apparatus on the right side. The lateral view displays only the muscles.

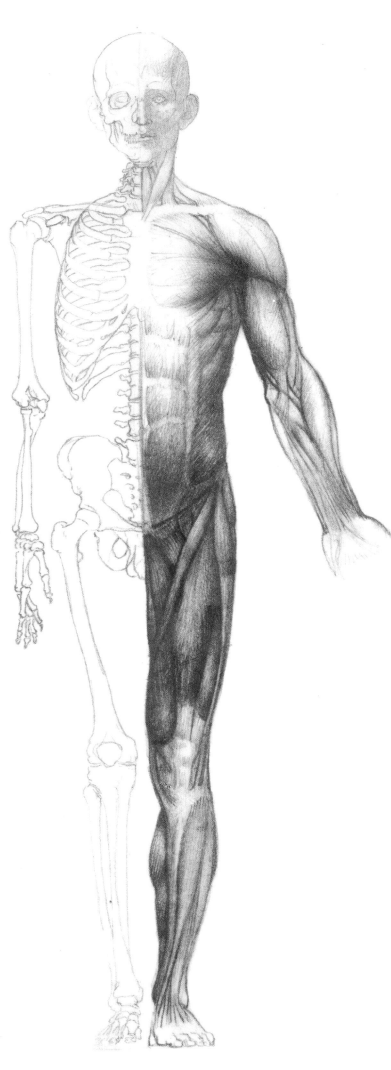

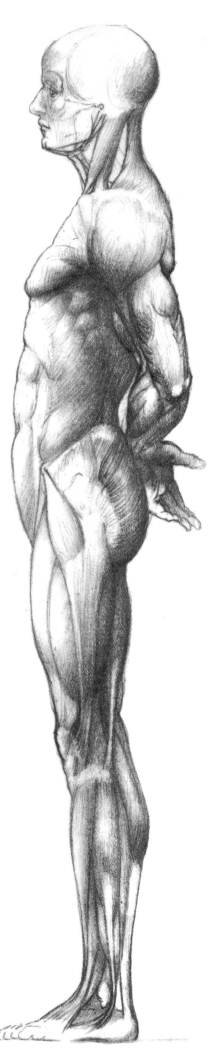

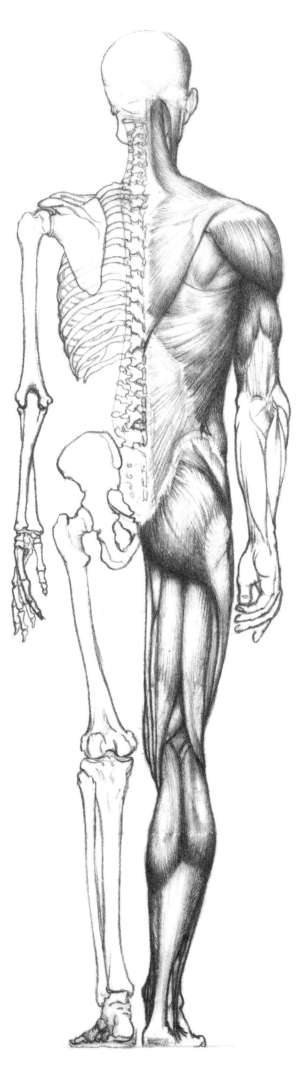

PROPORTIONAL DIFFERENCES OF THE MALE AND FEMALE BODY

CXV—CXVI

In both sexes, the waist is the narrowest place. Up- and downwards from this, the body becomes broader. The pelvis—shoulders proportion is different, the shoulders being narrower than the pelvis in the female, while in man the case is the reverse. Great differences are displayed in the form of the upper limbs. Men's arms are muscular, less rounded and smooth than those of women. In both sexes, the cross section of the upper arm is elongated in the sagittal direction, but this elongation is more marked in man, owing to his stronger muscles. The differences in the form of the lower limbs are likewise considerable as seen in Plates CXV and CXVI.

FEMALE BREAST

CXVII—CXVIII

The form and size of the female breast (mammary gland) is different according to type, individual, and age. Its shape is generally hemispherical (Plate CXVII, 1), apart from many slight variations due to gravitation. The deviation is greatest at the lower pole, due to the descent of the heavy breast made up of fat and glandular apparatus. There is some difference between the medial and lateral surfaces, too, as seen in the plates.

From the artist's point of view, the situation of the female breast is not unimportant. As a rule, the angle formed by the axes of the two breasts should not be too large. The prolongations of the axes should intersect at the spinal column (Plate CXVII, 3 a, 3 b). As for the distance between the breasts, all works of art made on the basis of living models show that certain standards of beauty have, at any rate in Europe, been gradually developed. Discussion of these standards does not belong to our subject.

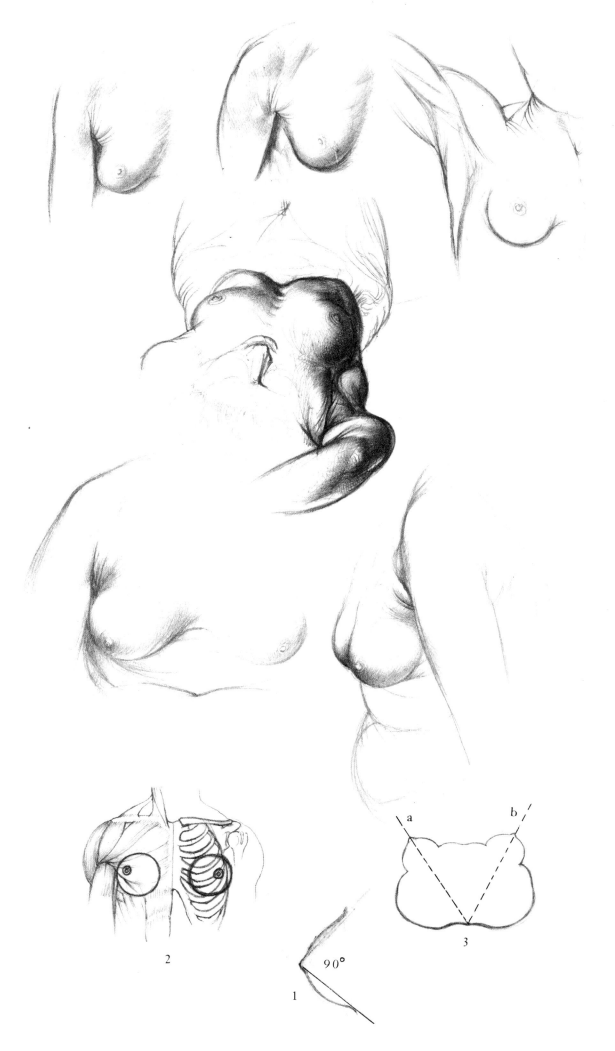

2

1 90°

a b

3

THE CENTRE OF GRAVITY

CXIX—CXX

The centre of gravity is that point of the body round which the body weight is distributed. The human body is supported by the lower limbs resting on three points: the tuberosity of the calcaneum, the sesamoid bones of the great toe, and the sesamoid bone of the little toe. The parts of the body supported in the centre of gravity mutually equilibrate each other, like the arms of a balance. The centre of gravity tends to move towards the floor along a straight line termed line of gravity (a).

STANDING

Standing, too, demands muscle work, as seen in tiredness from standing. If the body is to be kept standing, i.e., supported on the feet, the centre of gravity should be brought into the state of equilibrium. When standing still, the line drawn vertically from the centre of gravity of the ground passes between the feet (a).

SITTING

When the axis of a sitting trunk is vertical, the weight of the head and trunk rests on the pelvis (ischial tuberosities) and the muscles of the back prevent the trunk from falling forwards. The flexion of the trunk forwards and backwards is attended by the displacement of the centre of gravity. When the elbows of the sitting body rest on the thighs, the weight of the trunk is chiefly supported by the feet and the ischial tuberosities. These conditions are represented in Plate CXX.

a

CONTRAPPOSTO

CXXI—CXXVI

This term used in art means an equilibrated state composed of contrary movements. In this state, attention should be paid to the different position of the different axes of the parts of the body (Plate CXXV, a, b, c, d, e, f).

The axis of the limb bearing the weight of the body bends upwards and laterally. The hip axis turns towards the foot in flexion, the shoulder axis runs in the opposite direction. The vertical line starting from the suprasternal notch passes approximately through the talocalceneal joint of the standing leg. These conditions are shown is Plates CXXI—CXXIV. Essentially, all axes of the body being in contrapposto converge, like the axes a, b, c, d, e, f in Plate CXXV. Considerable change may be produced by the twisting of the body to the left or right as in Plate CXXVI, the axes in this case being partly diverging (a, b, c, d, e).

In contrapposto, the groove coursing in the anterior middle line of the body displays the same curvings as the vertebral column.

296

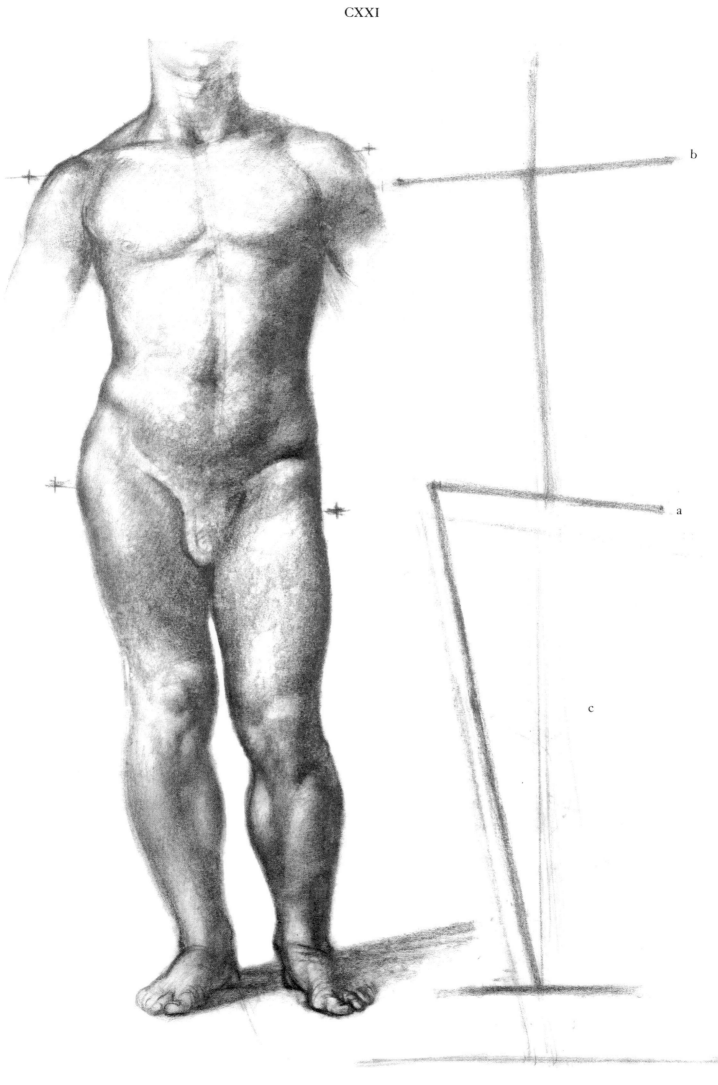

a

b

c

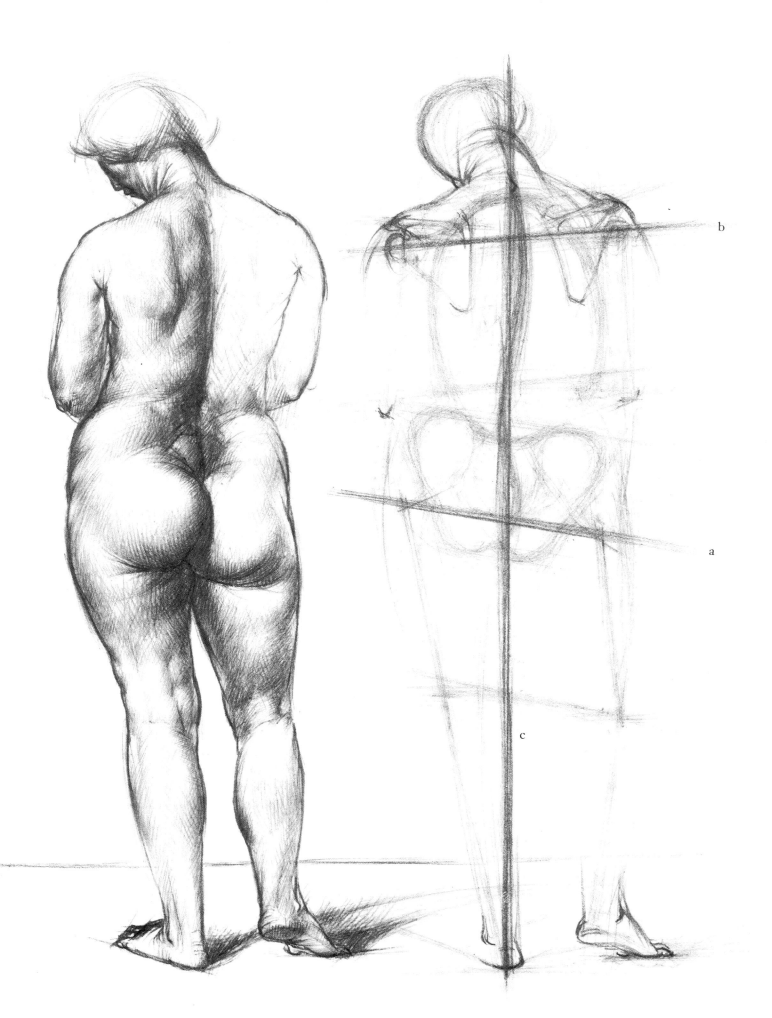

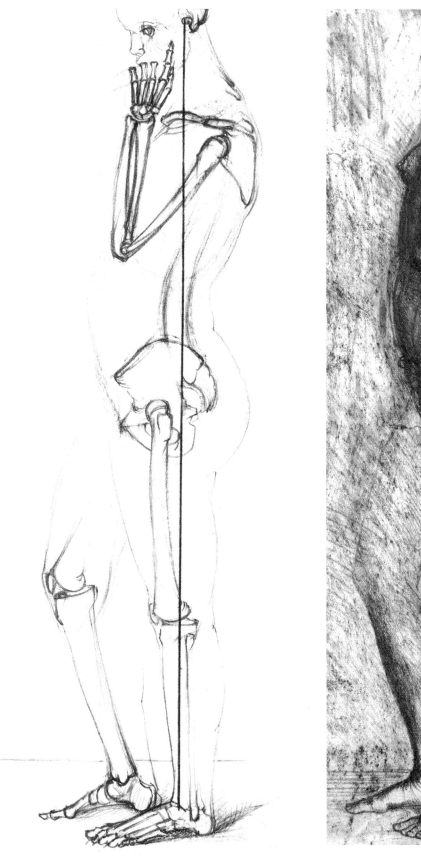

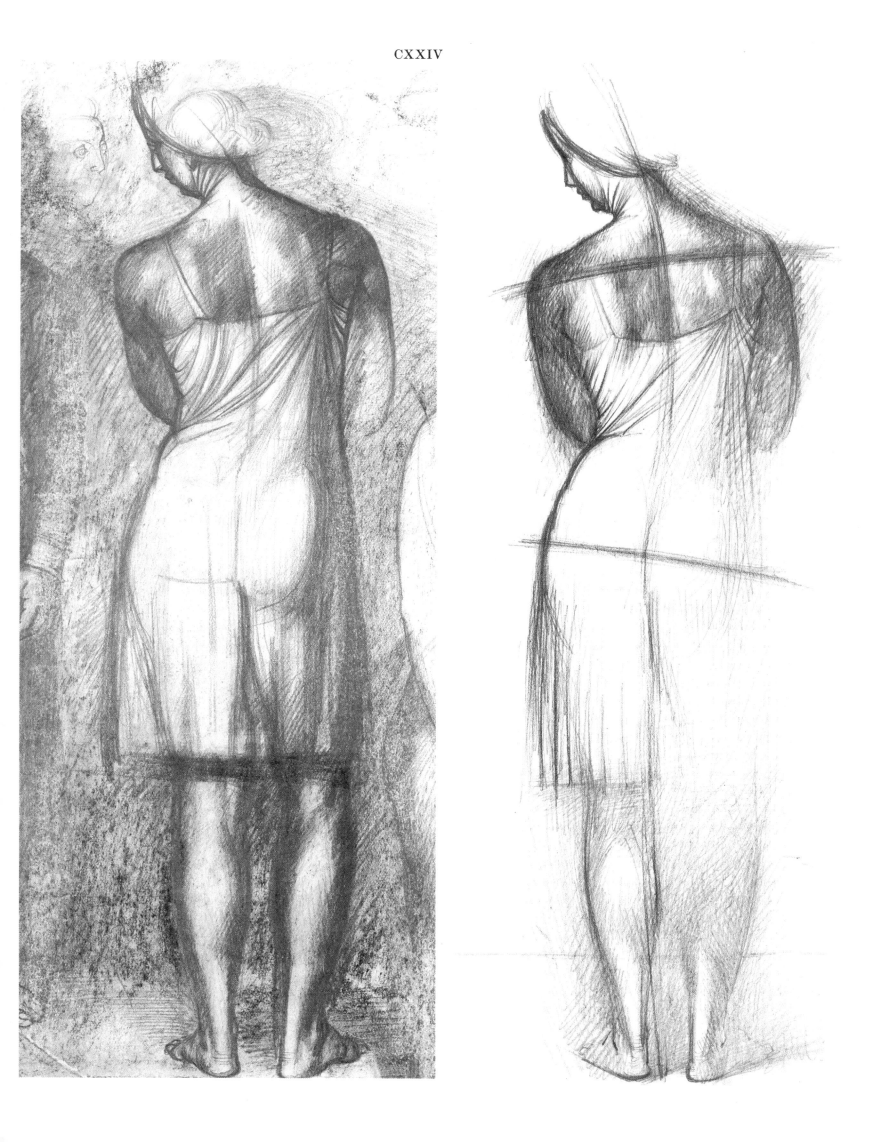

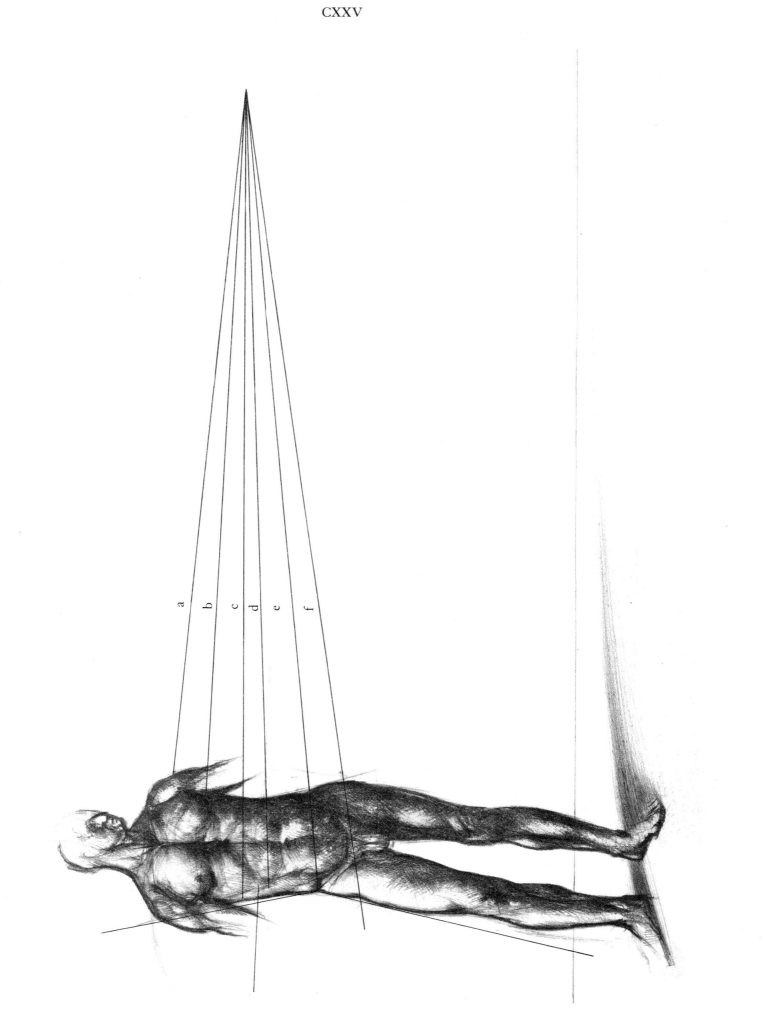

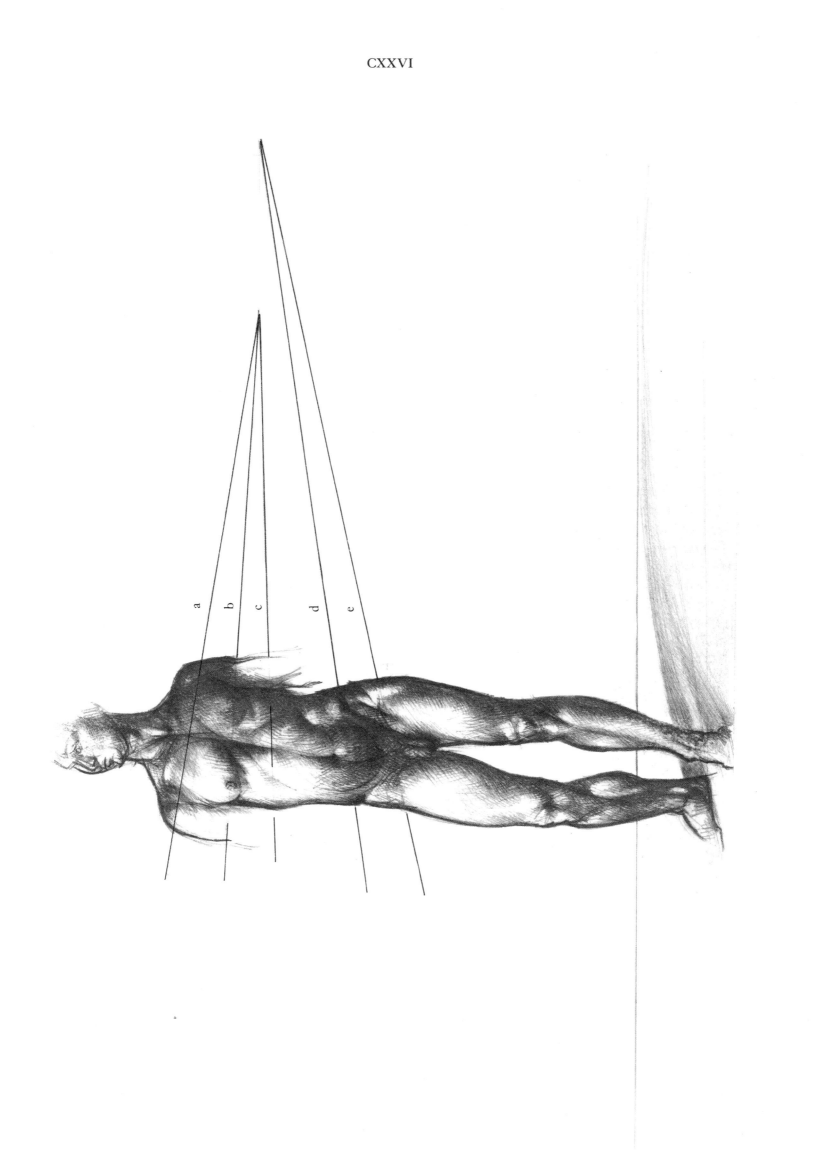

MOVEMENTS

CXXVII

In walking, the soles are put down to the ground alternately, the centre of gravity is alternately displaced and supported (fig. 1). The foot tends to push forward the centre of gravity above the ground, and to support it again. Walking is associated with different movements, such as vertical, transverse and horizontal swinging, and twisting.

VERTICAL SWINGING

This consists of the elevation and lowering of the trunk with each step.

TRANSVERSE AND HORIZONTAL SWINGING

This, too, is a movement in walking. The elevation and lowering of the trunk is attended by its alternate inclination from one side to the other. These swingings are due to the fact that the centre of gravity is shifted from the supporting leg to the other, in order to preserve equilibrium.

TWISTING

This arises from the contrasting movements of shoulders and hip. The latter turns towards the side of the moving leg (3 a—b). The changing position of the hip axis during the different movements of walking are shown in fig. 2. The simultaneous position of the shoulder and hip axis is shown in fig. 3.

WALKING ON SLOPES

During ascent, the centre of gravity ascends and progresses with each step. During descent the reverse occurs. These movements make a great demand on the quadriceps, especially the rectus femoris muscle (figs. 5 and 6).

RUNNING

The characteristic feature of running is the moment when neither foot touches the ground. This moment is due to the fact that the foot kicks itself off the ground. Thus it is very short, considerably less than one second (fig. 4).

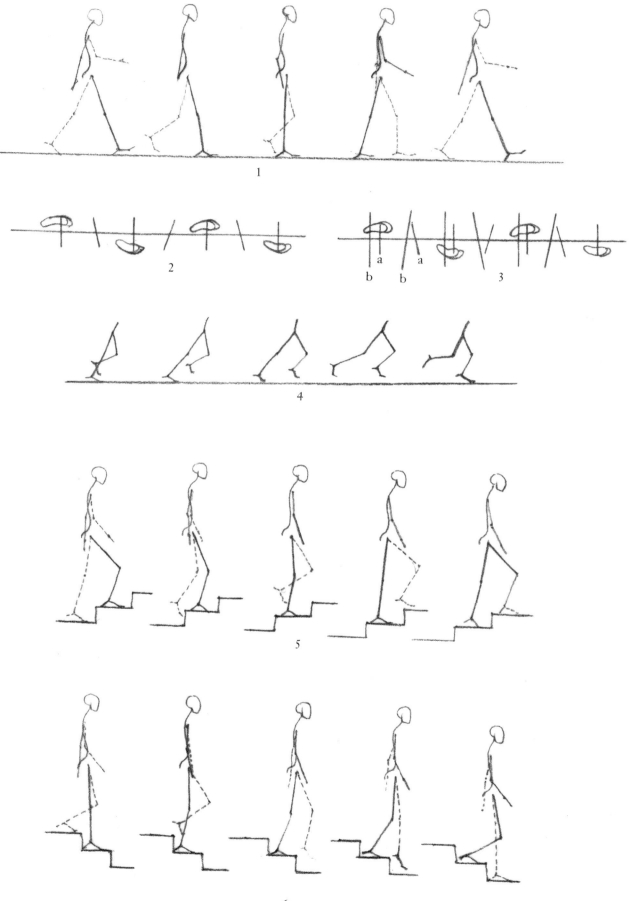

SIMPLE DELINEATIONS OF MOVEMENTS

CXXVIII—CXXX

After the description of the skeleton and its motor, the muscle system, the acting and moving man expressing feelings and emotions should be portrayed. It is impossible to solve this problem by studying a posed model. For this reason we have acquired some anatomical knowledge, and become acquainted with the bones, muscles. Moreover, we have studied the principles of movements, the centre of gravity and its effect on the supports, their reactions, the analysis of movements, etc. All this is shown by these drawings demonstrating simple movements.

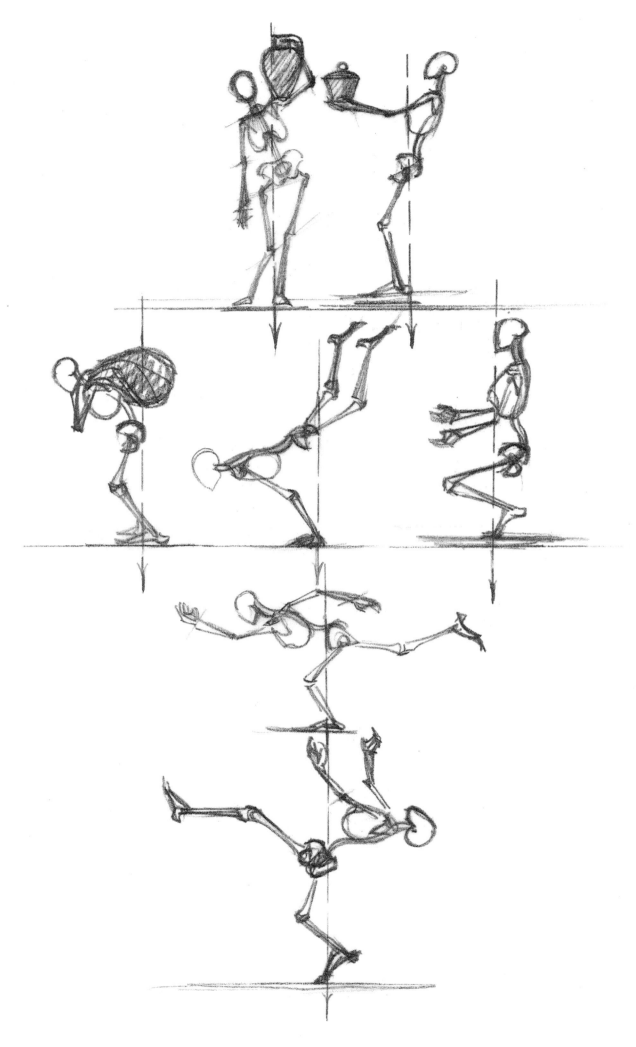

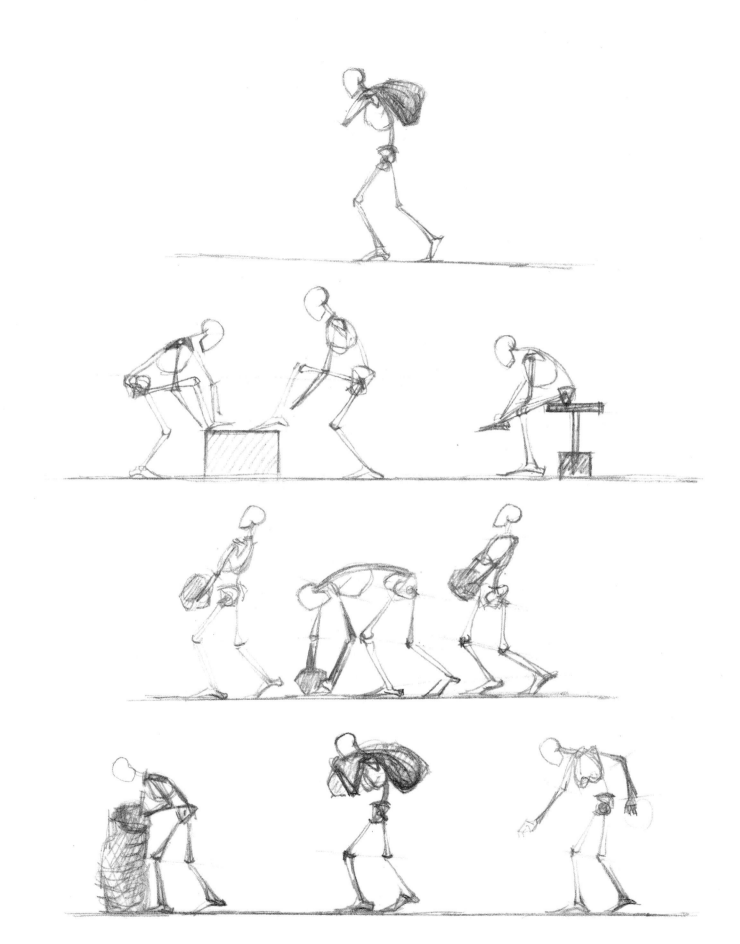

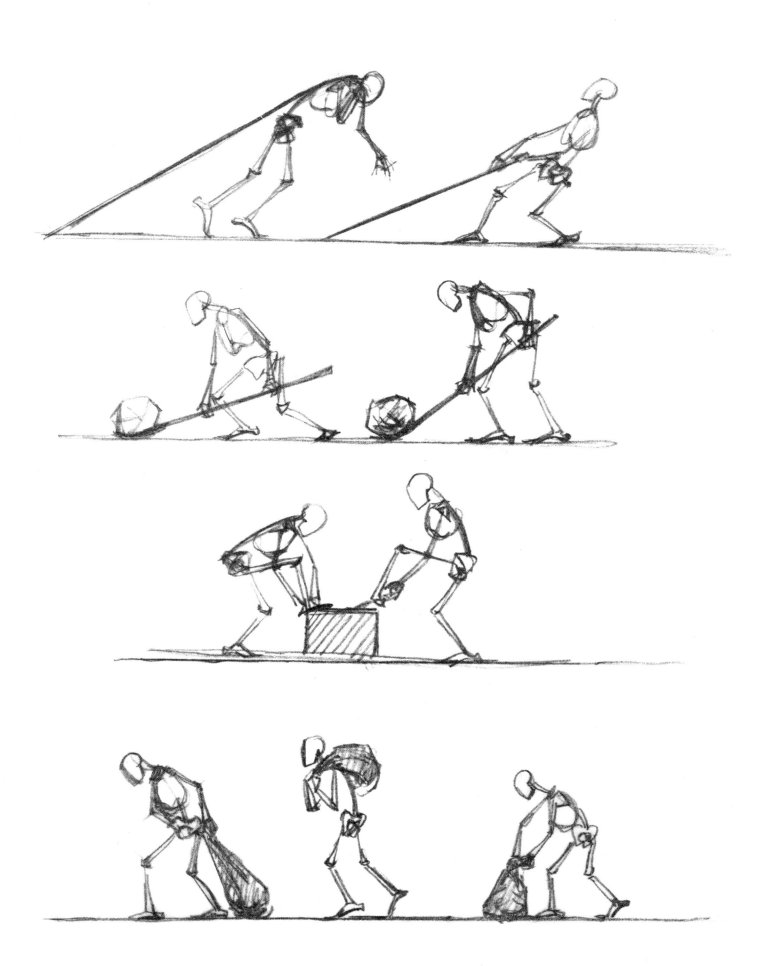

APPENDIX

MOVEMENTS DRAWN IN 1952—53 BY STUDENTS OF THE BUDAPEST ACADEMY OF FINE ARTS

CXXXI—CXLII

The figures in Plates CXXXI—CXLII were drawn by the students of the Budapest Academy of Fine Arts. In drawing the figures in Plates CXXXI—CXXXVIII, their memory was aided by a living model. The examination drawings (Plates CXXXIX—CXLII) were made on a blackboard, from memory and by improvisation, life-size.

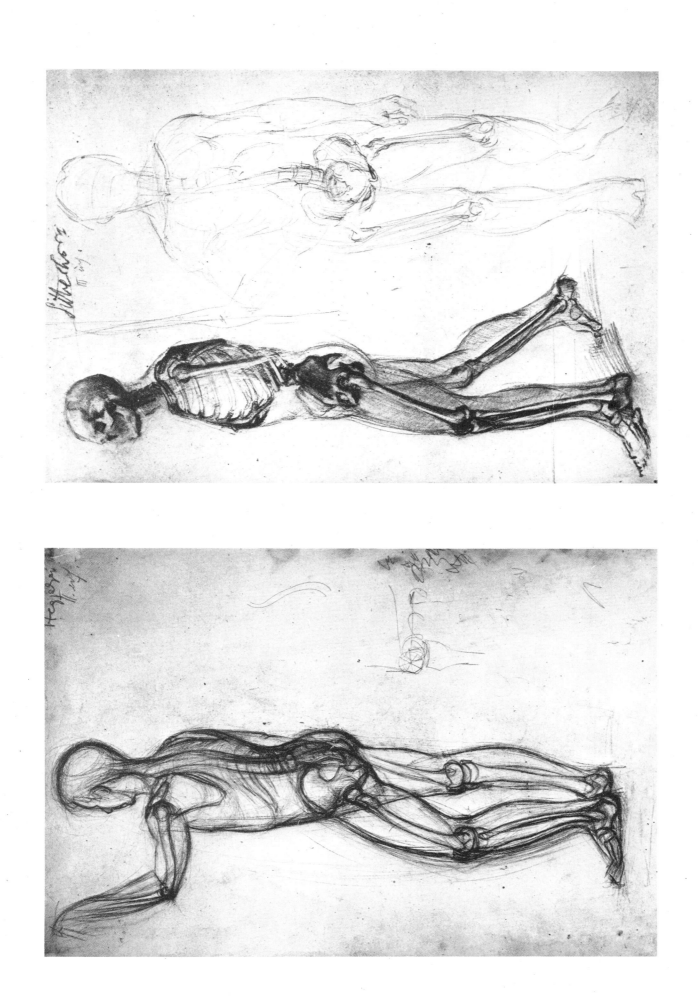

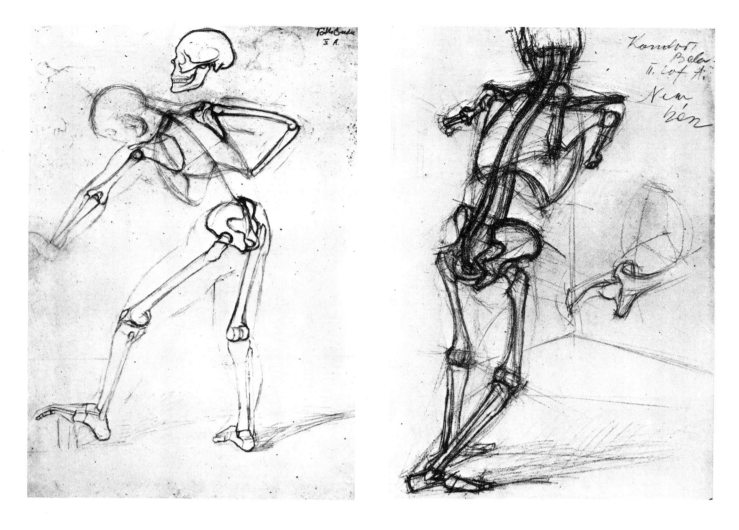

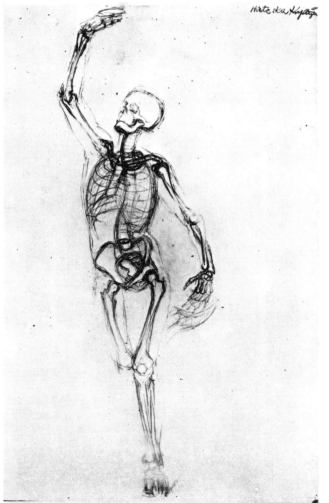

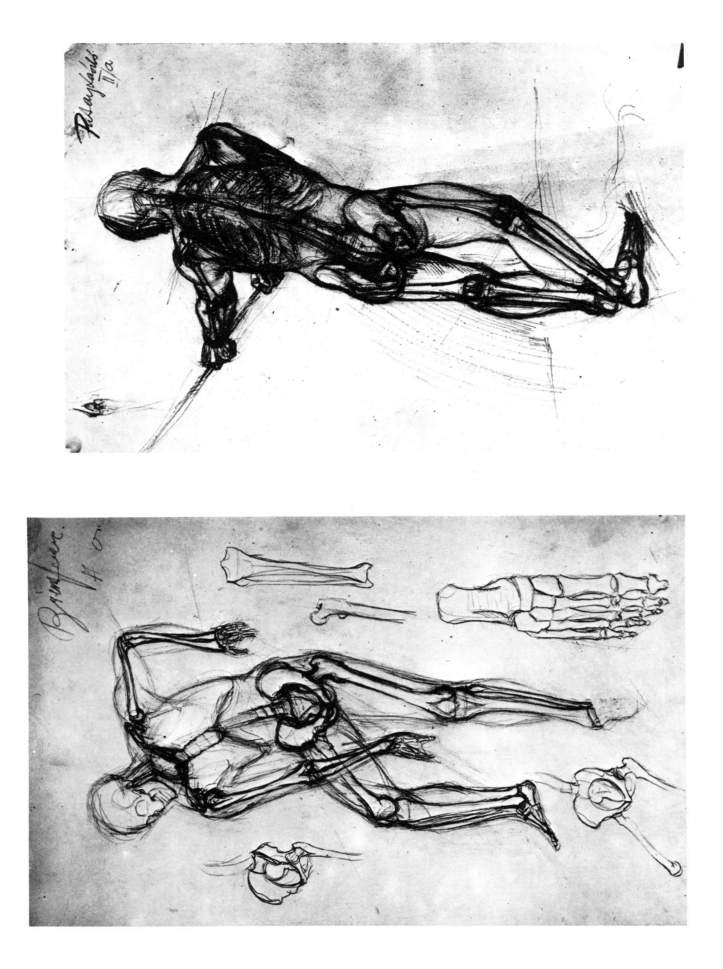

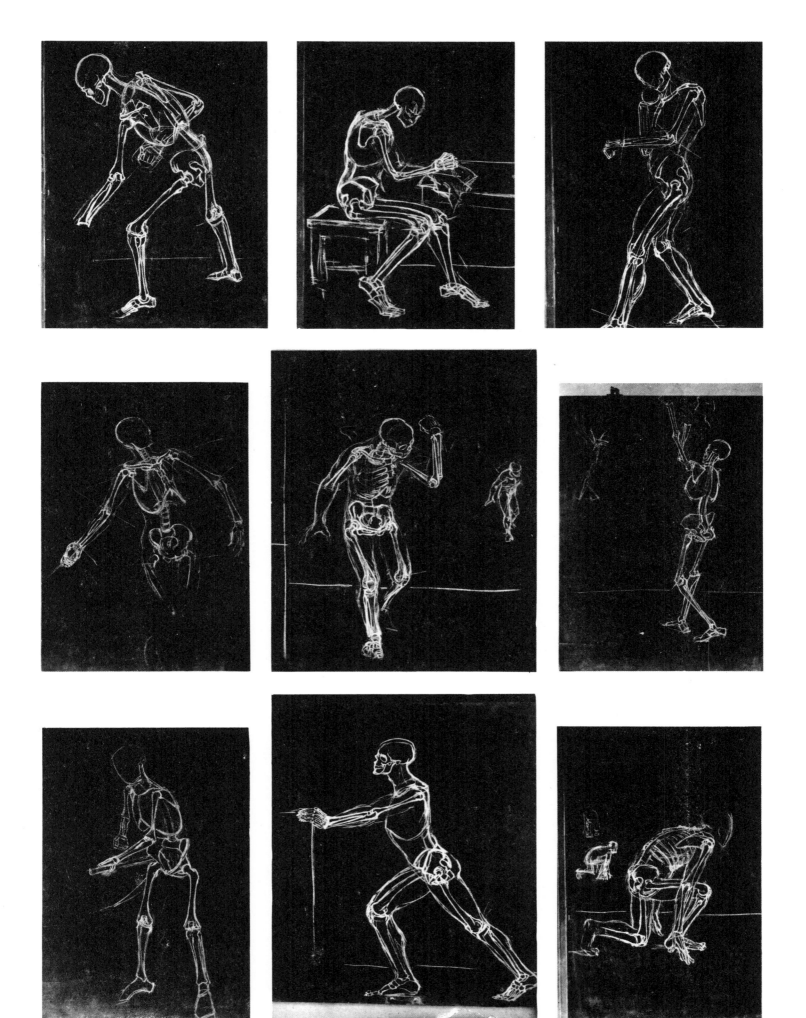

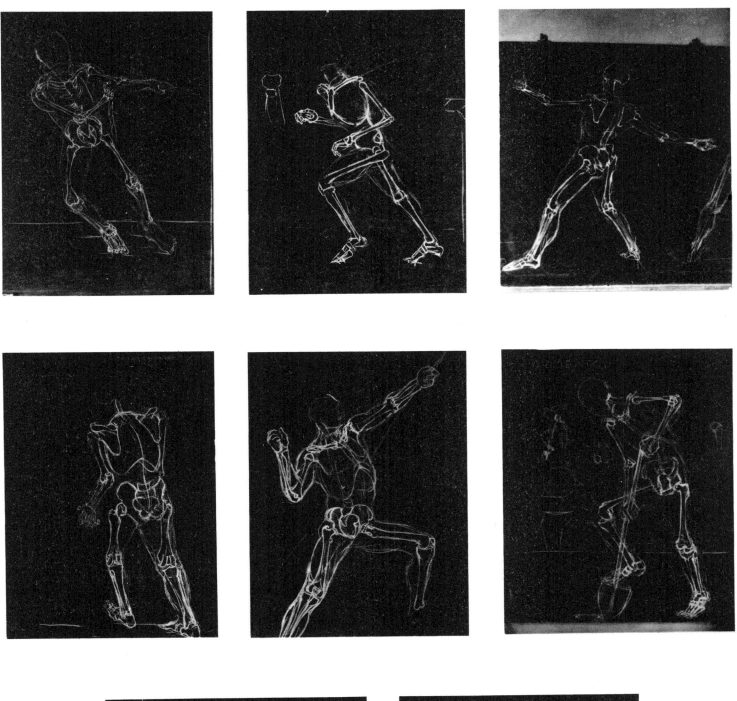

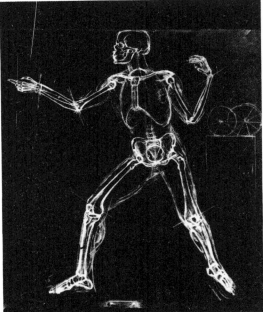

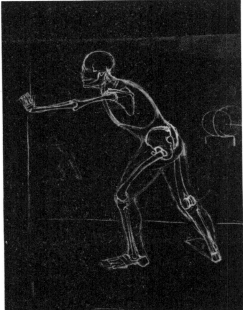

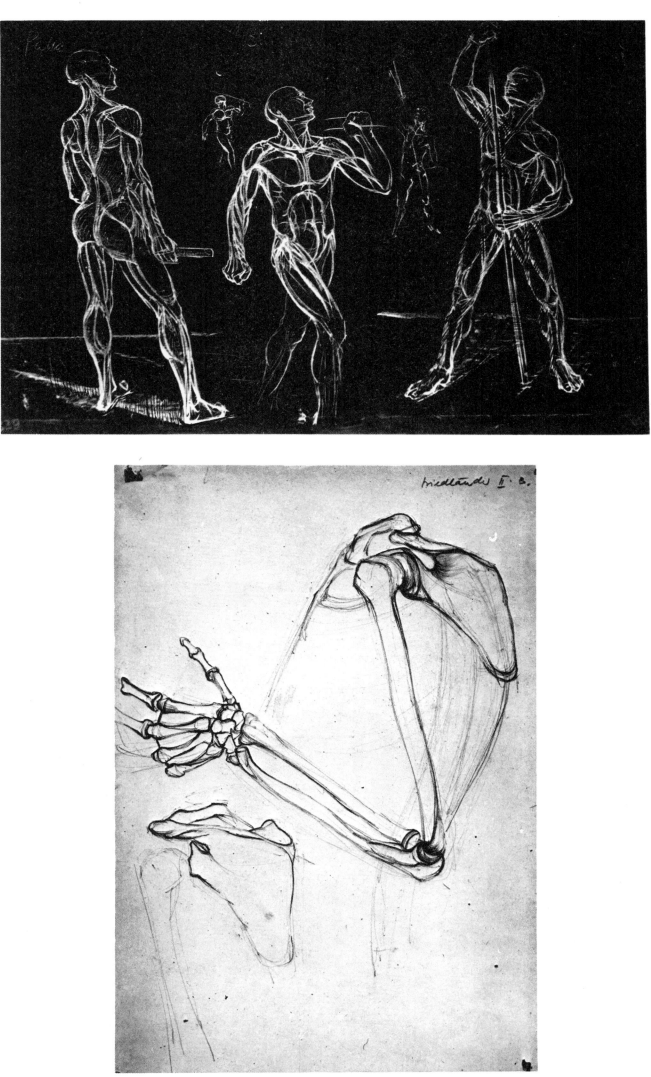